HO! FOR YO-SEMITE

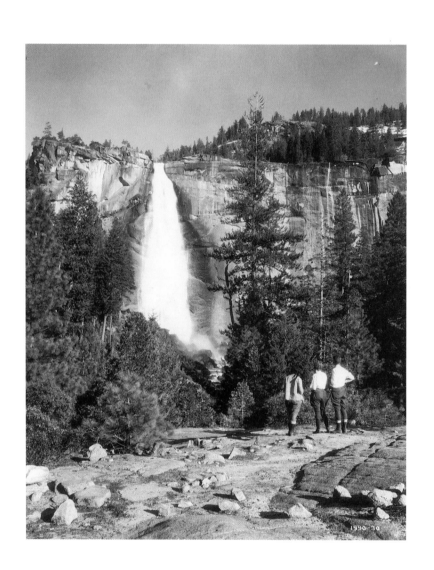

HO! FOR YO-SEMITE

BY FOOT, HORSEBACK,
HORSE-STAGE, HORSELESS CARRIAGE,
BICYCLE, & STEAM LOCOMOTIVE

Eleven Original Accounts of
Early Day Travel to Yosemite Valley

Introduced and annotated by
Hank Johnston

Yosemite National Park,
California

Yosemite Association
P.O. Box 230
El Portal, CA 95318

The Yosemite Association initiates and supports interpretive, educational, research, scientific, and environmental programs in Yosemite National Park, in cooperation with the National Park Service. Authorized by Congress, the Association provides services and direct financial support in order to promote park stewardship and enrich the visitor experience.

To learn more about our activities and other publications, or for information about membership, please write to the address above or call (209) 379-2646.

Visit the Yosemite Association web site at: http://yosemite.org

Design by Jamison Design, Nevada City, California

Printed in the United States of America

Note: Unless otherwise specified, the illustrations in this book are from the Yosemite Research Library collection, maintained by the National Park Service in Yosemite National Park.

Cover: The first automobile to reach Yosemite perched on the overhanging rock at Glacier Point in 1900 (see Chapter VIII).

Frontispiece: Early tourists at beautiful Nevada Fall. The fall was discovered by non-Indians in 1851 (see Chapter I). (Author's collection)

—✺—

CONTENTS

INTRODUCTION

This book is a collection of eleven original accounts of the travails of traveling to Yosemite Valley during the first half-century of tourist visitation. Together, they present an informative, often humorous, and sometimes poignant picture of what really went on in those pioneer days before the advent of modern transportation.

Five of the stories were published as magazine articles in various journals of the time, three appeared as features in California newspapers, two are excerpted from contemporary travel books, and one is a legal deposition taken from the victim of a stage holdup. All have long been out of print.

The topics comprise an overland trek to the Valley on foot in 1855; the rugged eighteen-year period of equestrian travel; the long and colorful era of the horse-drawn stage; a cavalry expedition from the Presidio when the army was in charge of the park; the first automobiles; a daring bicycle adventure; and finally, a memorable trip over the new Yosemite Valley Railroad soon after its completion in May, 1907.

For the most part, the accounts are reproduced exactly as they first appeared. In a few instances, extraneous passages not related to Yosemite have been deleted. The chapters are prefaced with background information about each journey; explanatory notes follow at the end.

—m—

I was assisted many times in the compilation of this book by my knowledgeable and accommodating friends at the Yosemite Research Library: Jim Snyder, park historian, and Linda Eade, reference librarian. In the same manner, Steve Medley, president of the Yosemite Association, graciously applied his expert editorial eye to nearly every phase of prepublication.

During the last half of the nineteenth century, "Ho! for Yo-Semite" was a popular rallying cry used to entice potential tourists to make the difficult, time-consuming, and expensive journey to Yosemite Valley. The phrase often appeared as a heading on posters and other forms of advertising issued by San Francisco agents for the various stage and saddle-train companies that competed in the business of Yosemite tourism.

So, to reprise that long-ago slogan one more time, it's "Ho! for Yo-Semite" in the adventures that follow—by foot, horseback, horse-stage, horseless carriage, bicycle, and steam locomotive. I hope you enjoy the journeys.

HANK JOHNSTON
YOSEMITE, CALIFORNIA

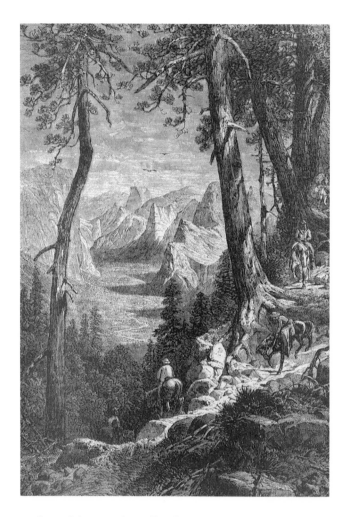

The trail down to the Valley floor was steep and dangerous.

—⚏—

PREFACE

A Brief History of Tourist Travel to Yosemite

So far as we know, Yosemite Valley was discovered by non-Indians and first entered on March 27, 1851, by some fifty members of the Mariposa Battalion, a volunteer military force engaged in a punitive campaign against the local Indians. The circumstances of the expedition are described by Dr. Lafayette Houghton Bunnell (1824-1903), a member of the party, in his classic book, *Discovery of the Yosemite and the Indian War of 1851 Which Led to That Event*. Originally published in 1880, Dr. Bunnell's book went through four editions, the last printed posthumously in 1911. (*Discovery of the Yosemite* is currently available in a new edition, with a preface by this author, issued by the Yosemite Association in 1990.)

During the three years following the battalion's 1851 entry, a scattering of prospectors and hunters also reached the Valley at various times, but left only fragmentary accounts of their wanderings. Among the adventurers was the famed animal trainer, James Capen "Grizzly" Adams, who said that the incomparable scenery "produced impressions on my mind that are ineffaceable."

Yosemite tourism really began in the summer of 1855 with the visit of a young Englishman named James Mason Hutchings (1824-1902), accompanied by three companions and two Indian guides. Hutchings, whose experience in the mining regions had led him to believe that an illustrated magazine about the wonders of California would be well received, was seeking subject material for his proposed publication. Reports spreading out from Mariposa of towering cliffs and spectacular waterfalls drew him to Yosemite like a magnet.

After following an "enigmatical course" over Chowchilla Mountain, the Hutchings party rode into the Valley on the afternoon of July 25, 1855. The next two days they explored the area for "ten miles, head to head," seeing Mirror Lake, Happy Isles, and Illilouette Fall in the process. On his return to Mariposa on August 1, Hutchings wrote an enthusiastic description of the Yosemite landscape for the *Mariposa Gazette* of August 3, of which no known copy exists. An abridged version of Hutchings' account appeared in the *San Francisco Daily California Chronicle* on August 18 and was subsequently copied by newspapers around the country. (The *Chronicle* article is reprinted in Peter Browning, *Yosemite Place Names*, Lafayette, CA: Great West Books, 1988, 213-15.)

Inspired by Hutchings' persuasive prose, two other expeditions set out for the Valley

at about the same time later that August. One, a mounted party of seventeen from Mariposa, included Galen Clark, who would be closely identified with Yosemite for the rest of his long life; the other, a group of ten adventuresome young miners, walked all the way to the Valley from their camp at Sherlock Creek, five miles north of Mariposa (see Chapter I).

The fourth party of that beginning year of Yosemite tourism was led by the Reverend W. A. Scott of San Francisco, who had heard about the Valley first-hand from his friend Hutchings. Among Dr. Scott's ten companions on his late-October

James Hutchings, second from left, guides a small tourist party in Yosemite Valley about 1881.

journey were a preacher, a doctor, a painter, a colonel, and L. A. Holmes, the enterprising editor of the *Mariposa Gazette*.

By the close of 1855, Valley tourist travel for the year totaled forty-two.

In 1856-57 three horse trails were cleared and blazed through the foothills and across the mountains to Yosemite by area businessmen, who anticipated an inrush of sightseers. On the south, brothers Milton, Houston, and Andrew Mann completed a forty-mile toll trail from Mormon Bar below Mariposa to the Valley in August, 1856. Two of the brothers had been members of the Sherlock Creek party the previous year.

North of Yosemite, Lafayette Bunnell, George Coulter, and others constructed a thirty-three-mile "free trail" from Bull Creek to the Valley floor that same summer. A rough seventeen-mile wagon road already existed between Bull Creek and Coulterville.

The following year (1857) Tom McGee, a local pack train operator, re-opened the western part of the old Mono Trail from Big Oak Flat, ten miles north of Coulterville, to a junction with the Coulterville Trail at Crane Flat. From here to Yosemite Valley, fifteen miles distant, the merged trails used a common route. For the next seventeen years, until the completion of stage roads in 1874, the Mariposa, Coulterville, and Big Oak Flat Trails provided the principal means of access for Yosemite-bound travelers, whether by horseback or on foot.

A trip to the Valley during this pioneer period was not to be undertaken lightly. From San Francisco, most Yosemite tourists embarked on an all-night, mosquito-plagued ship ride up the San Joaquin River to Stockton. Arriving at 6 a.m. the groggy passengers immediately set out on a jostling, dust-filled stage ride over rutted foothill roads to the end of the line at Mariposa, Coulterville, or Big Oak Flat, depending on

one's itinerary. Then came two or three days of rigorous horseback riding over steep, narrow trails to reach the rim of Yosemite Valley. The final few miles were the worst of the journey, for they included a sharp, scary descent down a narrow rocky defile full of loose boulders where one misstep could cause serious injury or even death. The time, effort, and expense of the arduous trip limited visitation to an average of only seven hundred sightseers a year.

On June 30, 1864, with almost miraculous foresight, the federal government ceded Yosemite Valley and the Mariposa Grove of Big Trees to the state of California as the world's first scenic preserve— "inalienable for all time." Despite this national recognition of Yosemite's uniqueness, it remained obvious to those involved in tourism that access to the Valley must be greatly improved before visitation would dramatically increase. By the late 1860s, three rival turnpike companies were in various stages of formation in the nearby foothill communities of Big Oak Flat, Mariposa, and Coulterville, their backers fully aware that the first wagon road to Yosemite Valley would be heavily used.

An early tourist party at Mirror Lake.

—m—

After overcoming a variety of obstacles, toll roads from Coulterville and Big Oak Flat were completed to the Valley in the summer of 1874. The Mariposa Road followed a year later. Thus began a heated competition for Yosemite tourist patronage that continued unabated until the opening of the Yosemite Valley Railroad in 1907.

Although a bumpy, dusty stage ride across the mountains from the various railroad connections to Yosemite was still a rigorous and largely unpleasant experience for travelers, it represented a considerable improvement over the dreaded horseback journey that it superseded. The new roads also made it possible for campers to drive their own wagons to the Valley, carrying their equipment and supplies with them. Tents were set up wherever convenient, and horses turned out haphazardly to forage in the meadows. In 1878 it became necessary to establish a designated campground in the east end of the Valley to prevent ongoing environmental damage. By the end of the nineteenth century, Yosemite travel had grown to an average of about eight thousand persons annually.

The modern era of Yosemite transportation began on May 15, 1907, with the arrival of the first train of the new Yosemite Valley Railroad, a seventy-eight-mile short line running from Merced in the San Joaquin Valley to a terminal called El Portal (the gateway), only twelve miles west of the Valley floor. From here tourists were

—m—

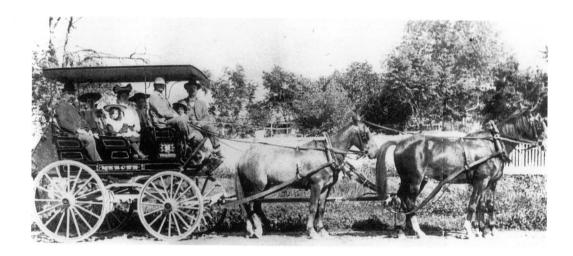

The horse-stage era lasted for forty years in Yosemite.

conveyed to their Yosemite hotels by horse-stage (after 1913, by motor stage). Pullman cars provided deluxe overnight accommodations from both San Francisco and Los Angeles to El Portal. In 1908, the first full year of rail service to Yosemite, 8,850 visitors entered the Valley. All but 1,469 traveled by train.

The first automobile to reach Yosemite, a tiny steam-powered Locomobile, arrived in the Valley via the Wawona Road on June 23, 1900. Over the next several years, a handful of other "horseless carriages" followed, utilizing all three stage roads. In June, 1907, the Acting Superintendent abruptly banned all motor vehicles from the park, saying that the Yosemite roads were too steep and narrow to permit the combined operation of horse-stages and automobiles. The edict remained in force until rescinded by the Secretary of the Interior on August 23, 1913. During the next dozen years, as both the quantity and quality of automobiles increased dramatically throughout the country, Yosemite visitation jumped from 739 cars in 1914 to 49,229 cars in 1925.

On July 31, 1926, the final segment of the low-level "All Year Highway" (Route 140) opened from Mariposa up the Merced River Canyon to the Valley floor. The new road had no grade steeper than 2.85 percent between Briceburg and El Portal, with a maximum elevation of 4,000 feet at the western entrance to Yosemite Valley. This was a considerable improvement over the 6,000-to-7,500-foot summits and 10-to-20-percent grades on the three existing routes. Within two years, passenger travel on the adjacent Yosemite Valley Railroad dropped 78 percent, effectively dooming the under-financed short line, although freight traffic along the right-of-way enabled the YVRR to remain in business on a greatly reduced basis until 1945. In 1927, 490,430 tourists entered the park, the overwhelming majority traveling in their own cars.

During the early 1930s, the Wawona Road was realigned and paved, followed in 1940 by the completion of the new Big Oak Flat Road to the Valley from the north. Annual Yosemite tourism passed one million persons in 1954, two million in 1967, and three

million in 1987. Today, more than four million sightseers visit the park each year. Almost half this number are "day trippers," who enter and leave the Valley the same day, often clogging roads and overflowing parking areas in the process.

In 1980 the landmark Yosemite General Management Plan committed the National Park Service to the eventual elimination of most private automobiles from the Valley floor, to be replaced by various forms of public transportation. As of this writing, that is still the goal.

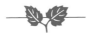

Arthur E. Holmes and Frank H. Holmes in their modified Stanley Steamer near Mirror Lake, July, 1900. The brothers Holmes drove the second car into Yosemite Valley over the Wawona Road (see Chapter VIII).

An engraving of Bridalveil Fall printed in the 1860s.

I

DISCOVERY OF THE NEVADA FALL
by James H. Lawrence

James H. Lawrence was one of ten "fearless spirits and noblehearted fellows" who walked from their mining camp at Sherlock Creek, five miles north of Mariposa, all the way to Yosemite Valley and back in August, 1855, the beginning year of Yosemite tourism.

Nearly three decades after that historic journey, Lawrence wrote the following article for the Overland Monthly (October, 1884), and gave a vivid and perceptive account of the party's experiences. He also describes, and sometimes laments, the changes that had taken place in Yosemite Valley during the twenty-nine years since his original visit. Lawrence concludes his story with a moving passage about his former companions—"the boys" of that period, as he puts it—now "living only in the chambers of memory."

The title, "Discovery of the Nevada Fall," is actually a misnomer, although most likely an unintentional one. Lafayette H. Bunnell, in Discovery of the Yosemite and the Indian War of 1851 Which Led to That Event (4th ed., 1911: reprint, with a preface by Hank Johnston, Yosemite: Yosemite Association, 1990, page 81), describes how members of the Mariposa Battalion saw Nevada Fall in 1851. Lawrence was probably not familiar with Bunnell's book (originally published in Chicago in 1880) at the time he wrote his article.

Many interesting reminiscences of pioneer excursions to the Yosemite Valley have been published in the shape of fragmentary sketches in the papers and magazines of the Pacific Coast; and some very interesting compilations issued in book form. One of the most complete is that embraced in "The Scenes of Wonder and Curiosity in California; or Tourist's Guide Book," by J. M. Hutchings.[1] It includes a detailed narrative of the discovery of the valley in 1851, by an expedition under Captain Boling,[2] (the object of which was the pursuit and capture of a marauding band of Indians); also accounts of subsequent explorations by the author of the work, together with notes of local tourists in 1855, '56, and '57. Those who lived in Mariposa County during those years, and had the opportunity of personal observation, will take pleasure in testifying, to its truthfulness. It is correct as far as it goes; but one of the early excursions, and one which, from its results—both immediate and subsequent—deserves a place in history,

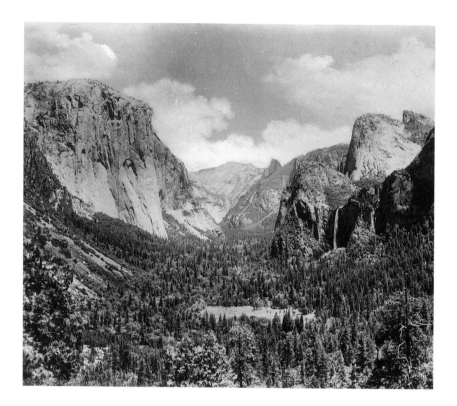

"It was a grand view," said Lawrence, "worth the whole journey." This photograph
was taken from New Inspiration Point about 1900. (Author's collection)

seems to have been inadvertently shelved. No published account of it has ever been
given, and in fact, not even a notice of it has appeared in print, except a very brief
allusion to it in the "Mariposa Gazette" in the year 1855, and an article written by
George C. Pearson for "The Rural Press" in May, 1873,[3] (eighteen years thereafter), and
subsequently republished in the "Chicago Journal of Commerce."

The party mentioned by Mr. Pearson in this article was made up of miners—the old
time sort—numbering ten in all, and was organized at "Sherlock's," a mining camp of
some celebrity, about five miles from the town of Mariposa. The date was about the
10th of August, 1855. In the sketch given in "The Press" the writer says: "The party was
composed of ten as fearless spirits and noble-hearted fellows as ever shouldered a rifle
or gathered around a camp-fire." Looking back through the intervening gap of twenty-
nine years, it becomes a cheerful duty—even at the risk of being charged with boasting
as one of the survivors—to endorse the sentiment, and supplement the same with a
few details.

With one exception, the Sherlock crowd was made up of pioneers of the "days of
'49." One boy, a sort of waif, had straggled into camp about three months before the

expedition. He had been adopted by a party of big-hearted miners, and was known as "the Orphan." He was a trifle green in camp life, and was taken along out of pure kindness, for educational purposes. The others had "seen the elephant" in his native ferocity—the genuine untamed animal—and in divers places and at sundry times had examined his trunk and taken an inventory of its contents. Our frontier experiences had made us familiar with the perils and dangers of border life. Some had been in the Mexican War; others had fought Indians; all were more than average rifle shots; could pack a mule with the dexterity of a Mexican vaquero; were skilled in woodcraft, and inured to every variety of camp-life. "Hardship" was a word discarded from our vocabulary, and the shorter one, "fun," substituted. It was emphatically a lively crowd.

A roll of the names of the entire party, with notes of the trip, and various other records of pioneer times in Mariposa, laid away for historical purposes, were swept from the face of the earth by the fire of 1866. I suspect that was the only record of the excursion. As I must trust to memory alone for the names of my companions, not even knowing whether any of them are still alive, the list is necessarily incomplete. There were two of the Mann brothers, Milton and Houston, abbreviated to "Milt" and "Hugh," E. W. Haughton,[4] J. E. Connor, Geo. C. Pearson and his partner Dickerman, a man by the name of Priest,[5] the long-legged boy, and one other whose name is forgotten.

E. W. Haughton, who was with the Boling Expedition in 1851, was our guide. Two pack mules loaded with blankets, a few cooking utensils, and some provisions constituted our camp outfit; while a half-breed bloodhound, whose owner claimed that he was "the best dog on the Pacific Coast," and who answered to the name of "Ship," trotted along with the pack mules. There was some talk about going mounted, but the proposition was voted down by a handsome majority, on the ground that superfluous animals were "too much bother."

Our first day's tramp ended in the neighborhood of "McNeill's saw-mill," since known as "Lovejoy's," and more recently as "Clark's."[6] Here was a magnificent camping ground, with all the essentials of wood, water, and grass. The mules were tethered on a luxuriant meadow; camp made; supper cooked, and the prospects of the campaign discussed. Then followed a general sociable smoke; stories of adventures—marvelous escapes from dangers by flood and field; traditional legends of events located "away back in the States"—"home" we all called it, for hardly any one at that date dreamed of making California a permanent abode; the *repertoire* of songs was opened, for we had musical talent not classical, but melodious and inspiring. How the woods and hills rang! Whoever has experienced camp-life in the mountains can fill the gap in this outline description, and draw a picture of the group of hardy pioneers, all in the flush of young, vigorous manhood, as they reclined in a semi-circle about the camp-fire.

In fancy, I see them yet, and hear the ringing chorus, the exultant whoop, and the genuine, unrestrained laughter. It would be worth a year of humdrum civilized society life to recall the reality of one week of the old time.

Daylight saw "the boys" up and astir. Breakfast was cooked and disposed of, and the animals packed. After a brief parley, it was decided that the main body, under the guidance of Haughton, should make a detour in a southerly direction, by way of the Magoon Ranch, somewhere in the vicinity of which our guide knew they would

Captain John Boling was an officer in the Mariposa Battalion of 1851.

—〰—

James M. Hutchings published his first book, *Scenes of Wonder and Curiosity in California*, in 1860. It consisted mainly of extracts from his *California Magazine*. The book was well received and went through a number of editions between 1860 and 1876.

—〰—

intersect the old Indian trail followed by Boling; while two of the party, known best as Hugh and Jim, followed a ridge which led up to the divide near the head of Devil's Gulch, from which point it was easy to strike the trail on the northern slope of the Chowchilla Mountains, and follow it up to the south fork of the Merced, at the old crossing, where it was agreed that the next camp should be.

This side show was not on the original bills, but was an impromptu affair, improvised after this fashion. Hugh, who was a noted deer-slayer, had once killed the "biggest and fattest buck that you ever saw, boys, right over on the head of Devil's Gulch—and," he continued, "the chances are that a fellow might stumble on a deer this morning; and broiled venison isn't bad to take."

Jim, the owner of "the best dog on the Pacific coast," suggested that a deer was "a little too much for one man to pack," and that in case of wounding the animal, "a good dog might be handy to have along."

"All right," said Hugh. "It's a whack. I was just waiting for a pard, and you and Ship will fill the bill."

"We'll meet you at the South Fork!" halloed the hunters, as they started up the divide.

"South Fork goes; and drinks for the crowd, when we get back to Sherlock's, that we are there first," responded Connor, as the train filed through the oaks Chowchilla-wards.

"We take that bet! game's made! roll!" was echoed back as a parting salute.

The ridge, up which the two skirmishers meandered, grew steeper as they progressed, and the summit—their objective point—appeared to be getting higher, or as Hugh expressed it, "We don't appear to gain on it much." Long before it was reached, mid-day was at hand; the scorching rays of the August sun had begun to tell on them; and what with prospecting right and left for "deer sign," making sundry observations on the topography of the country, and examining scattered specimens of quartz or "float," as the miners call it, it was perhaps

—〰—

three o'clock in the afternoon before they rested on the crest of the "divide."

"Now," remarked Hugh, "here we are, twenty miles from home, and about ten from any other place—not a smell of deer meat—not even a fresh track—dry as a powder horn. Look at that dog's tongue!"

"Ship, old fellow, this is rough on you," said his owner soothingly, as he fondled his faithful dog. "But you are not in the fault—you have *some* sense. If you could talk, you would say that nobody but two dog-goned idiots would have expected to find a deer on the sunny side of a mountain in the middle of the day, in the month of August. You would have got into the neighborhood or their range and camped the night before—wouldn't you, Ship, old boy?"

"Oh, let up, Jim. I take it all on myself," responded Hugh. "But I'll swear I didn't think it was such a climb." And then he explained how he became acquainted with this region through the experiences of a prospecting party of which he was one; that they had penetrated these hills further than any body; that after they had prospected Devil's Gulch and pronounced it "no good," they had followed the south fork of the Merced up to a point higher than anybody had ever gone before or since: and then he was branching off into a story of what an old Indian had told a man who had told his partner—when he suddenly changed the subject with the exclamation:

"Listen! what's that?"

"Deer in a walk?" queried Jim. "I am ready to make oath that no four-footed animal—nothing but a fool man—is going to run, or even trot, in such a temperature as this."

"Thunder?" suggested Hugh.

Jim laid his ear to the ground.

"Keep quiet!" this to Ship, who was getting restive.

"Running water! by the rod Moses smote the rock with!"

"Blamed if I don't think you are right, Jim; and away down, down the slope, don't you see there's a clump of bushes? Looks like a healthy hill of potatoes or a bunch of weeds. You beat me on 'harkers,' but I lay over you with the 'blinkers.' But, there's the water, sure; let's make for it, for my throat is worrying me."

It did not take long to "limber up," and the descent, like that of Avernus we read of, was facile. Ship had apparently snuffed water in the air, for he held his nose knowingly in that direction, and led us straight to the little oasis.

Here was, indeed, a welcome discovery—a living spring; and more than that, a flowing stream. Not a trickling, babbling brooklet, but a roaring, foaming stream of ice-cold water, gushing out of the mountain side.

"Talk about miracles, Hugh; did you ever see anything to equal this?"

"Never!" and then the quality of the beverage was tested. Anybody who has been traveling exposed to a hot sun, and without water, for half a day, knows how it was.

A little clump of gooseberry bushes loaded with berries, ripe and luscious, growing near the fountain, next claimed the attention of the pilgrims. As they had eaten nothing since morning, it is not wonderful that they agreed that they were the best they ever saw.

They lunched. Then a brief conference was held, and it was concluded, judging from what knowledge they had of the "lay of the country," of their own progress, and of the

probable course and distance made by their companions, that they were ahead of the main body, that it could not be very far to the old Indian trail, and that the distance to the South Fork crossing would not exceed four or five miles. So they loitered along leisurely, leaving the heavy timber to their right, and keeping a bright lookout for the trail.

"Hunt for it, Ship—look sharp, old boy," was the order given this intelligent quadruped by his owner.

"Looks like he knows what you want," said Hugh.

"Knows? I should say so. Why, that dog understands every word I say. Let me tell you what that dog did one day. It was when I was camped up at the—"

"There!" interrupted Hugh: "he's found it—see, he has changed his course. Now, he stops. He's beckoning, with his tail for us to come on."

Sure enough, when they reached the spot where the dog was, there were the faint traces of an old Indian trail—barely discernible, but still a trail. Hugh decided that the divide along which it ran led to the crossing. A further examination developed mule tracks—two mules. These were followed a quarter of a mile or more, till a closer scrutiny showed that they must have been made some days before. Then it occurred that they remembered hearing that an artist and a "magazine man" had gone through Mariposa, *en route* for the Valley. "That accounts for the tracks," they both said in the same breath.[7]

Ship didn't appear at all anxious to proceed any further in the direction of the South Fork.

"Look at that dog!" said Jim, with a "proper pride": "See him turn around and whine. Now listen to that little half-whispered bark. He's talking, Hugh. Do you know what he's saying? Just simply this: 'What in the blazes are you darned idiots going down to the South Fork for? Do you expect to live on air? I don't—I want a bone.'"

Another council of war was held, and it was then and there resolved to take the back track until they should meet the pack train. Hugh held the opinion that they would collide with them just about the edge of the heavy timber. The arrangement appeared to be eminently satisfactory to Ship, who started in a dog trot as soon as the decision was announced.

By the time the timber was reached, the shades of twilight were upon them. Twilight soon deepened into darkness. The moon had not yet risen, and the only suspicion of light was the glimmer of the stars through an occasional peep-hole in the dense shadows of the overhanging boughs of the lofty firs, cedars, and sugar pines.

"This is about the thickest growth of timber I ever struck," remarked Hugh, "and tall! Whew-w, Jim; did you notice just as we were getting into it—before the daylight had faded out entirely? Why, a fellow had to look twice to see the top of one of these trees."

"Yes," replied Jim; "they seem to almost touch the stars. Look up whenever you can see a little opening. Did you ever see a clear sky look so dark blue, or stars so bright and so beautiful? Wonder if any of them are lost, and looking for a roosting place in the tall tree-tops?"

Before this time the trail had faded out of sight, and the nose of the sagacious Ship had been called into requisition.

"Here," said the owner; "you go ahead of me; but keep close, old fellow—keep close—do you hear? And Hugh, you keep close to me. The dog will nose out the trail—eh, Ship?"

The dog said "yes" as plainly as he could speak it, and in this order they made their way through the dense forest. Sometimes a fallen tree obstructed their path. Then would follow a halt, and a leap over or a crawl under by the faithful guide.

"Where are you, Ship?" An answering whine. "'Trail all right?" An assuring sniff. An hour or more of this groping, feeling, climbing, and crawling, and a comparatively smooth, open space was reached.

The situation was getting serious. It was evident that their companions had made camp on the other side of the mountain; but wherefore, when they had agreed to meet them at the South Fork?

"That's not a square way of acting," commented Jim. "They know we have not a thing to eat nor a blanket to our names. It's a blanked mean, miserable piece of business."

Hugh agreed, but suggested that possibly they had met with some accident. "Don't you remember we saw just before sunset some little columns of faint blue smoke rising up in the hills east of us? We agreed that those were Indian fires. About this time of year straggling bands of Monos come over here to gather pine nuts and seeds. Maybe they have lit on to our boys—not that they are unable to take care of themselves, but they might have their mules stampeded, and be delayed and bothered."

It was reduced to a certainty that the meeting on the South Fork was indefinitely postponed. It was also agreed, without opposition, that they wouldn't budge another step that night. "Right here we camp."

A gurgling stream of water was close at hand. Its rumbling underground defined its locality, while an open pool convenient for drinking was but a few yards away. Ship made this discovery.

"Now for a fire—got any matches, Hugh?'"

"No! haven't you any, Jim?"

"Nary match; but I know the trick of lighting a fire without matches"—and then Jim explained to Hugh how he could kindle a fire by loading a rifle with a small charge of powder, "just a squib," using a cotton rag for a wad, and then blowing it into a blaze. "Here are cords of dead wood and no end to dry leaves for kindling," he added; "This is an old Rocky Mountain project. I had a pard once who was an old trapper. We were together two years. There isn't anything worth knowing about wood craft and Indian tactics that he and I don't know—but we'll try it awhile without fire."

So, weary with the distance traveled, the steep mountain climb, and the scramble through the timber, they felt around for a smooth place, stretched out for a nap, and were soon fast asleep—three in a bed; Ship in the middle.

Sometime away late at night they awoke shivering. Jim was the first to speak. "Hugh, I don't know how you feel, but I don't propose to stand this any longer. What in thunder is the use of a man's having brains and not setting them at work. You rustle up some dry leaves and light stuff for kindling. I can't draw this ball, so here goes to shoot it out. As you are a little fidgety about Indians, we'll make as little noise as possible. I'll pull it off easy as I can. Now, then—ready—fire!"

"Bang!" went the rifle, and a thousand echoes responded.

"Great Scott!" exclaimed Hugh. "Just listen to it. Will it ever quit? Jee-whillikins! Who ever heard a gun crack like that? It seemed to stop for a while, but it's going yet—broke out in a new place."

"Well, now, I'm happy and content," responded Jim; "for if there are any Indians within ten miles of us, they are going to get up and dust. No little squad of Piutes, Diggers, or Monos are going to stop within hearing of a whole army. They'll think there's about five hundred of us—won't they, Hugh?"

"Yes, a *thousand*, easy enough. Did you ever hear the like of the echoes? They rattled away along the crest of the mountain, jumping in and out of the ravines, butting against the tops of the tall sugar pines, till they got tangled up and lost in a big cañon somewhere away yonder, where they seemed to die out, muttering and grumbling; till directly they gathered themselves together again, and came rolling out big as pounds of wool. Now I'll gather some dry leaves, and you get your tinder ready."

The process involved some little trouble and patience, but resulted in a cheerful blaze. After they were thoroughly warmed, the fire was removed a few yards away, the place carefully swept, clean leaves scattered over the spot, the soothing influence of the pipe invoked, the events of the day briefly discussed, and they laid them down to sleep.

"It isn't as soft as a feather bed," murmured Hugh, as he gave himself a "good night" stretch; "but it's nice and warm, and beats that first arrangement all to pieces, eh, Jim? Well, may I be blamed if that chap isn't fast asleep." He looked for Ship. The dog had curled himself at his master's feet and was snoring like a man. "So you don't want to be sociable neither? I'm blest if you are going to get the best of me. I'll take a little of this myself"—and in two minutes he was dreaming of his "old Kentucky home, far away."

Daylight had dawned, and the rays of the rising sun were touching the tops of the pines on the crest of the ridge above them before they awoke. A brief observation showed that they were close to the trail, and then were soon on the move. A few minutes walk brought them to the summit of the Chowchilla Mountain. Here they halted for a rest.

"This is the way they must come," said Hugh: "that's as sure as shooting; and we'll wait for them. This is the trail, and Ned Haughton isn't the man to leave it to take any cut-offs. Unless something serious has happened, we won't have to wait long."

The words were hardly spoken till Ship gave a low growl.

"Do you hear what he says? 'They are coming'"; and in the space of a minute the voices of the boys, the rattle of the cooking traps, and the clatter of the hoofs as they toiled up the steep ascent, were audible. The meeting was a cordial one. Each party had felt some alarm about the safety of the other. The main body, who had failed to come to time as per agreement, were profuse in apologies.

"Now you just thank us for not ambushing and killing the last one of you," said Hugh.

"And drive those mules straight to our camp, unpack, and cook breakfast, while we sit down and look at you," added Jim. "Then Hugh has got to tell all about last night's experience, and you have all got to stay and hear it."

"Yes," said Hugh, by way of finish, "and any body who doubts a word of it has got to lick us both."

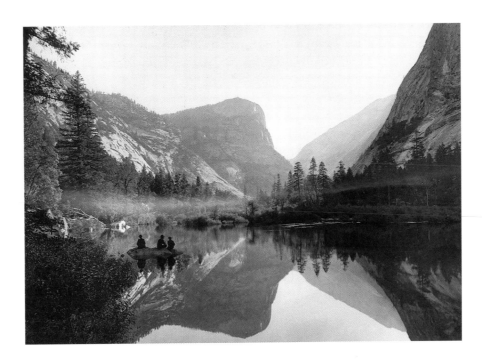

Mirror Lake as it appeared about 1900. (Author's collection)

So everything, was smoothed over. Each vied with the other in serving the hungry hunters, and the breakfast, after their prolonged fast, was a regal feast. Under the cheerful influence of a cup of steaming hot coffee, Hugh grew eloquent. His rendition of the passage in which the report of Jim's rifle and its wonderful echo figured, approached the sublime. When he described how it died away in a distant cañon and then came rolling out with renewed volume, or, as he had it, "big as pounds of wool," Connor, a one-eyed genius, the wag of the party, gave utterance to a prolonged whistle. A significant gesture from Jim, and he subsided with the remark: "Boys, I wish I had been with you."

The episode of kindling the fire was done in pantomime with great dramatic effect, and after an interchange of good-humored comments, the mules were repacked and the march resumed.

The intervening distance to the South Fork was made and the river crossed early in the forenoon.[8] Then a camp was selected and as one of the articles of agreement upon starting out was, "Never get into a hurry," it was determined to stop here over night. Besides rest and recuperation, which were needed by at least two of us, an inducement was offered in the shape of angling—for the stream seemed to be speckled with mountain trout. The record made by the fishermen, however, was not of a character to entitle it to special notice; hence, with the simple statement that we had trout for supper, the subject is dismissed. Next day saw us rested and refreshed, and on our way to the Valley.

Tourists who roll over the road in coaches by the easy grades of the present day, or who, even at an earlier date, made the trip on horseback by trail, after some improvements had been begun, can hardly realize the difficulties which were ambushed along the route when men had to pick their way through a rough, mountainous region, where there was only here and there a trace of a trail. An Indian trail does not amount to much even when it is at its best, and as this one had been unused for several years, it took pretty good engineering to get over some of the rough places with a couple of pack-mules.

As we were leaving the South Fork, we were passed by a mounted party from Mariposa.[9] We repassed them at Alder Creek, where they had halted for lunch, an example which we followed, giving our animals, as well as ourselves, a breathing spell. It was nearly sunset before we reached what is now termed "Inspiration Point." Here we had our first view of Yosemite. There it lay before us in all its beauty, an oasis walled in by towering cliffs; a virgin meadow threaded by a silvery stream and girdled with a zone of granite—an emerald in a setting of gray. It was a grand view, worth the whole journey; and we would have liked to linger and watch it fade away through the hazy twilight till it was lost in the somber uniformity of night, but we had no time to lose. "It's about four miles to the foot of this little hill," said Haughton, "and it will be as much as we can do to make it before dark. We must repack and cinch those mules for keeps. From here to the foot of the hill, though not exactly dangerous, is liable to be troublesome in the night time. In fact, it's safe to say it's the roughest you ever saw."

"All ready," sang out one of the boys who had been attending to the packing; "roll ahead," and down, down, we slid, and scrambled, and tumbled—men and mules managing to keep their feet most of the time—now and then dislodging great masses of loose rock, which rolled and rattled like a young avalanche.

"Let the mules go ahead," said one.

"Put Jim's dog in the lead; he's the boss path-finder," said Hugh.

"Look out there!" cried the long-legged boy in the rear, who had turned loose a four hundred pound bowlder, which went bounding down the mountain, just ahead of the leading mule.

"None of that foolishness," came from the front. "One more shot of that sort, and some man will lose a mule, and like enough we'll have to pack a boy with blankets and things."

Thus we floundered and rattled along in cheerful humor. Our animals kept their feet without a slip, and no casualty of a serious nature occurred. The previous season had been one of general drought, and this was the driest month in the year, so there was no trouble in finding a convenient ford. We crossed near the foot of the mountain. As we neared the river there was a whir-r-r of many wings. "Grouse! hundreds of them!" gleefully ejaculated several of the party in chorus. "We'll get out early and pay our respects to them."

We made our camp temporarily on the north side of the river, at the lower end of the valley, just below the base of the grand old cliff now known as Tutockanulah and El Capitan. Then, around the cheerful fire, we went over the experiences of the day and laid our plans for the immediate future. The first item of these was to select another

—◊—

camping ground further up the valley—"a nice, smooth spot," said Haughton, "dry, and with plenty of shade—wood, water, and grass close at hand, and much more convenient as a point of departure for our future explorations," he added.

How still it was! Only the least bit of a breeze stirring tree leaves and whispering in the tree tops. A gentle, soft murmuring rose and fell with the variable wind.

"That comes," said Haughton, "from a waterfall on a stream the other side of the river—a tributary of the Merced. At this low stage of water its volume is very small, and it breaks into a cloud of spray long before it gets to the bed of the stream below." We had no names for the different falls at that time, but this one described by our guide and afterwards visited by us was the Bridal Veil, otherwise known as the Pohono, or "Spirit of the Evil Wind"—a dreadful name to attach to a waterfall that never did anybody any harm.

Haughton next entertained us with a graphic account of the Boling Expedition, of the scouts in search of the Indians, up through the Cañon of Pyweah, and of the capture of their *rancheria* about ten miles above Mirror Lake, on the shore of Lake Tenieya.[10] In time the conversation flagged. The camp fire flickered. At our feet murmured the Merced. Behind us frowned the Tutockanulah, great shadows flitting across his grizzled front as he seemed meditating upon the propriety of toppling over and engulfing us. A solemn rest pervaded the atmosphere.

> "Peace breathes along the shade
> Of every hill,
> The tree-tops of the glade
> Are hushed and still,
> All woodland murmurs cease
> The birds to rest within the brake are
> gone."

The valley slept.

Next morning, soon as it was fairly light, the cheerful crack of the rifle awoke the slumbering echoes. Four of the best shots had been detailed to replenish the commissary supplies, and in about half an hour they came in loaded with mountain grouse.

"Looks like you had good luck."

"Struck a perfect streak."

"Did any of 'em get away?"

Those were among the congratulatory greetings, to which the response was that the woods were full of them; there were plenty left; that they were fat as butter balls. The prospect of fresh meat in unlimited quantities was encouraging. "Broil the youngest for breakfast and save the others for a grand stew," was the order of the *chef de cuisine*— while we all volunteered in dressing the birds.

After breakfast we moved camp, and drove our stakes three or four miles further up the valley, on the north side of the river nearly opposite the Yosemite Fall. This became our permanent headquarters, and was made the point of departure for all our exploration in and about the valley.

—⁓—

Our first excursion was up the Cañon of Pyweah to Mirror Lake. Pohono, or the Bridal Veil, came in for a share of our attention. As surmised by Haughton, it was only a wreath of spray, which hung pendant and gracefully swinging with the breeze. The great Yosemite Fall was a thing of the past. It had left its impress on the naked rocks in a broad stain, but a meager, trickling, straggling stream, lazily crawling down the face of the seamed cliff, and wiggling among the jagged rocks below, was all that was left of the grand fall, which, with its roaring and thundering, strikes terror to the soul of the tourist who ventures near it during the spring or earlier summer months.

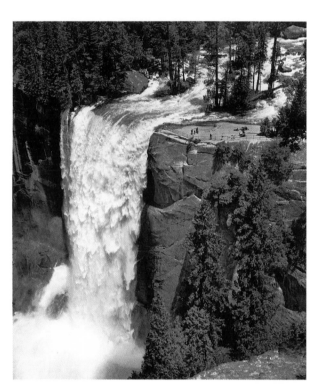

Vernal Fall from Clark's Point. (Hank Johnston photograph)

—◊◊◊—

Perilous attempts to penetrate the forbidding looking cañons were made. Usually one man was left to "keep camp"—sometimes two. This meant to go a fishing, and have dinner well under way before the rest of the party returned.

One evening, after a series of dare-devil escapades for no particular purpose, except to demonstrate how near a man can come to breaking his neck and miss it, some one suggested an expedition up the main river, above the valley. Haughton was appealed to for information. He favored the proposition, and said he would cheerfully make one of the party. As for information he had none to give; neither he nor any of the Boling Expedition ever dreamed of attempting it. They came on business—not to see sights or explore for new fields of wonder. Their mission was hunting Indians. They tracked their game up the Pyweah Cañon to their *rancheria*, where they captured them. As to the main river above the valley, he had taken a peek at it. There was no sign of a trail. It was a deep, rough cañon, filled with immense boulders, through which the river seethed and roared with a deafening sound, and there had never been seen a foot-print of white man or Indian in that direction. The cañon was considered impassable.

There was a chorus of voices in response.

"That's the word."

"Say it again."

"Just what we are hunting."

"We want something rough."

"We'll tackle that cañon in the morning."

"An early start, now."

—◊◊◊—

It was so ordered. "With the first streak of daylight you'll hear me crow," was Connor's little speech as he rolled himself in his blankets. Next morning we were up and alive, pursuant to programme. Everybody seemed anxious to get ahead.

Three of us—Milton J. Mann, G. C. Pearson, and the writer of this sketch—lingered to arrange the camp fixtures, for everybody was going up the cañon. When we came to the South Cañon, or Taloolweack, our friends were far in advance of us. We could hear them up the cañon shouting, their voices mingling with the roar of the waters. A brief consultation, and we came to the resolve to diverge from the main river and try to effect an ascent between that stream and the cañon. It looked like a perilous undertaking, and there mere some doubts as to the result; nevertheless, the conclusion was to see how far we could go. Away up, up, far above us, skirting the base of what seemed to be a perpendicular cliff, there was a narrow belt of timber. That meant a plateau or strip of land comparatively level. If we could only reach that, it was reasonable to suppose that we could get around the face of the cliff. "Then we will see sights," was the expression of one of the trio. What we expected to discover somewhere up the main stream was a lake or perhaps a succession of lakes—such having been the result of the explorations up the Pyweack Cañon, and mountain lakes being not unfrequently noted as a feature of the sources of mountain streams.

But to reach the plateau—that was the problem. It was a fearful climb. Over and under and around masses of immense rocks, jumping across chasms at imminent risk of life and limb, keeping a bright lookout for soft places to fall, as well as for the best way to circumvent the next obstacle, after about three hours wrestling, "catch as catch can," with that grim old mountain side, we reached the timber. Here, as we had surmised, was enough of level ground for a foothold, and here we took a rest, little dreaming of the magnificent scene in store for us when we rounded the base of the cliff.

In Pearson's letter, to which reference has heretofore been made, the writer expresses his sentiments upon the subject in these words:

"That first view of the glorious scene, as it burst upon us when we raised our heads above the rim of rock, cannot be described and can never be forgotten. It was so entirely unexpected, so utterly different from what he had looked for, that we were spellbound—completely overwhelmed with awe. We stood motionless and mute—the first of civilized men[11] to view nature's wildest mood, modeled by the Creator's hand from rugged mountain sides."

The oft-quoted phrase, "A thing of beauty is a joy forever," was never more fully realized. The picture is photographed on the tablets of my memory in indelible colors, and is as fresh and bright to-day as was the first impression twenty-nine years ago. To the tourist who beholds it for the first time, the Nevada Fall, with its weird surroundings, is a view of rare and picturesque beauty and grandeur. The rugged cliffs, the summits fringed with stunted pine and juniper, bounding the cañon on the southern side, the "Cap of Liberty" standing like a huge sentinel overlooking the scene at the north, the foaming caldron at the foot of the fall, the rapids below, the flume where the stream glides noiselessly but with lightning speed over its polished granite bed, making the preparatory run for its plunge over the Vernal Fall, form a combination of rare effects, leaving upon the mind an impression that years cannot

efface. But the tourist is in a measure prepared. He has seen the engravings and, photographic views, and read descriptions written by visitors who have preceded him. To us it was the opening of a sealed volume. Long we lingered and admiringly gazed upon the grand panorama, till the descending sun admonished us that we had no time to lose in making our way campward.

Our companions arrived long ahead of us. "Supper is waiting," announced the chief cook: "ten minutes later and you would have fared badly; for we are hungry as wolves."

"Reckon you've been loafing," chimed in another. "You should have been with us. We struck a fall away up at the head of the cañon, about four hundred feet high."[12]

"Have you? We see your little, old four hundred-foot fall and go you four hundred better"—and then we proceeded to describe our trip, and the discovery which was its result.

The boys wouldn't have it. None of them were professional sports, but they would hazard a little on a horse race, a turkey shooting, or a friendly game of "draw"—filling the elegant definition of the term "gambler" as given by one of the fraternity, viz.: "A gentleman who backs his opinion with coin." Connor was the most voluble. He got excited over it, and made several rash propositions.

"Tell me," said he, "that you went further up the cañon than we did? We went till we butted up against a perpendicular wall which a wildcat couldn't scale. The whole Merced River falls over it. Why, a bird couldn't fly beyond where we went. Of course, you think you have been further up the river, but you are just a little bit dizzy. I'll go you a small wad of gold dust that the fall you have found is the same as ours."

Connor was gently admonished to keep his money—to win it was like finding it in the road—nay, worse; it would be downright robbery—but to make the thing interesting we would wager a good supper—best we could get in camp, with the "trimmings"—upon our return home, that we had been higher up the cañon, and that our fall beat theirs in altitude. It was further agreed that one of us should accompany the party as guide.

"Better take along a rope—it might help you over the steep places," was a portion of our advice, adding by way of caution to "hide it away from Connor" when they returned, for "he would feel so mean that he would want to hang himself.'"

To Pearson, who was ambitious to show off his qualities as a mountain guide, was delegated the leadership—an arrangement which was mutually satisfactory—"Milt" agreeing with me that a day's rest would be soothing and healthful. Besides, we had laid a plan involving a deep strategy to capture some of those immense trout, of which we had occasional glimpses, lying under the bank, but which were too old and cunning to be beguiled with the devices of hook and line.

The plan was carried out, on both sides, to a successful issue. On our part, we secured two of the largest trout ever caught in the valley, and had them nicely dressed, ready for the fry-pan, when our companions returned, which was almost sunset. Soon as they came within hailing distance, their cheerful voices rang out (Connor's above all the rest), "We give it up!" They were in ecstacies, and grew eloquent in praise of the falls and scenery, at the same time paying us many compliments.

A courier was dispatched to notify the Mariposa party of our discovery. It was a

surprise to them, but they had made their arrangements to leave for home early the next morning. They regretted the necessity, but business arrangements compelled their departure. We fell heir to about half a sack of flour—dispensation of Providence which gave us a day or two more in the mountains.

We were not idle. One day was devoted to another visit to the Nevada Fall, our explorations this time being extended above the fall into the valley, now known as the "Little Yosemite," and including a climb to the summit of the Cap of Liberty. Rude drawings were made of points of especial prominence and interest. Our evenings were pleasant and sociable. Around the cheerful camp-fire we discussed the grandeur of our surroundings and the possibilities of the future. It was unanimously agreed that for beauty and sublimity of scenery the valley was without a peer: as people from all parts of the world visited Niagara Falls, and our own countrymen made the European tour for the special purpose of viewing the wonders of the Alps, why should not this wonder-land attract thousands from the Atlantic States and Europe, when its fame should become world-wide? An improved trail was suggested, and various places along the route, where steep and abrupt pitches could be avoided and an easy grade substituted, were mapped out and theoretically surveyed.

These subjects were argued at length, and particularly during the evening of our last day in the valley, when the discussion ran on till after midnight. Even the feasibility of a wagon road was suggested, and the construction of a railroad was vaguely hinted at as one of the possibilities of the far-away future—sometime in the next century.[13] "We will none of us live to see that," despairingly remarked one fellow; "nor is it likely that this place will become much of a resort during our life-time."

There was a division of sentiment on this point, some even proposing to give practical testimony of their faith by making an actual settlement in the valley and surveying a route for a road. A stringency in the money market alone prevented the beginning of these measures; but as it was, this agitation bore its legitimate fruit and led up to practical results. The Mann Brothers, erratic in some respects, were energetic and enthusiastic. The following year they went to work to construct a trail, which, in its grade, was a vast improvement on the original, and a comparatively safe route for saddle and pack animals.[14]

During the same season they employed a French artist by the name of Claveau to make sketches of the valley, and paint a panorama embracing the points of greatest interest. They paid him by the month at an exorbitant rate. He was a fraud, and humbugged them—dawdling away his time for the best part of a year, and giving them, instead of a panorama, a series of wretched daubs. They traveled with it to some extent, but the enterprise proved unremunerative, and wound up in a vexatious lawsuit. As to what became of the painting, there is no information at hand. It went out of sight in some mysterious way.[15]

The trail was a little premature, and when its proprietors applied to the Board of Supervisors for a license to collect tolls, it would have been surprising if the enterprise had not been anathematized by some of the intelligent sovereigns as a "monopoly." It is perfectly proper and legitimate for anybody to curse a monopoly unless he is in with it. However, the trail never paid its original proprietors, who were good, big-hearted

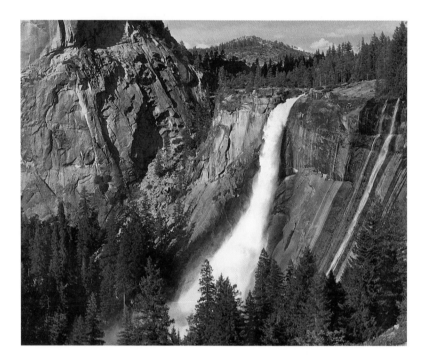

"Nevada Fall," said Lawrence, "is a view of rare and picturesque
beauty and grandeur." (Louise Hammond photograph)

fellows, and had some excellent ideas of the future of the valley, but lacked a
knowledge of the commercial world and were unschooled in business.[16] Their efforts
were well meant, as were those of others of their contemporaries, who urged upon the
good people of Mariposa the necessity of constructing a wagon road to Yosemite.

Nevertheless, all these incidents which had their origin in the Sherlock Expedition
became factors in bringing this wonder-land to the notice of the outside world, and
opening up highways over which the modern tourist can travel with comfort and ease.

A residence of twenty years in Mariposa has given me opportunities of frequent
visits to this beautiful valley, which have been improved to the fullest extent, and on
several occasions extended to the high Sierras, above and beyond, under circumstances
differing very materially from those of the expedition herein outlined. Hence, the
improvements in traveling facilities and local accommodations which have opened the
gates of this mountain paradise to the outside world are the more fully appreciated;
and the day when the iron horse shall be heard snorting and whistling through the
cañon of the Merced is looked for as an event of the not distant future.[17] Yet a tinge of
sadness comes over me as I travel along the new paths amid the old scenes. The river
still meanders its serpentine course, glittering with its ancient radiance as it kisses the
sunlight. The majestic water-falls bound from their giddy heights, mocking the
thunder in their reckless plunge. The rugged peaks and beetling cliffs, their summits

touching the clouds, stand grim and defiant against the march of civilization. But the bed of the valley itself has been roughly handled by the agencies of Nature and Art. The floods have done their work, even to the extent of sweeping away a grove of trees whereon were carved the initials of several American citizens—pioneer Californians. Immense slides, avalanches of debris front the mountain sides, have buried many acres of what was once fresh, verdant meadow. Man has not been idle. Dynamite has played its part, and trails have been blasted out, enabling the "Tenderfoot" to reach points once deemed inaccessible to anything but a mountain sheep. The dust of rattling coaches offends the nostrils. The toll gatherer confronts the wayfaring man, and the camper is abridged of his former vested rights, looked upon as an interloper, and suspected of being "an awful mean man." Hotels, in some of their features vieing with the more pretentious metropolitan palaces, have multiplied on a scale commensurate with the demands of the traveling public. Healthy, able-bodied tourists, invalid tourists, lame tourists, fat women tourists, tourists of both sexes, all ages, and diversified nationalities, make elaborate annual pilgrimages to this Pacific Coast Mecca. They bring with them valises, bandboxes, miscellaneous packages, and the traditional horror of the mountain stage driver, the Saratoga trunk. The guide is not insulted if a voluntary contribution is tendered him for extra attention, and the aproned flunkey extends an itching palm for bacscheesh, as a reward for ordinary civility, with a coolness and nonchalance which would do credit to one of the regular army at Niagara Falls. The trout decline to be caught except by Indians; and the grouse, in disgust, have fled over the mountains, or scattered among the junipers and dwarfed pines of the higher ranges.

"There is but one Yosemite!" exclaims an enraptured tourist, as he staggers at description in the shadow of its grandeur. There never will be another as it was when there was no print of hoof nor trace of moccasin track within its lonely precincts. Its pristine loveliness is a thing of the past, with the voices which awoke musical responses from its cliffs and cañons nearly thirty years ago living only in the chambers of memory. "The boys" of that period— my companions—where are they?

I bear with me a picture of them grouped together on the homeward march, as we turned to take a parting look at the valley, and another of a jolly, sociable reunion upon our return to the old camp. It was our last assemblage. Soon thereafter our paths diverged; further and further we drifted apart. Some have gone over to the "silent majority." The echoes of their voices have died away beyond the hill-tops. Will they some time come rolling down with renewed volume, like the echo so graphically described by my old friend Hugh?

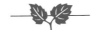

CHAPTER I
NOTES AND REFERENCES

—ɯ—

1. James Mason Hutchings, *Scenes of Wonder and Curiosity in California* (San Francisco: Hutchings & Rosenfield, 1860), and later editions.

2. Captain John Boling was the commander of Company "B" of the Mariposa Battalion, which took part in the epic discovery journey to Yosemite Valley on March 27, 1851. Major James Savage was in charge of the battalion, however, not Boling, as Lawrence incorrectly states. Boling, who subsequently became the Mariposa County Sheriff, made a second foray to Yosemite Valley in May, 1851, and captured thirty-five Yosemite Indians including Chief Tenieya.

3. G. L. Pearson, "Discovery of Yosemite Valley," *Pacific Rural Press*, June 21, 1873. Lawrence cites the author as George C. Pearson, and the magazine's name and publication date, erroneously, as *The Rural Press*, May, 1873. George C. Pearson is probably correct. The name so appears in the *Solano County Register of Voters* of that time.

4. Lawrence gives the guide's name as "Haughton," and so copied by Hutchings in his book *In the Heart of the Sierras* (Oakland and Yosemite: Pacific Press Publishing House, 1886), but the official roster of the Mariposa Battalion spells it "Houghton."

5. The "man by the name of Priest" may have been William C. Priest, who was later an important person in Tuolumne County. For many years, Priest and his wife operated Priest's Station at the top of the precipitous Priest Grade on the old Big Oak Flat Road. Priest was also a director of the Great Sierra Stage Co. and was active in the construction of the Great Sierra Wagon Road (Tioga Road).

6. "Clark's" was probably the ranch of David Clark on Bear Creek. It should not be confused with Clark's Station, a stopping place operated from 1857 through 1874 by Galen Clark at present Wawona.

7. As related in the preface, the James Hutchings party of July, 1855, made the first tourist visit to Yosemite Valley about two weeks before the Sherlock Creek group. Hutchings, who was seeking subject material for a proposed magazine about California's wonders, was undoubtedly the "magazine man" referred to here. Since only two sets of mule tracks were observed, they may not have been made by the Hutchings party, which consisted of at least four animals.

8. The crossing of the South Fork was most likely near present Wawona.

—ɯ—

9. The mounted party of seventeen men from Mariposa is mentioned in the preface. Lawrence's account indicates that his group and the Mariposa group arrived in the Valley the same day.

10. The reference here is to the second expedition of the Mariposa Battalion to Yosemite Valley made in May, 1851, when the remaining Yosemite Indians were captured at Lake Tenaya (see note 2).

11. As earlier indicated, Lawrence's party was the second to see Nevada Fall. Members of the Mariposa Battalion discovered the fall in 1851.

12. Vernal Fall, actually 317 feet in height.

13. The first wagon roads were completed to Yosemite Valley in 1874. The Yosemite Valley Railroad began operations in May, 1907.

14. Milton and Houston Mann, along with their brother Andrew, proprietors of a Mariposa livery stable, finished their forty-mile horse trail from Mormon Bar to Yosemite Valley in August, 1856.

15. According to the *San Francisco Bulletin* of October 26, 1857, Antoine Claveau brought suit against the Mann brothers for $3,500 alleged to be due him for painting a panorama of twelve Yosemite views and filed for possession of the panorama in lieu of payment. He must have won the case because the *Bulletin* of December 13, 1858, carried an advertisement announcing the showing of the panorama in the San Francisco Musical Hall, Antoine Claveau, proprietor. Lawrence is correct in saying that the painting was subsequently lost, but he may be unfair in his condemnation of Mons. Claveau.

16. The Mann brothers trail, which cost "between $700 and $1,000" to build, never had sufficient patronage to turn a profit. The Manns sold the trail to Mariposa County for $200 in 1860.

17. Lawrence was remarkably accurate in his prediction about the "iron horse . . . snorting and whistling through the cañon of the Merced . . . [in] the not distant future." The Yosemite Valley Railroad operated from 1907 to 1945, running seventy-eight miles from Merced to El Portal up the Merced River Canyon.

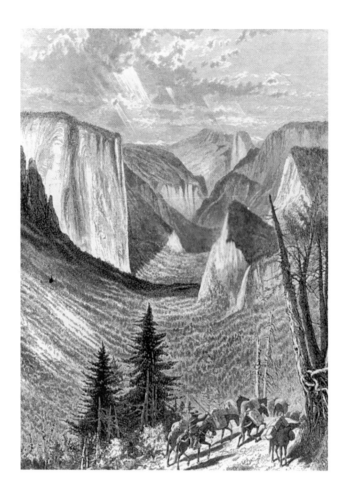

This early engraving depicts the view from the Mariposa Trail,
which, Ayres wrote, "produces an impression never to be forgotten."

II

A TRIP TO THE YOSEMITE VALLEY
by Thomas A. Ayres

Thomas A. Ayres (1816-1858), a native of New Jersey, arrived by ship at San Francisco on August 8, 1849. He turned to art after an unprofitable attempt at mining. In June, 1856, James Hutchings hired Ayres to make illustrations for several contemplated magazine articles about remote places where the clumsy photographic apparatus of the day could not be easily transported. In that capacity, Ayres was one of Hutchings' three non-Indian companions on his initial tourist visit to Yosemite Valley in July, 1855.

During the party's brief stay in Yosemite, Ayres drew six pencil sketches, four of which Hutchings later used to illustrate an eight-page lead story about Yosemite in the first issue of his California Magazine, *July, 1856. In October, 1855, Hutchings began selling a large lithograph of the "Yo-Hamite Waterfalls," taken from one of Ayres' sketches. The sixteen-by-thirty-two-inch poster was the first artistic representation of any Yosemite scene to reach the public.*

Ayres made a return trip to Yosemite the next year (1856) over the new Coulterville Trail and made additional drawings on his own behalf. The following account of that journey was originally published in the Daily Alta California *(San Francisco) on August 6, 1856.*

Ayres drowned on April 28, 1858, when a ship on which he had taken passage from San Pedro to San Francisco capsized off the Farallon Islands. A number of his drawings still exist in various collections. Additional data about Ayres appears in David Robertson, West of Eden—A History of the Art and Literature of Yosemite *(Yosemite: Yosemite Natural History Association, 1984).*

Glad to escape the intense excitement which still unfortunately prevails in our city,[1] I left by the Stockton steamer, June 16th, on a second trip to the celebrated Valley of the Yohemity and the sources of the Merced River. Arriving at Stockton next morning, we left by the Sonora coach, reaching Mound Springs by 4 o'clock, P.M. Here the stage was waiting bound to Coulterville, where we arrived safely at 9 o'clock P.M.

From this point the distance to the valley is some forty miles, and is reached upon mule or horseback. After waiting in vain for several parties who were "about starting" for the valley, Mr. Coulter's son (a lad of thirteen) and myself concluded our

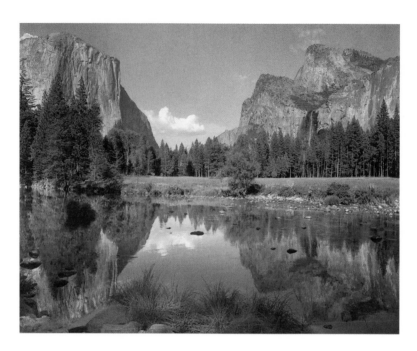

"The Gateway of the Merced," now more commonly
known as "Valley View." (Charles Cramer photograph)

—ɯ—

arrangements for the trip. The afternoon of the 23rd of June saw us off, Master Coulter
mounted upon his grey and I with my mule, accompanied by a sadly-complexioned
donkey, bearing sundry packages and bundles necessary for mountain life.

Passing the "diggins" at the head of Maxwell's Creek, and ascending the Chemical
Mountain, we soon reached the sawmill five miles above Coulterville. Here the pine
region commences. Twilight found us wending our way down the north fork of the
Merced, and missing our trail at the forks, we reached the vicinity of Wheeler's
Quartz Mill, near where we encamped for the night. Early next morning found us in
the saddle, and passing the mill of Capt. Gillsen, soon reached Schroeder's store at Bull
Creek,[2] the poetical name of a branch of the North Fork of the Merced River.

A few miners are located upon this stream and its branches, but the vicinity has not
been rich in placer "diggins"; several rich quartz claims occur in the vicinity, however.

After partaking of a hearty breakfast at Shroeder's, we resumed our journey, and
passing up the valley of the Creek, taking the new trail up the left-hand branch,[3] we
soon passed the last party of miners near the head of the stream, reaching a fine grassy
flat at its source. To the left rose "Pilot Peak," one of the highest points of the lower
mountains, while to the right of the trail lay the valleys of the Merced and its
tributaries, the mountains fading away into the dim purple distance. We now reached
the dividing ridge between the waters of the Tuolumne and Merced Rivers, the trail
winding along the summit and through a majestic forest of pines and cedars. Passing
"Hazle [sic] Green," a beautiful meadow amid the forest, we made camp some three

—ɯ—

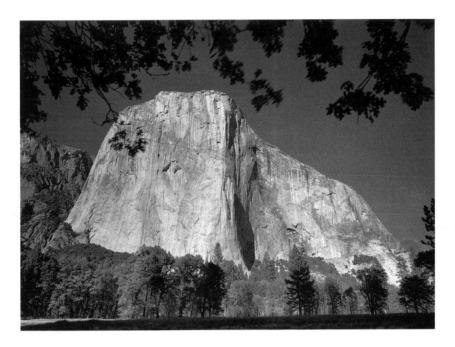

El Capitan, or "Chieftain of the Yohemity." (Ted Orland photograph)

—◊—

miles beyond, where we found water and grass for the animals. Below and around us the forest was on fire, and our sleep during the night was disturbed by the crash of the falling timber and the mournful cry of the California lion.

June 25th—A very perceptible change in the temperature has taken place since leaving Coulterville, owing to our increased altitude. The vegetation, also, has a spring appearance—beautiful flowers in bloom upon every side—while at Coulterville and the region below, everything green has disappeared in the summer drought of California. Mounting our animals, we soon reached "Crane Flat," a large meadow surrounded by the lofty forest, and adorned with brilliant flowers. Here the trail leads to the right, leaving the divide to the left, and descending into the waters of Cascade Creek and its tributaries. Ascending and descending several steep spurs and crossing several streams, we finally caught a glimpse of the everlasting walls of the Yohemity, and farther as we saw gleaming like a silver thread from the dark precipice, the "Cascade of the Rainbow."

We now commenced the descent into the valley in earnest, and in an hour reached the level of the river, by a good though very steep trail, constructed by the enterprising citizens of Coulterville. Nature has done more for the descent by the Mariposa trail, but the route from Coulterville reaches the valley at a lower altitude (an important consideration, on account of the snows early in the season, when the falls are to be seen in their glory); it also avoids the dangerous crossing of the South Fork on the Mariposa side. Yet the first view of the valley as seen from the Mariposa road is the best, and produces an impression never to be forgotten.

Resuming our journey up the valley, the first object that attracts our attention is the Cascade of the Rainbow, descending into the valley on our right from a height of nine

—◊—

hundred and twenty-eight feet.[4] The water comes over the sharp granite edge of the precipice, then descending, is broken into fleecy forms, sometimes swayed hither and thither by the wayward winds; at other times the sun lights up its spray with all the colors of the rainbow, hanging like a prismatic veil from the sombre cliff. The surrounding peaks are riven into varied forms, most picturesque in their outlines, contrasting beautifully with the emerald meadows and masses of pines, cedars and oaks at their base. The stream has a large body of water, and has its source far away to the south, towards the divide of the San Joaquin River.

As we proceeded onward we were held in silent awe by the sublime proportions of "El Capitan," or the Chieftain of the Yohemity—a cliff of granite lifting its awful form on the left to the height of three thousand one hundred feet—a sheer precipice jutting into the valley. Upon the opposite side of the valley (which is here only three-fourths of a mile in width) immense cliffs also occur, their serrated pinnacles piercing the very skies, and forming with El Capitan the colossal "Gateway of the Merced."

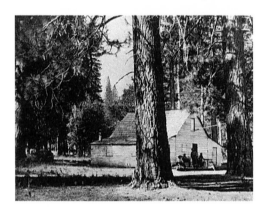

The frame house described by Ayres became the "Lower Hotel" by 1858. This is perhaps the earliest known photograph of the structure, taken in the 1860s when Fred Leidig was the manager.

We rode slowly and almost reverentially along the base of El Capitan, and fording the river beyond, reached the camp of Judge Walworth, directly opposite the "High Fall," where we remained during our sojourn in the Yohemity. The Judge and his companions, Messrs. Anderson, Walling and Epperson, have located lands, and partly completed a frame house, which is to be enlarged and opened for the accommodation of visitors early next season.[5]

Looking from the edge of the grove in rear of the house, we obtain a full view of the High Falls, which are the great feature of the valley as far as waterfalls are concerned. The valley is here a mile and a half in width, the river of the valley flowing near the middle, with meadows and groves upon either hand, while the cliff beyond rises to the height of three thousand feet. The water is seen flashing over the cliff at the height of two thousand five hundred feet, and at one bound reaches the granite shelf fifteen hundred feet below—hanging like a fleecy cloud from the precipice, from which dart masses of foam, gleaming like rockets in their perilous fall; gathering themselves upon the immense granite floor, the waters descend by a succession of cascades (the lower one being six hundred feet), finally reach the valley and unite with the river below.[6] Every hour of the day varies the effect of light and shade upon the cliff, which rises with picturesque outlines, surmounted with sentinel pines, dwindled in their majestic proportions to mere straws by the height and distance, while ever and anon comes the roar of the cataract falling upon the ear, now in fitful lower tones—the lonely voice—the solitary hymn of the valley.

Every day of our sojourn in the valley was made interesting by excursions to other points of remarkable interest, the one to the falls of the middle fork especially. Leaving camp, we rode up the valley some three miles, and turning to the right, crossed the

broad delta where the waters of the middle and south forks unite with those of the valley. Here we tied our animals and proceeded on foot. Immense masses of granite from the surrounding heights block up the narrow chasm, the stream descending to the left, roaring over its rocky bed. Scarcely able to follow the indistinct trail, we clambered along, and crossing the South Fork, entered the canyon of the Middle Branch, which comes in from the right. After an arduous walk, we saw the waters of the fall gleaming between the trees, and passing a huge mass of granite, upon which many visitors have inscribed their names with charcoal, we reached an immense mass of granite covered with moss, from which we obtained a fine view of the "Lower Falls of the Middle Fork."

For picturesque beauty, together with the surrounding combinations of rocks and trees, this waterfall excels; yet it is the least in height, being not more than two hundred feet perpendicular.[7] It comes over the cliff in a broad sheet, retaining its form until lost in the pool below. Crawling along the sloping edge of the cliff, drenched with spray, we passed the falls and reached the Arch Rock beyond. Here the rocks overhang some seventy-five feet, forming a magnificent arch, its recesses adorned with exquisite ferns and mosses—one of Nature's own temples, not made with hands—while the cataract below fills it with the melody of many waters. One of our companions climbed over the cliff to obtain a view of the upper cliff beyond—a feat having too much of the terrible for me to undertake.

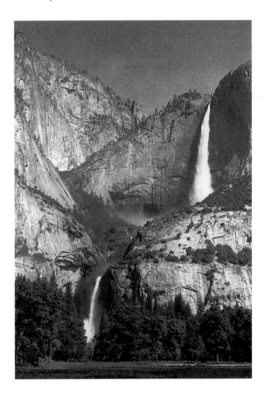

"...a full view of the High Falls, which are the great feature of the valley as far as waterfalls are concerned." (Hank Johnston photograph)

—◊—

The next day, however, we ascended the mountain below, and after a desperate climb, passed over a shelf, reaching the "Upper Falls." These are situated about half a mile above, upon the same stream, and are about seven hundred feet high.[8] The water descending about half-way perpendicularly, then shooting over the shelving part of the cliff, at an angle of seventy degrees, reaches the rocky pool below in clouds of silvery spray; a small portion of the same stream comes down the rocky canyon to the left; all the waters then shoot over an inclined bed of granite, reaching a deep reservoir below; collecting again, they plunge over the lower fall, and reach the depths of the Yohemite Valley by a succession of picturesque rapids some two miles below.

The general view of the Upper Falls from the shelf by which we reached them, is grand, as it embraces the surrounding peaks. Commencing at the extreme left, the South Dome rises with its bare granite column fifteen hundred or two thousand feet above the surrounding cliffs, an intervening mass is seen, while immediately to the left of the falls a peak rises bare and abrupt to the height of a thousand feet above the edge

—◊—

of the precipice. Above and beyond the falls, the mountains are lost in the distance, their ragged outlines softened by dark masses of pines and firs, the scene altogether having a wild Alpine grandeur, sublimely beautiful.

This fork of the river has its source some thirty miles directly east of the valley, among the highest peaks of the Sierra Nevada, contributing the largest body of water to the Yohemity. Having determined to visit the falls of the South Fork (another tributary coming into the valley to the right of the middle fork), we left its confluence with the latter stream some four miles above camp, and commenced the ascent of the canyon leading to the falls; and of all the rocky places of the Yohemity, this certainly takes precedence. The gorge is about two miles in length, bounded upon either hand by immense cliffs, which seem to have vied with each other in contributing their share of rocks, some of which have been added lately, as seen by the scattered remains of immense boulders whose fragments have flown like thunderbolts amid the surrounding rocks and trees. Crossing and recrossing the foaming torrent with much difficulty, we approached and entered the amphitheatre which forms the head of the canyon. The water comes over the cliff to the left like a gust of living light from heaven, foaming into feathery spray, descending five hundred feet, then glancing over a portion of the cliff (scarcely removed from the perpendicular), descends into the pool below.[9] Returning down the canyon, the scene looking down the gorge is sternly magnificent. Awful precipices of granite frown upon either side, immense masses of rock cumber the chasm through which the torrent descends, while far, far below lies the valley of the Yohemity in all its loveliness. Beyond tower its walls of everlasting granite, while above all rises the bare isolated pillar of the South Dome, lit up by the rosy hues of the setting sun.

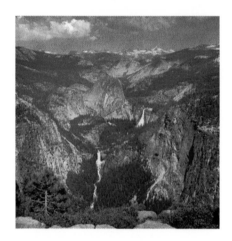

Vernal and Nevada Falls as seen from Glacier Point. These are the "Lower and Upper Falls" described by Ayres as "situated about half a mile apart upon the same stream." (Hank Johnston photograph)

An excursion to the lake or pond of the North Fork occupied us another day. Leaving camp, we rode up the valley, and fording the river a mile above, we crossed the large meadow beyond. From here we obtained a fine view of the North and South Domes—the former rising on the left to the height of three thousand two hundred feet above the level of the valley, perfect in its form as the dome on the Capitol at Washington. To the right the South Dome lifts majestic form four thousand seven hundred feet, its northern face cleft down, forming a sheer precipice of two thousand feet, as smooth as a wall.[10] This remarkable peak is the highest point of the valley, and stands at the confluence of the north, middle, and south forks of the river. Between the domes upon the North Fork lies the lake—a gem set amid the surrounding mountains, whose aerial heights with the trees upon its borders are reflected in its silvery bosom, with nought to disturb its calm surface save a stray zephyr or a springing trout. Standing on the western side of this lovely sheet of water, and looking up the valley of the North Fork, the scene is beautiful in all its combinations.[11]

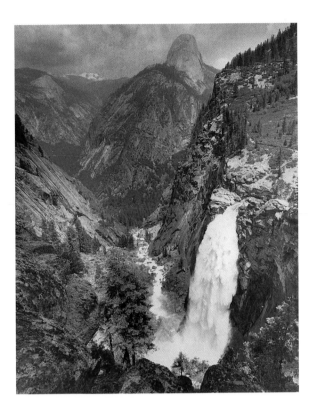

Ayres made the difficult ascent up the rocky gorge
to the base of Illilouette Fall, shown here, elevation
370 feet. (Kingsley Roberts photograph)

Upon another occasion we rode down the valley some six miles, and crossing the picturesque ford where the Mariposa trail enters the valley, ascended the mountain, reaching a point on the trail some fifteen hundred feet above the river. From here the traveler obtains the most complete general view of the entire valley. Far below lie its green meadows and beautiful groves of oaks and pines, the river at intervals gleaming amid the forest and winding like a serpent through the valley, while the surrounding walls of granite lift their awful forms, contrasting their stern sublimity with the beauty spread at their feet. To the right descends the Cascade of the Rainbow in all its beauty, giving life and expression to the scene, while the Two Domes bound the dim distance. All, all is as Nature has made it, fresh and beautiful from the hand of the Creator.[12]

On the glorious fourth we were treated to a salute from Nature's artillery. The effect of a thunderstorm in the valley was such as words cannot describe.

> "From crag to crag
> Leaped the live thunder—
> Not from one lone cloud,
> But every mountain then had found a tongue."

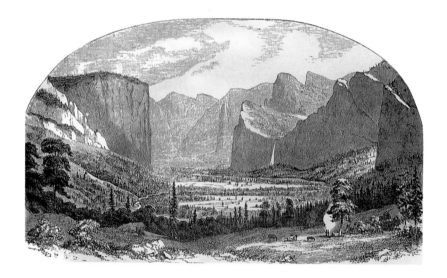

Called "General View of the Yosemite Valley," this engraving appeared
in several of James Hutchings' publications. It derived from a pencil
drawing sketched by Thomas Ayres during his 1855 journey to Yosemite
Valley with the Hutchings party. (Author's collection)

Sitting by our campfire, the next evening, a mass of rocks fell from the cliff near us,
loosened, probably, by the the previous rain. Starting like a crash of thunder, it came
like the tread of an earthquake, while rocks and trees dashed into the valley, whose
twilight solemn stillness was broken by the uproar, prolonged by innumerable
reverberations. We retired with feelings fully impressed by the awful manifestations of
Nature with which we were surrounded. —

It would require a much larger space to recount our adventures in grouse shooting
and trout fishing, my wanderings with pencil and sketch book, hunting after the
picturesque, admiring the glorious sunrise effects, or the beauties of the declining day
from choice points of view. The time passed like a dream, and it was with regret that
we left the beautiful Valley of the Yohemity, bound on an exploring trip to its
headwaters, far among the snow-clad peaks of the Sierra Nevada, of which more anon.[13]

Thos. A. Ayres

CHAPTER II
NOTES AND REFERENCES

—⚍—

1. Ayres may have been referring to several stabbings and other incidents of violence then occurring in San Francisco.

2. Schroeder's store at Bull Creek was subsequently taken over by former miner Alexander Black. Black and his wife ran a wayside hotel there until the summer of 1870 when they took personal charge of their Yosemite Valley hotel (the "Lower Hotel," later Black's), which they had owned since 1861 but leased out.

3. The Coulterville Free Trail, running from Bull Creek to Yosemite Valley was completed in 1856. Further information on early trails and roads to Yosemite is contained in Hank Johnston, *Yosemite's Yesterdays Volume II* (Yosemite: Flying Spur Press, 1991), 30-64.

4. Bridalveil Fall, elevation 620 feet.

5. This structure became known as the Lower Hotel after a second hotel (the Upper Hotel) was opened about seven-tenths of a mile upstream (see note 2). A detailed description of early Yosemite Valley hotels can be found in Hank Johnston, *The Yosemite Grant, 1864-1906: A Pictorial History* (Yosemite: Yosemite Association, 1995).

6. Yosemite Falls, elevation 2,565 feet in three drops: the Upper Fall, 1,430 feet; cascades, 815 feet; Lower Fall, 320 feet.

7. Vernal Fall, elevation 317 feet.

8. Nevada Fall, elevation 594 feet.

9. Ayres here describes the difficult scramble up Illilouette Creek to Illilouette Fall, elevation 370 feet.

10. Half Dome, elevation 8,842 feet above sea level, was first called "South Dome" because it stood across from North Dome. The original 1865 King and Gardner map of Yosemite Valley identified the unusual peak as "Half Dome," a name that soon became firmly established.

11. Mirror Lake.

12. The view Ayres writes about was probably observed from some distance below Old Inspiration Point on the Mariposa Trail.

13. Apparently there was never "more anon," at least none has yet come to light. Ayres most likely departed the Valley by going up Indian Canyon to Tuolumne Meadows via Tenaya Lake.

—⚍—

This engraving of the Valley ferry was derived from a photograph by Charles Weed, who took the first pictures of Yosemite in 1859. (Author's collection)

III

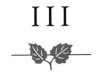

YOSEMITE
by John Olmsted

In 1880, one John Olmsted (apparently no relation to the noted landscape architect and one-time Yosemite Commissioner Frederick Law Olmsted) published a 132-page, privately printed volume detailing a western journey he had completed twelve years earlier with his son, William D. Olmsted. Titled A Trip to California in 1868, *the now extremely rare book seems to be a collection of articles that once appeared serially, perhaps in a weekly newspaper of the time.*

The Olmsteds traveled by ship to California via the Isthmus of Panama and returned to New York over the transcontinental railroad. In the Yosemite section of his narrative, Olmsted provides an explicit look at tourist travel during the peak of saddle-train days, six years before stage roads reached the Valley in 1874. His descriptions of Hutchings' hotel, a harrowing climb up the Vernal Fall ladders, and a daring ferry-boat crossing of the turbulent Merced River are especially informative.

Like most Yosemite-bound sightseers of the period, Olmsted boarded the overnight steamship running from San Francisco up the San Joaquin River to Stockton. Arriving at dawn, he immediately set out on a dust-filled, one-and-a-half-day stage ride to the end of the line at Coulterville. There he mounted a horse for the first time in twenty years and joined a guided party that proceeded fifty miles along the old Coulterville Free Trail to Yosemite Valley. At the end of his brief sojourn in the Valley, Olmsted departed via the Mariposa Trail, passing through present Wawona and the Mariposa Grove of Big Trees along the way.

The following account is a reprint of Chapters VII and VIII from Olmsted's book A Trip to California in 1868 *(New York: Trow's Printing and Bookbinding Co., 1880).*

Cut the Palisades in two opposite Yonkers, swing the Fort Lee end around to Dobbs Ferry, press the two banks together to an average width of three-quarters of a mile, then pile six tiers of Palisades top of each other on each side, then give them a shaking and tossing up, narrow the river to the width of Spuyten Duyvil creek, scatter groves of oaks, pines, and cedars irregularly up and down, and you will have a faint conception of Yo-sem-i-te valley, one of the greatest wonders of the world.

If the valley was a rugged defile, devoid of trees and barren of vegetation, it would attract visitors by its sublimity; but when it combines beauty with grandeur—when

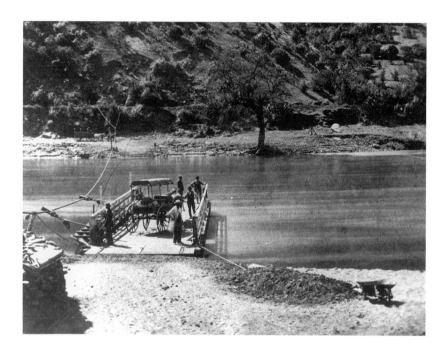

Charles Hoswell's rope ferry at Stevens' Bar on the Tuolumne River
functioned from about 1862 until 1885 when J. H. Moffitt erected a
300-foot toll bridge. (Tuolumne County Historical Society collection)

—m—

oaks and pines of marvellous size stand sentinels over the snowy buckeye and the
brilliant manzanita; when level meadows covered with countless varieties of wild
flowers of brightest hue nestle along the river banks; when inaccessible mountain
peaks, covered with snow, tower towards heaven and rivet the admiring gaze as you
loiter on the smooth trail, with every sense lulled to repose by its quiet beauty; when
sparkling waterfalls leap from the mountain top in unbroken fall of one thousand six
hundred feet, soon to meander gently at our feet; and when Nature in her wildest and
most savage aspect is supplemented by the arts and comforts of civilized life, no
wonder that the tourist feels his incompetency to describe, or the artist to paint, the
matchless splendors of Yo-Semite.

This celebrated valley is about two hundred and fifty miles easterly from San
Francisco. It is in the heart of the Sierra Nevada mountains, and 4,600 feet[1] above tide
water. From the summit of the falls, 3,000 feet higher, can be seen mountain peaks a
mile higher still, making a total altitude of about 13,000 feet.

The round trip, from San Francisco, requires twelve to fourteen days, and the
average expense, exclusive of outfit, is one hundred and twenty-five dollars.

I took passage on the steamboat Amelia for Stockton on the 18th of June. I was told by
a gentleman who had just returned that it was rather too early in the season to go; that

—m—

the streams were high, the trails in poor order, and the snow drifts long and deep: and I soon learned by experience that the half was not told me. It was a bright afternoon—wonderful to say no fog impeded our progress as we passed between Angel and Alcatross islands—up the Bay—along Mare Island—through the Straits, stopping at Benicia; then into Suisun Bay, where the various channels of the Sacramento and San Joaquin rivers bewilder the voyager, and along the tules, stopping at New York and Antioch.

Here night set in after a gorgeous sunset, and the deck was exchanged for the saloon. But from Antioch to Stockton, some seventy-five miles, one might as well sleep, for there is nothing to be seen but the muddy crooked river and the tules, which cover a great area and are utterly monotonous. The tule lands are elevated but a little above high tide, covered with rushes and a kind of long coarse grass, and are valueless. They border the rivers for a great distance. The crooked channel is partially fringed with bushes, and here and there cottonwood trees stand like lonely sentinels in the uninhabited marsh, but they are not numerous enough to dispel its wearying sameness.

It was soon after daybreak when I awoke, sprang out of my berth and opened the blinds, and found that the Amelia was snuggly docked at Stockton. A long shed covered the wharf or bulkhead between the street and river; and on the opposite side of a wide street were rows of spacious stores, hotels, restaurants, stage offices, and saloons.

As the stages leave Stockton only on alternate days for Mariposa and Coulterville, I thought it would be well to secure seats early, and sent my companion to the office for that purpose, while I packed our carpet-bags. He soon returned and said that the stages were full already, eighteen seats having been sold, and several other applicants refused. Here was a dilemma—to hire a carriage for a ride of ninety miles, to stay in Stockton from Friday to Monday, or return to San Francisco in the afternoon. But luckily a man and his family from San Francisco were unable to secure seats, and the stage agent offered to send us to Chinese Camp by an extra, on our way to Coulterville; and at 6 o'clock we were off.

Stockton is situated on a bayou four miles from the river; the country around is level but dry, and elevated above high tides and spring freshets. It contains 12,000 inhabitants, is well laid out, and ornamented with shade trees in abundance. It is a very prosperous place, and as the country north and south becomes populated and the fertile fields brought under cultivation, it will be hardly second to Sacramento.

For the first eight miles out of Stockton the road was very badly cut up, but it seemed to make no difference with our driver; his schedule time was eight miles an hour and he drove up to time. I soon learned why the road was so bad, as we began to meet the six and eight-horse teams from Copperopolis and the upper mining regions, carrying from five to ten tons to each load.

We rode all day in an easterly course, in the forenoon through an undulating country, barren of trees, along and through fields of wheat ready for the s——— I was going to write sickle—but the sickle was long ago superseded by the cradle, and the latter has given way to the mowers and reapers. Even with the help of this most invaluable auxiliary, such is the extent of the wheat and barley crop in California that it takes several months to harvest them. But as they have no rain, the crops are not injured by this delay. The only risk is the danger by fire, which is great and unavoidable; so much

This sketch shows the Stockton pier area with the
steamboat having just arrived. (Author's collection)

so that large producers are now in the habit of getting the crop insured.

Soon after noon we arrived at Knight's Ferry, on the Stanislaus river, which is here
spanned by a bridge. The bed of the stream is much below the general level of the
country, making the village one of the hottest places I visited. Placer mining had been
followed extensively for years, and the river bed and the hills each side had been
trenched, and furrowed, and excavated in every direction.

From Knight's Ferry to Chinese Camp, on the stage route to Sonora, we found a
rough and rocky country. We had entered the foot-hills, those tenders to the great
mountain ranges, quite lofty in themselves, yet no more like the grand Sierras than is
the ripple on a mountain lake to the waves of the ocean.

These foot-hills nestle at the bases of the mountains, projecting into the valleys
sometimes several miles. They are of every conceivable shape and run in all directions.
Those nearest the plains are barren of timber, but fertile, producing great crops when
cultivated. In the crooked narrow valleys between these hills may be seen ranches,
with enclosed fields, and orchards and gardens irrigated by the running brooks,
contrasting pleasantly with the yellowish parched appearance of the surrounding hills.

At and around Chinese Camp the entire soil contains gold, and in the rainy season
everybody is at work; with shovel and pan dig where you will, and gold is the reward.
But as there are no living streams near by, when the dry season comes on gold digging
is suspended from necessity. The mercury marked 80° at eight p.m., but the air was so
fresh and elastic that I experienced no discomfort from the heat.

The next morning at five o'clock we were off for Coulterville. Our route lay across

high mountains, down into deep valleys, across rapid swollen streams, and up rugged cañons, every rod seemingly having been dug over; and the remains of flumes and ditches marking the valleys for miles. Soon after crossing the Tuolumne by a rope ferry, we ascended one of the highest mountains which I encountered. The turnpike followed a narrow crooked ravine, up a steep continuous rise of three miles.[2]

We breakfasted at the foot of this mountain at a ranch whose owner was merchant, farmer, tavern-keeper, and postmaster.

Flocks of goats were skipping over the hills; fat and sleek cows were going leisurely to pasture; several yokes of large cattle stood by, and fowls of different kinds were gadding about. Everything betokened thrift and prosperity. As we were leaving, a bottle of excellent wine, made on the ranch, was brought out and discussed to our great satisfaction. Just then an itinerant butcher came along. His mule came first, however, jogging along without bridle or halter; a kind of saw-horse across his back from which a box was suspended on each side, containing the stock in trade—a joint of beef and a few pieces of mutton. The lid forms a shelf on which the meats are divided to suit customers.

Arriving at Coulterville about noon, we found a good hotel, kept by Mr. Coulter, roomy, clean and cool, —and after thorough ablution, partook of a most excellent dinner. Here we were to bid adieu to steamboats and vehicles, and trust our precious persons to the joltings and caprices of a mule or a horse for the next ten days.

It was to be a new experience. I had not been astride a horse in twenty years. So I made a clean breast of it to the livery-man, and he had compassion on me and gave me "General Rosecrans" to ride—his best horse, he said; and, though the "General" would not gallop, and trotted rather hard, I will do him the justice to say that his foot never stumbled, his eye did not quail, or his strength fail in the arduous and perilous paths which we traversed together.

Guides are indispensable in these mountain excursions. A man by the name of Freeman had been recommended to me, and I was so fortunate as to secure his services for the trip. He had been to the valley a score or two of times, was familiar with every trail, knew every lofty distant peak, the names of trees, plants, and flowers, and his memory was stocked with anecdotes and incidents, "with hair breadth 'scapes and moving accidents by flood and field." He was communicative, but not garrulous; attentive, but not officious; kind-hearted and social, but not too familiar.

Travellers have to place implicit reliance on their guides, and this dependence begets great intimacy, which sometimes becomes very annoying when the guides prove vulgar, rough and uncultivated; but Freeman was a gentleman by nature, and dignified his calling by constant attention to his duties, and his unobtrusive deportment. Freeman should chaperone parties with ladies exclusively—he would seat a lady on her horse, or lift her from it, and steady her steps up the steepest trails, or over the most dangerous passes, with the strength which imparted confidence, and the gentleness which awakened gratitude.

All our baggage consisted of small travelling bags and overcoat, but the former had to be left at Coulterville. A few shirts and collars, socks and handkerchiefs, with tooth and hair brushes and shaving tools, were placed in one end of a sack, with overcoats in the other, and tied securely on the back of the saddle, when we were pronounced ready

for the adventurous trip. So, at four o'clock on Saturday afternoon we started for a ride of eighteen miles.

I had heard such a good report of "Black's," up in the mountains, in the midst of beautiful scenery, that I preferred to go there to spend the Sabbath, instead of remaining in the hot and dusty village of Coulterville. The guide led off, the "General" followed, and my companion brought up the rear. I thought riding abreast through the village would look better than single file, but to get in line required that I should urge the "General" to a trot; and I preferred to forego [*sic*] etiquette rather than to practise on an untried movement in the face and eyes of the citizens, who ran to their doors to see us. For it was early in the season, and we were amongst the first excursionists to the valley.

Alexander Black ran a stopping place on the Coulterville Trail from the 1850s until 1870, when he moved to his new hotel in Yosemite Valley.

—⚏—

A wagon road runs to Black's, but as horses and guides can only be had at Coulterville, carriages are generally dispensed with. It was a rough ride, up and across mountains, but steadily attaining higher elevations. Through heavy groves of sugar pines, live oaks, white oaks, ash and spruce, up the sides of mountains covered with chapparal, which a rabbit could hardly penetrate, past open glades covered with wild flowers, we sauntered leisurely along.

In places the road was lined with bushes called the buckeye, about ten feet high, spreading wide, bearing white flowers about eight inches long, which are very beautiful; also with the chim flower, a kind of cedar bush, four feet high, with delicate branches and white flowers on the ends. The chapparal was also in bloom, and the manzanita vivified the landscape. The latter grows only in high altitudes. It grows about as large as the buckeye, with gnarled spreading shoots, as firm of texture as the hickory, glossy red bark, and small, thick, shining foliage.

The arzalia [*sic*] is another handsome bush, very beautiful, four feet high, bearing two or three flowers, like white lilies, on a stem, with one to three different colored flowers on the same branch. The madrona is one of the handsomest trees which I saw. It is an evergreen with an open growth, with bright green and lustrous leaves, and a bright red bark. Its height is sometimes fifty feet, and diameter two feet. The leaves are oval-shaped, pea-green underneath and dark and shining above; the bark is smooth and renewed every year; the new bark is a pea-green, which changes to a bright red; the wood is white and hard and susceptible of a high polish; the tree bears a bright red berry in clusters.

The laurel or bay tree is quite common in the coast valleys, and its wood is very valuable. It is an evergreen of the size of the madrona; the leaves are dark green, lustrous, four inches long, one inch wide, sharp at both ends, with smooth edges; the wood is grayish in color, very hard and crooked grained; it is used for ornamental purposes, for billiard tables and panelling, and is considerd handsomer than rosewood or mahogany; it has an aromatic odor resembling bay rum.

The sugar pine is a magnificent tree; it sometimes grows three hundred feet high and twenty feet in diameter. I saw them for miles upon miles, two hundred to two hundred

—⚏—

and fifty feet high and five to ten feet in diameter; the young trees, of not more than eighteen inches through, are very tall and perfectly straight, nearly all the trunk without a flaw, and sparsely set with branches toward the top; the foliage is not dense; the cones are large, sometimes eighteen inches long and four thick; I brought one of them to San Francisco on my way home, but it was so bulky and sticky that I had to abandon it.

A few miles before reaching Black's we passed near Bower Cave, about one hundred feet long and deep, and ninety feet wide, at the bottom of which is a small lake. The present proprietor has a fine farm under cultivation and an excellent garden; everything looked inviting, but it was too dark for us to visit the the cave, and we lost the chance of exploring its mysteries.[3]

Near this point we passed a drove of some 3,000 sheep, attended only by two boys and a shepherd's dog. On inquiry I learned that it is customary every spring to bring great droves of sheep and cattle up into these mountains for pasture, where they are kept until the snow begins to fall. The keepers pitch a tent, and with the rations which they bring, and fish and game which they kill, they live through the summer, only moving their camp when the grass gives out, when they take their flocks and herds to still higher ranges.[4]

We reached Black's at half-past eight; it had been dark, but starlight, for some time, and I had trusted to General Rosecrans' strategy, giving him a free rein and my best wishes, for I could not tell a hill from a hollow, or a bush from a boulder. A tired but happy man, as Black's white face and gray whiskers shone in the red light of a kerosene lamp; and as, soon after, the fragrant fumes of coffee and steak invited us to table; and most particularly happy when a spring mattress yielded gently to my weary pressure, giving promise of needed rest and repose.[5]

No lovelier Sabbath morning ever dawned over any spot of earth's paradise than greeted us in the little secluded valley at Black's on the 21st of June. But the sun was high in the heavens before, in answer to a summons to breakfast in half an

The trail down to the Valley "was so steep that my companion, the guide, and myself all walked and led, or rather pulled our horses." (Author's collection)

—⁂—

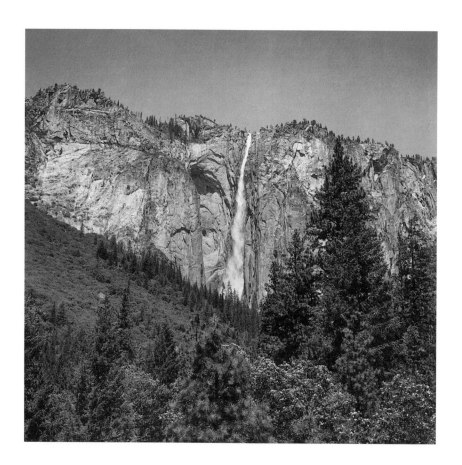

"Maiden's Tear" is now better known as Ribbon Fall. (Hank Johnston photograph)

hour, we looked out upon its splendor. We had lodged in a long, low building, one room deep, containing a nicely furnished parlor and several lodging rooms, all opening on a piazza.

Its rustic columns were wreathed with honeysuckles and running roses, while standard roses of great size and beauty looked through and over the balustrade. A clean, well-ordered garden was in front, abounding with fruit and vegetables, and irrigated by ditches of water brought from the mountain stream.

In the rear a high hill was occupied by an encampment of Digger Indians. To the left, up the valley, a small quartz mill kept up a steady thump, thump, while in front the crystal stream danced in the sunlight, and lofty mountains gently undulated towards the blue expanse.

After breakfast I walked out to limber my running gear a little, for my limbs were exceedingly stiff, almost useless; and towards sunset took a short ride up a winding gulch, where quartz and placer mining had long been carried on. Chinese now work these placers, and if they can wash out a dollar of gold in a day they do not abandon them.

Amongst the squalid Digger Indians encamped around the valley, I noticed several very old men—they were almost skeletons; their hands looked like claws; they sat muttering and jibbering, partially covered with rags, and filthy to the last degree; their hair was black and thick, their sight and hearing tolerably good. The Indians subsist mainly on bread made of acorns. These they gather and put in large wicker hampers, made water-proof for winter use. The acorns are cracked, pounded fine in stone mortars, then wet like dough, when heated stones are placed on the mash, which bake it to a paste, which can be eaten from the hand.

An arduous day's work was before us on Monday. We had to ride thirty-four miles. Not far to ride on a railroad, on a steamboat, or in a carriage over a smooth road; but this thirty-four miles to be traversed was a very different affair. On horseback—we had no locomotive but a tender behind—on horse-back or muleback, it's all the same, up almost perpendicular cliffs, plunging down into dark cañons, across rapid streams, on tops of huge boulders, along side hills whose projecting rocks and bushes scraped my shins and tore my trousers; under limbs which would knock off my hat; around trees where it took skillful riding to prevent being rubbed off; through treacherous swamp, smooth and firm to the eye, but which in places would engulf horse and rider; to encounter these was the work we had before us.

But not all the way. Our smooth trail, two feet wide, wound for miles in gentle curves, through beautiful groves, up gentle acclivities, over smooth lawns and green pastures carpeted with flowers and studded with blossoming shrubs; squirrels chattered on every side; quails and partridges scarcely cared to get out of our way, and the woodpecker kept at his noisy work with utter unconcern.

The air was redolent of the fragrant pines; ice-cold water was shimmering in every gulch; and now and then the eye would be ravished by sparkling terraces of snow-clad summits, or deep abysses of vernal beauty.

There are a few squatters living within ten miles of Black's, but in the twenty-four miles beyond all is wilderness. At Crane Flat, there is a deserted building, at which we stopped for a few minutes to read the names and initials so profusely carved on its exterior. The guide said most parties lunched there; but as it was early, he advised us to go on a few miles further to a more inviting place.

Soon after noon, Mr. Freeman told us that he would, in a few minutes, give us a bird's-eye view of Yo-semite valley; and, leaving the direct trail, we were soon on a projecting ledge of rock called the "Stand-point of Silence," from which one-half of the length of the valley could be seen. We were now some 6,000 or 7,000 feet above the valley, and over 10,000 feet above tide-water. The Merced river falls into the valley at its head, and runs nearly a westerly course for six or eight miles, when it turns abruptly to the south, and passing through stupendous gorges of mountains, finds its way through the foot-hills into the plain below, finally merging its waters with those of the San Joaquin.

It was in front of and high above this sharp bend in the river, where we stood and gazed in wonder and awe on the scene. On the opposite bank of the river, about three miles off, the "Bridal Veil" cataract poured its silvery waters over the cliff 1,000 feet high.[6] Nearly opposite was the stupendous mountain of smooth rock called "The Captain," 3,200 feet in

Artist's rendition of a steamer making its way to Stockton up the
San Joaquin River. Mount Diablo is shown in the distance. Olmsted
described the journey as follows: "there is nothing to be seen but the
muddy crooked river and the tules." (Author's collection)

perpendicular height. On either side, as far as the course of the valley would permit to be
seen, were nearly vertical walls, capped here and there by towers and pinnacles, while
further east the tops of the walls indicated the direction of the chasm.

With the exception of the walls of granite, and now and then a spot of green in the
valley below, an unbroken forest was before us. This is a remarkable feature of the
Sierras; the most splendid groves that we saw or passed through were on the highest
elevations which are accessible. While Mount Washington is only a waste of bare rock
and boulders at a height of 5,000 feet above the ocean, the Big Trees of Mariposa have
been nourished for thousands of years by the virgin soil of a much higher altitude.

A short distance from the "Stand-point of Silence," in a cozy nook down which tumbled
a sparkling stream spanned by a short bridge, we stopped to lunch. Under the shade of a
magnificent oak, seated on a cushion of spruce branches, with an appetite sharpened by
eight hours' hard exercise, we enjoyed our cold-fowl, boiled eggs, and sardines, with a
relish unknown to the habitués of cities, or the pampered devotees of fashion.

We entered the valley by a zigzag narrow path down the face of the northern
declivity. For the last mile or two the trail was so steep that my companion, the guide,
and myself all walked and led, or rather pulled our horses; and when, some days after,
we were going out, on the Mariposa trail, the mountain we were now descending looked

too nearly perpendicular for any living thing but goats or wild beasts to descend.

But we got down safely in ten minutes over an hour, and found ourselves on the bank of the Merced; which was roaming and foaming after its terrible leap of thousands of feet in a distance of six miles. The water was about as high as was ever known, covering the lower trail, and compelling us to keep the trail at the very base of the rocks, and to go through and over the huge piles of boulders which often extended to the river's bank. But we were more than compensated for our inconvenience by the enhanced beauty of the falls, which carried large volumes of water where, later in the season, it merely trickles down the face of the cliffs.

Looking up the valley, eastwardly, we saw the immense walls, on either side, of solid glistening granite, averaging over half a mile high, while the "Maiden's Tear" on the left,[7] and the "Bridal Veil" on the right, hung over the rocks like a silver cord, falling one thousand feet in one leap, then tumbling in snowy cascades, down, down, amongst rocks and trees until their waters are lost in the Merced.

We had been riding towards the immense rock called "The Captain" for some time, but still it seemed no nearer. While I was wondering at this strange phenomenon, the guide stopped and asked me how far I thought it was to the face of the rock. I replied, "a hundred yards," but my companion said, "No, not half that." The guide laughed heartily, and assured us that it was at least one mile and a half distant. I was utterly incredulous, as I was at most of their statements of height and distances, at first, but after riding and riding first to get to the rock, and then to get away from it, for over an hour, I concluded that the guide was right.

Just above the base of "The Captain" we had to cross the river in a scow, with our horses. As the river at this point kept close along the northern bank, we had no trouble in getting on to the scow; but the difficulty was to get off—for the river had overflowed the flats on the other side, and the boatman had to hold the scow by the aid of a rope tied to a tree while he jumped our horses off the bow. The water was three feet deep and running swiftly. After much urging, the guide went overboard splash into the water, seeing which the "General" took courage, and by dint of much coaxing and some urging, followed his file-leader, giving me no greater wetting than soaked feet and a thorough sprinkling. My friend's horse, seeing his two companions wading round the boat fearlessly, took the plunge, and we soon reached dry land again.[8]

Amidst such wonders we rode up the valley about four miles further to the famous Hutchings' Hotel;[9] and if there ever was a tired and weary traveller he was the one who soon after sundown dismounted from a jaded nag in front of this hotel. Mr. Hutchings came out; the guide introduced us, and by the aid of the former's shoulder, I slipped off my horse, hobbled into the house, and was ushered into a large rear room, where an immense fireplace, filled with logs, was shedding its cheering, warming light. Directly in front of the fire stood a rustic arm-chair, big enough for Daniel Lambert, into which I subsided, a weary yet happy man.[10] In about an hour we were fully ready for a delicious supper of speckled trout and venison, finishing off with strawberries and cream.

Hutchings' Hotel is on the south aide of the river, near the base of Sentinel Rock, which towers 3,200 feet above it. Between the house and the river is a small lawn with

scattering shade-trees, some large boulders and hitching posts and rails for the horses. Across the river there stretches an interval of meadow land which furnishes abundance of hay for winter use of the stock raised in the valley.

Beyond we come to the winter residence of Mr. Hutchings—a large cabin made of hewn logs, warm and snug, a huge stone fireplace in one end;¹¹ hanging shelves, containing some two hundred and fifty volumes, in the corners; fishing rods, guns, and rifles along the walls; and, a pair of snow shoes, indispensable to that snowy region— they were made of strips of soft pine, 9 feet long and 4 inches wide, with heel-pin and noose for toe in the centre, and a groove in the bottom to keep them from slipping sideways. They use a light pole, about eight feet long, to push themselves up hill with. This pole has a button eight inches from the lower end, of six inches in diameter, to retard their speed down hill and to steer with. People go on down grades with great velocity on those snow shoes, sometimes nearly a mile in a minute.

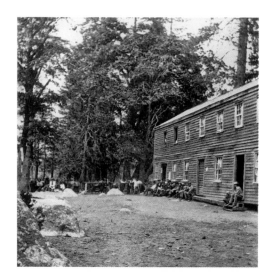

James Hutchings' hotel as it appeared about the time of Olmsted's visit. Hutchings and daughter Florence, the first white child born in Yosemite Valley, sit in the doorway at the right.

Near the house are sheds and hay racks, and a fruit and vegetable garden of several acres—at least one acre in strawberries. In the rear of this house, and fronting the hotel, is the far-famed and beautiful Yo-Semite fall. It pours over the top of a straight line of rock into the valley, falling one thousand six hundred feet perpendicular into a huge basin, from thence by a second fall four hundred feet, and again rushing over a third fall of six hundred feet. For two-thirds of the way down the principal fall the water is one sheet of white foam, and as the stream is swayed by the wind it cracks and snaps like a discharge of small arms. The weather that day was cloudy, windy and cold for the season; in the afternoon it rained for two hours, winding up with a heavy hail storm. On the mountains, as visitors who were on the trail informed me, the weather was very tedious; and the ladies of the party suffered much from the fall of sleet, hail, and snow.

I met a gentleman at dinner who said he made his first visit to the valley under peculiar circumstances. It was in December 1859, a party of three had started for some point, with three days' provisions, got lost, and were twelve days wandering in a snow storm. They made their provisions last for six days, and lived on bark and nuts the balance of the time. At length, when near the east end of the valley, being on the lead, he suddenly fell or sank through the snow some thirty feet. With great difficulty they worked their way down and finally reached the hotel. This was shut up—no living soul but themselves in the valley, but they found some odds and ends of provisions, which sustained them until they got out into the settlements.

At dinner also was James Duncan, the famous bear-hunter, who has killed forty-six

bears, besides wild animals and deer, of which he kept no account.

There are some very large trees in the valley; I noticed an oak ten feet in diameter; also four spruce trees, in a line and near together, which averaged seven feet through, five feet above the ground. The kitchen of the hotel is built around a cedar tree, seven feet in diameter and 200 feet high.[12] There is a tree in a cleft of the mountain, near Yo-Semite fall, which looks about fifteen feet high, but is known to be one hundred and fifty. In a seemingly small fissure or alcove in the face of "Le Capitaine," six hundred or eight hundred feet high, is a shrub or small tree, looking about large enough for a walking cane, which is claimed to be two and a half feet through.

The valley is full of wild flowers, sometimes growing in beds as though the seed had

Hutchings in front of his cabin about 1882, flanked by son William Mason Hutchings at left and daughter Gertrude "Cosie" Hutchings at right. William was born with a deformed spine that severely limited his energy and activities. (Author's collection)

—⁓—

been sown, then nestled amongst the boulders, where no soil is to be seen; and running vines and roses of various kinds clamber amongst the rocks in picturesque profusion.

I was amused at an account of Mr. Greeley's visit to Yo-Semite. He had not rode on horseback for thirty years, yet was rash enough to undertake to ride sixty-two miles in a day. He arrived in the valley at one o'clock in the night—had to be lifted off his horse and carried into the hotel; he was then rubbed with oil and whiskey and put to bed. Rising about ten o'clock a.m., he breakfasted, rode up the valley about two miles, made

—⁓—

some disparaging remarks about the scenery, and started on his return the same afternoon. While conceding to Mr. Greeley great and varied talents which he has so long exercised for the lasting benefit of his country, these Californians wondered how he could manifest so little enthusiasm—so slight an appreciation of this wonderful valley.[13]

But it was not so with Speaker Colfax. When about leaving the valley, with his party, said he: "Mr. Hutchings, I have had a great time; I never felt so much like making a speech in my life." "You have my full permission," said Mr. H., gracefully bowing; but time would not permit, and the future Vice-President rode away to the regret of all. Mr. Hutchings asked me if I would probably see Mr. Colfax on my return to "the States." Said he, "If you should see him, tell him that if I am alive next November I am going to ride fifty miles on purpose to vote for him."[14]

"The winter residence of Mr. Hutchings—a large cabin made of hewn logs, warm and snug, a huge stone fireplace in one end." The rustic armchair made by Hutchings from manzanita wood is at the left.

—ɯ—

Mr. Hutchings has lived in the valley about six years.[15] He has taken up one hundred and sixty acres of land in the form of a cross to cover his improvements, and is pressing his claim. But there is a decided aversion in the minds of the people to alienating any portion of the valley, and it will probably remain the property of the State, and under its protection. I understand that all that Mr. Hutchings asks is to have his claim respected if the land is sold, or be paid for his betterments if the State retains it.[16] He is an enthusiastic admirer of Yo-Semite, and expects to spend his days there out of pure unselfish love for its marvellous beauty and sublimity.

All objects of interest in the Valley can be seen without fatigue, except the Nevada and Vernal Falls. These are, in fact, the principal falls, being on the Merced river, at the very head of the valley, while Yo-Semite, Bridal Veil, Maiden's Tear, and Sentinel Fall are small streams which pour into the valley over its sides, and almost disappear late in the season.

The Nevada is the first and by far the grandest cataract. From the general altitude of the country round the valley, the Merced here falls perpendicularly seven hundred feet, and half a mile below are the Vernal Falls, three hundred and fifty feet high.[17] The Nevada Falls cannot be reached without great fatigue; and speaking in a business way, I think it doesn't pay to climb up to it. But I will tell you how I reached it, and what I saw, and you can judge for yourself.

A live party of half a dozen of us left the hotel one fine morning soon after breakfast, for the excursion. We rode up the valley about two miles, when it narrowed to a ravine, up the sides and bottom of which we rode half a mile further, when the ascent grew so steep and rocky that we had to leave our horses and take to walking or climbing. Another mile brought us to a projecting point called Lady Franklin's rock, where we had a perfect view of the Vernal Falls; having ascended, thus far, about 2,000 feet.

—ɯ—

The interior of the "Big Tree Room" as it looked about 1900.

—⁂—

The real hard work was now to be done. Above us the path grew steeper and steeper, until it led along the face of a sloping rock partially covered with muck—where the wind blew furiously, and the spray from the fall was blinding. At this juncture I availed myself, for once, of the strong hand of the guide. On a slippery shelving rock, with a seething cauldron on our left, a precipice on our right, with a boggy, slushy path rising before us, a thick penetrating spray eddying around, filling our eyes and ears, the wind roaring, and bellowing, and lashing against us, and the thunders of the cataract booming in our ears—surely this was a position to be sought but once in a lifetime, and to be endured but once more, and that from necessity.

Soon, however, the whole party were safely at the foot of a high rock, parallel with the face of the fall, where stood a ladder about sixty feet long, nearly perpendicular. Stepping from the top round on to a ledge of rock, I found another ladder some twenty feet high, at right angles with the first, from the top of which a little smart climbing brought the party to a smooth expanse of rock at the very verge of the Vernal Fall.[18] We

—⁂—

were now in an amphitheatre of a mile or two in circuit, surrounded on all sides by high mountains, and half a mile above was the majestic Nevada Fall, pouring its immense volume of water over the cliff, and thundering on the rocks at its base.

Across the river to the north of this fall rises a detached mountain called "The Cap of Liberty," of sugar-loaf form, regular in outline, inclining somewhat towards the fall, the top of the mountain being 2,000 feet above the top of the fall. Midway between the two falls the river rushes through a sluice not more than twenty feet wide with great rapidity, from which it emerges on to a smooth sloping rock, called the silver apron, spreads to a width of 100 feet, and dances and sparkles in the sunlight like liquid silver.

When retracing our steps into the valley we came across two Indians loaded with venison and smaller game, and it was astonishing to see with what ease they carried their heavy loads, and how quickly they disappeared ahead of us.

I kept a thorough lookout on that day's excursion for a boulder as big as the Getty House, but the largest one I noticed was eighty feet long, twenty feet high, and thirty feet wide, and nearly as smooth and regular in shape as if cut from a quarry.

The next morning I visited Mirror Lake, a charming sheet of crystal water of a few acres in extent, but which would not be worthy of notice except for the picturesque grandeur of its surroundings. To the north and west lie immense rocks that have become detached from the mountain above; to the north-east opens a vast cañon, down which rushes the north fork of the Merced, and feeds the lake. On the south-east stands the majestic "South Dome," 6,000 feet high; to the north-west rises the "North Dome," nearly 4,000 feet above the valley, and on a straight line not over one hundred rods apart.

No one, not even old residents, can realize the immense height of a tower of rock like "South Dome" except by an effort to scale it. A gentleman told me that he climbed to the top of the "North Dome," and when there, that the "South Dome" looked as high above him as it did from the valley beneath. The reflection of these stupendous mountains in the bosom of the lake, on a still morning, is a sight seldom equalled. The eye is ravished by a wall of glistening granite nearly a mile and a quarter high, with its counterpart, softened and subdued deep down in the tranquil waters.

Emerging from the little basin of Mirror Lake, on our return, my attention was called to "The Royal Arches" on the face of a mountain of solid granite rising 2,000 foot vertically; the crown of the arch bout 1,700 feet high, and its span 2,000 feet; its depth in, from the face of the rock, about eighty feet.

With an appetite sharpened by our three miles' walk, and the bracing air, we sat down to a dinner of baked speckled trout, roast venison, and mountain mutton, with a dessert of coffee, cakes, and strawberries and cream. Such cream as we read about, but seldom taste. So thick that it had to be coaxed and stirred with a spoon before it would leave the capacious jug. Then came an hour or two of sleep, or of dreamy reverie under the shade of a noble oak on the river's bank, or the luxury of a good cigar; —when our horses were saddled and bridled, and eager for a gallop down the smooth and winding trail.

We wanted to see the "Bridal Veil" fall where the sun was shining obliquely upon it, and we did see it in its most brilliant and unapproachable beauty. Before the water falls half way, it breaks into spray, cracks and snaps like the noise of a thousand rifles, and at the foot of the fall fills the air with the most brilliant rainbows, in circles and half

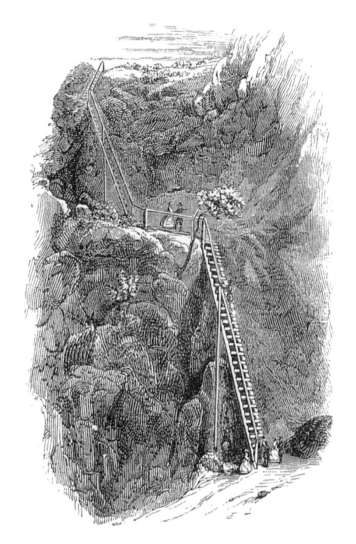

Artist's rendition of the original Vernal Fall ladders about 1869.
Descriptions of the ladders indicate that they were much less sturdy
than they appear in this drawing. (Author's collection)

—ɯ—

circles, sometimes wide and high up, then near the ground, then dancing around your hands and face, and inserting their variegated hues seemingly into your very pockets. Across the river stood our old friend "The Captain," projecting into the valley a quarter of a mile, grayish-white and smooth-surfaced; which not even the storm of thousands of years have furrowed; a most awe-inspiring monument of Almighty power and majesty.

On Friday morning, having been three days and a half in the valley, we reluctantly bade our accomplished host farewell and took our departure by the Mariposa trail. As we were about commencing to climb the mountain, we had to pass over a field of

—ɯ—

This photograph of Clark's Station was taken about the time of Olmsted's visit—"a ranch fragrant in the memory of all Yo-Semite travellers for its good fare and comfortable rooms."

—⟋⟍—

sand and boulders which had covered the trail and the meadows several feet deep; the débris having washed down into the valley during the rainy season. The entire trail was in bad condition, and much obstructed by fallen trees, some of which had to be leaped and others flanked. We were several hours in reaching "Inspiration Point," where we halted awhile to take a final look, from its dizzy height, on the magnificent panorama beneath us.

We soon began to encounter deep and long snow-drifts, which in places broke through, to our great discomfort, and danger to the horse's legs. Some of these drifts covered acres of ground, and were five or six feet deep. Our task on that day was to reach Clark's Hotel, on the south fork of the Merced, twenty-four miles distant. It was an easy day's work, and we took it leisurely. I was amused in noticing the sagacity of our horses; if the guide's horse jumped a ravine or a log, mine would do the same; in one case we had to go over a huge tree, on a side hill, and the guide, after many efforts, made his horse step on to the tree, and over it, instead of trying to jump it, and the other horses followed the example.

We occasionally saw that most beautiful of all plants, called the snow-plant. It grows at the foot of large pines, from four to ten inches high, pineapple shape, stem one to three inches round, and white as ivory, close bell-shaped flowers of beautiful scarlet all

—⟋⟍—

round it, and long crimson leaves wound round the cups. Though growing in, or by the side of, snow banks, it is yet so sensitive and delicate that it will not bear transplanting, but when plucked, soon turns black, withers and dies.

About five o'clock p.m. we arrived on the bank of the river opposite Clark's. The bridge was gone, and a new one, of one hundred and fifty feet span, was going up. Mr. Clark himself, a veteran pioneer, was at work on the other side, bareheaded, under the rays of a hot sun.[19] Since he had a course of fever, some years ago, he seldom wears a hat; but he has hair enough to make a covering for the head equal to a dozen modern bonnets, with a chignon thrown in. The river was very high, and too rapid for a boat; so, an immense tree had been cut on each side of the river, and made to fall into it, the tops of which stranded on projecting rocks; then, with a little trimming up of the branches, and long poles for a hand-rail, a passable crossing-place was completed.

But the poor horses, they had to swim for it. A strong rope was stretched across, twice the length of the ford, the slack drawn over to our side, then a rope halter was tied to the neck of the horse and to the cable; two men on each side of the river then took the rope; the horse, quite unsuspicious of such a bath, waded in, soon lost his footing, and was swept by the current rapidly down the stream; but while the opposite parties tugged at the rope, on our side it was played out, so that soon the dripping animal was safely landed, feeling all the better for his forced bath.

So here we are at Clark's; a ranch fragrant in the memory of all Yo-Semite travellers for its good fare and comfortable rooms—its splendid lawn and umbrageous groves— for its charming views of woodland scenery, stretching far away to where the Big Trees of Mariposa stand, like giant sentinels of past ages, the absolute monarchs of the vegetable kingdom. But I must postpone any description of them, and of the route from Clark's ranch to Stockton, to some other time.

CHAPTER III
NOTES AND REFERENCES

—⧓—

1. The average "pier" elevation of the Yosemite Valley floor is slightly less than 4,000 feet above sea level.

2. Built by one Charles Hoswell in the early 1860s, the "rope ferry" at Stevens' Bar was a scow shuttled back and forth across the Tuolumne River by pulling a rope. The ferry did a thriving business until 1885 when J. H. Moffitt erected a 300-foot toll bridge a few miles down river. His ferry effectively defunct, Hoswell went to Chinese Camp, took room 13 at the Garrett House, and ended his life with a bullet at the age of forty-six. The "steep rise of three miles" mentioned here became known as Priest's Grade after Priest's Station was established at the summit in 1875.

3. Bower Cave, so named by a visitor in 1858 because of arching maple limbs that formed a bower over the entrance, was a popular tourist stop, first on the Coulterville Trail, and after 1874 on the Coulterville Road. It was closed to the public in the 1950s. Now a part of Stanislaus National Forest, Bower Cave may be opened for public viewing on a limited basis sometime in the future.

4. Beginning in 1864 when a great California drought forced sheep owners to move their animals into the high country for pasture, shepherds took over the Sierra as their own private grazing grounds. After the establishment of Yosemite National Park in 1890, army troops instituted rigorous patrols of the reserved area, and by 1900 virtually all illegal grazing had been discontinued (see Chapter VI).

5. Alexander and Catherine Black ran a stopping place for tourists at Bull Creek on the Coulterville Trail from the mid-1850s until the summer of 1870 when they moved to their new hotel in Yosemite Valley.

6. Bridalveil Fall, elevation 620 feet.

7. Ribbon Fall, elevation 1,612 feet.

8. In the summer of 1858, Yosemite pioneer Steven Cunningham rigged up a toll ferry across the Merced River in Yosemite Valley. The ferry fell into disuse after the state erected a bridge in the same area in 1866. The new bridge was washed away in the great winter flood of 1867-68, and one Philip Coulter rebuilt the ferry shortly before Olmsted's arrival in June, 1868. Coulter replaced his ferry with a truss-type wooden toll bridge in 1870 (later known as Folsom's Bridge).

9. In the spring of 1864, James Hutchings, leader of the first tourist party to Yosemite in July, 1855, purchased the so-called "Upper Hotel" from the mortgage holder and began an eleven-year stint as a Valley innkeeper and publicist. For information about early development in Yosemite Valley, see Hank Johnston, *The Yosemite Grant, 1864-1906: A Pictorial History,* (Yosemite: Yosemite Association, 1995).

—⧓—

10. About 1866 Hutchings added a combination sitting room and kitchen to the rear of his box-like, two-story hotel building. Trained as a carpenter in his youth, Hutchings constructed the arm chair described by Olmsted out of manzanita wood. The chair, which was used by many famous visitors over the years, is now in the Yosemite Museum.

11. Hutchings built his one-and-a-half-story log cabin in the summer of 1865. It stood on the open north side of the Merced River, which, unlike his hotel location, received considerable sunshine during the cold winter months when the hotel was closed.

12. Not wishing to fall a large incense cedar that stood directly behind his hotel building, Hutchings enclosed the tree within the lean-to addition described in note 10. Later used as a parlor, the structure achieved fame as the "Big Tree Room," even though it involved a cedar tree and not a sequoia.

13. Although noted editor Horace Greeley called Yosemite Falls "a humbug" (only a trickle of water remained at the time of his mid-August, 1859, visit), he later wrote that Yosemite was the "most unique and majestic of nature's marvels."

14. Schuyler Colfax (1823-1885) was a seven-time Indiana congressman and speaker of the house (1864-69). He later served as vice president of the United States during President Ulysses S. Grant's first term (1869-73). In July, 1865, Colfax and a party of dignitaries from the East visited Yosemite and subsequently wrote glowing reports of the scenery. After becoming caught up in the Credit Mobilier of America scandal, in which he and other high government officials, including some members of Congress, were accused of taking bribes, Colfax departed public life.

15. Hutchings began innkeeping in Yosemite Valley in the spring of 1864, four years before Olmsted's visit.

16. After a lengthy legal battle, Hutchings was evicted from his Yosemite Valley claim in the fall of 1874, ten years after the establishment of the Yosemite Grant by the federal government. The state awarded him $24,000 for his holdings, a sum many observers felt was "exceedingly munificent." A biography of Hutchings appears in Hank Johnston, *Yosemite's Yesterdays, Volume II* (Yosemite: Flying Spur Press, 1991), 14-29.

17. Vernal Fall is actually 317 feet high.

18. The Vernal Fall ladders were erected by Steven Cunningham and others in the summer of 1858. They were replaced in 1871 by a wooden stairway, superseded in 1897 by the present stone steps.

19. Galen Clark was a member of one of the four 1855 tourist parties as earlier described. Suffering from poor health, he claimed 160 acres at present Wawona "to take my chances of dying or growing better, which I thought were about even." In 1857 Clark erected a log cabin on his property and soon began administering to tourists traveling over the Mann brothers' trail from Mariposa to the Valley. In 1866 Clark was appointed guardian of the new Yosemite Grant, but continued to operate his way station until going bankrupt in 1874. Clark's long and interesting life is described in Shirley Sargent, *Galen Clark, Yosemite Guardian* (Yosemite: Flying Spur Press, 1981).

—⁓—

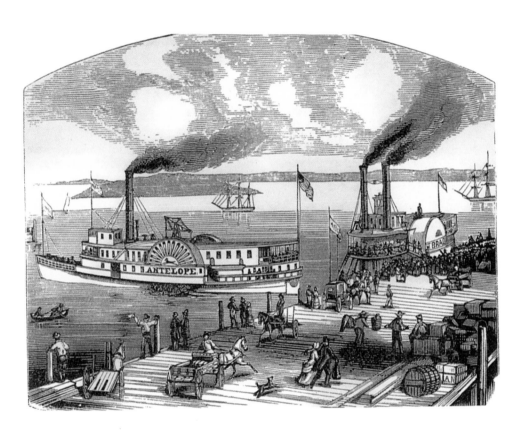

Knowlton and his friend took the steamer to Stockton on the first leg
of their Yosemite journey. The sketch depicts the "Antelope" heading
for Sacramento and the "Bragdon" for Stockton from the Broadway
Street wharf in San Francisco. (Author's collection)

IV

YOSEMITE ON FOOT
by Ebenezer Knowlton

In the late afternoon of June 28, 1869, two San Francisco school principals, Ebenezer Knowlton and a friend identified only as "Leukos," set out on a remarkable twelve-day odyssey: a walk across the foothills and mountains to Yosemite Valley and back. Although time constraints required the use of conventional transportation (steamship and stage) at the beginning and end of their journey, the intrepid hikers covered the most difficult part of the trek, from Stockton to Mariposa via Yosemite Valley and the Mariposa Grove, entirely on foot.

Knowlton's wry account of the pair's adventures, which appeared in the Overland Monthly *a year later (July, 1870), contains a detailed description of the outfits and equipment utilized on the approximately 180-mile walk. It also provides some interesting first-hand information about the places and people encountered along the way.*

Little is said about Yosemite itself. "We do not propose to describe the valley," Knowlton wrote. "He who has seen it, listens politely to the most enthusiastic accounts of the most widely traveled tourists, simply answering, with a calm, superior smile, 'Ah! but you should see Yosemite.'"

We were a quadruped—Leukos and I. A brace of pedestrian pedagogues, from San Francisco, who walked to Yosemite and back in less than two weeks of last year. And this is an off-hand story of our on-foot tramp.

Our outfit was this:

1st. A loose-fitting, strong, woolen suit, from cuticle out; short sack-coat, with plenty of pockets—large pockets and small, both inside and out—in fact, in ease of emergency we could have stuffed the whole coat into its own pockets. A common linen-duck, or cotton-duck shooting-coat would do very well.

2d. Easy old boots, having low and square heels, with broad, thick, elastic, sewed soles; heels and soles well studded with short, stout, soft-iron nails; the brown linen-duck, or cotton-duck upper, with russet leather at the heel and toe; the laced ankle-boot, worn by base-ball players, or the stouter one made for the feet of the boxer, would serve very well in the open, but for thickets, and swamps, and deep dust the leg-boot is better. Cut the trowsers-legs off three inches above the ankles, fold them smoothly over the stockings, secure by a light elastic, and draw the boots over all.

3d. Medium-thick, seamless stockings or socks, of the finest and softest of wool, well "run" at the heel—one pair on the feet, and two extra pairs snugly stowed in side-pockets.

4th. An India pith-hat, of the double-dome shape, having an inch of clear space all round the head, and a regular parasol-brim. Awkward for looks is that hat, but vital for health, when the sun beats straight down on a broad, sandy plain, or scorches a breezeless mountain-side trail at midday.

5th. A thick, coarse crash-towel, about two feet by one and a half, with a piece of hard, old, castile soap, suited in size to the probable length of the tramp, and the actual size of one's feet.

6th. Two ounces of arnica, in a thin, flat vial, easily stowed in the pocket. If the vial is tin, all the better.

7th. A shallow tin box of pure mutton tallow, as large over as a double-eagle, as thick as four of them laid in a pile, and worth as much as the pile, with a fifth laid atop. If you doubt this at all, just trust one who has tried, and read on.

8th. A strip of Robbin's Isinglass Adhesive Plaster, twice as large as a green-back. The need of this will appear farther on.

9th. A medley: made up of two or three needles, in a small reel of strong linen thread; two or three spare buttons, of each kind on your suit; pins, matches, and knife, besides your indispensable comb, tooth-brush and pick—which you can't leave behind without most abject self-contempt.

"Too much plunder," you say? Well, leave out anything that you like, try one tramp without it, then omit it, next time, if you can. Aside from the suit, the knickknacks weigh, may be, two pounds, and they'll pay you ten pounds of solid comfort a day. Then, too, the farther you go the lighter they grow, both by actually using them up, as well as by getting so used to the trifling burden that you seldom notice it at all. Thus, the longer *your* way, the lighter *they* weigh.

The towel and soap, for the un-get-along-withoutable foot-baths, which the would-be comfortable trampist must have at least three times a day—at morning, at noon, and at night—else he will find it quite impossible to preserve a good understanding through such trials of sole as he must unavoidably meet. One must carry his attention even to extremes, and learn, with the soldier, that on very long marches his feet are fully as important as his arms.

The tallow prevents chafing, and softens any callus which may threaten discomfort. The plaster protects any spot which may chance to get chafed in spite of preventive precaution. The arnica is a sovereign specific to take away soreness before it increases to actual discomfort. The needles, thread, and buttons, for rents and jerks untimely, when far from helpful, female fingers.

Three things more one will find very convenient and helpful, so much so that we should not think of repeating the walk without them: a handy pocket-revolver; a blank-book and pencils, for journal and sketches; and Hittell's "Yosemite: its Wonders and its Beauties," containing an excellent two-page lithographic map of the valley. If you have room for it, the "Yosemite Guide-Book," edited by gentlemen of the State Geological Survey, and published by authority of the State Legislature, is late, official, and accurate, but it is four times as large and heavy as the other.[1]

Gobin's second hotel at Crane Flat pictured about 1900. The first structure burned in 1886 and
was rebuilt as shown in 1888. Billy Hurst's saloon, a gathering place for teamsters and shepherds,
is the building with the white roof across the road from Gobin's. (Author's collection)

—ɯ—

Thus equipped, we set forth, on the afternoon of Monday, June 28th, 1869. We rode
to Stockton, chiefly for lack of time.[2] The Yosemite runners forthwith besieged us, but
speedily gave over on learning our intentions. Thus, at the very outset, the walkers
beat the runners.

Woke at Stockton pier at 3:50 next morning; had a good, comfortable, hot-coffee
breakfast at 4:30, and five o'clock found us fairly out of the city on the straight road to
Knight's Ferry, thirty-six miles away. Seven miles stretched behind before the *early*
morning stage overtook us, laden with San Francisco friends bound for our own
destination. Commerce and Law taking comfort inside, Medicine perched up behind,
while Theology sat close at the driver's rein-hand. It won't be a bad thing for the
world, by the way, when Theology has the ear of those who drive. All looked
pleasantly, though somewhat patronizingly and pityingly down upon us, wished us
good speed, and dashed dustily on. We walked slowly, carefully, and easily after.
Wherever an inviting way-side bank lay in an agreeable shade, we lay lazily with it,
while appreciative birds caroled their cheering lays above. Thus plodding patiently on,
with frequent short rests, we made the seventeen-mile house at an hour after noon.
Dined well, but not heavily, gave an hour to digestion and rest, then to the highway

—ɯ—

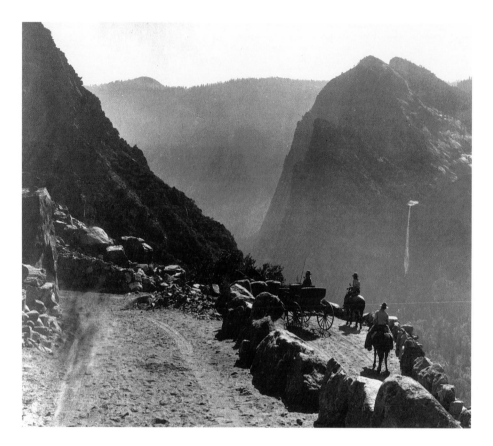

"The sight was grand—too grand for speech." This view from the zig-zag turn
on the later Big Oak Flat Road approximates the vista described by Knowlton as
he descended into the Valley. (Tuolumne County Historical Society collection)

again. Dust, heat, and stillness were the main things against us, but through them all
we made slow and steady gains. As our track lay due east, the sun, setting clear behind,
threw sharply drawn shadows at least a hundred yards along the level plain far in
front. They stretched weirdly beyond into the deepening twilight, like ghostly figures
pointing our way.

That night we slept four miles this side of Knight's Ferry; and slumbered as soundly
as if Morpheus sat on one lid, and Somnus lay on the other. Next morning up before
the sun, and off as soon as up. Into Knight's Ferry, wrote and mailed letters home,
crossed the dustiest bridge in the State, climbed the opposite hill, and fortunately
breakfasted at Dingley's Hotel, a mile beyond the ferry. Dingley's is snug, neat, clean,
and home-like, where a tasteful lady presides over a bountiful table. At least it was so
that morning. Thence on, and presently into the midst of a rocky tract, looking like
one of Creation's workshops, wherein gigantic hands had left loosely lying titanic

chips and mammoth blocks not needed for terrestrial underpinning. Still on, along a monotonous way, relieved by nothing unusual save a solitary, shallow pond. The middle of the afternoon brought us to Stevens' Hotel, wherein four feet and two stomachs found cause of rejoicing. Night-fall arrested us in Chinese Camp. We lay at the Granite House³ all night, rose at 3:30, and got fairly on the trail again at 4:07. Walked four miles to the Tuolumne House, where we breakfasted, and after the usual sanitary siesta, a romantic stretch of two or three miles brought us to Stevens' Bar Ferry. A bit of a dory and two stalwart arms soon placed the deep and rapid Tuolumne behind. Our next objective point was Munn's store, six miles farther on. Here we found a lady having quite a geological curiosity in the shape of a porphyry pebble, water-torn to a thin oval, and showing a well-defined cross of white quartz on both sides. Just beyond Munn's store rises the hill "Difficulty," four miles steadily up, scorched with a vertical sun, dry, dusty, breezeless, and shadeless—by far the hardest bit of the whole way. If you're walking that way, plan it to climb that hill early or late in the day—as we did not, much to our sorrow. Never attempt it between ten and two of such a day. At the top of the hill, Kirkwood's.⁴ The card says this is two miles from Munn's store. It may be two miles in an air-line, but when one's walking up-hill, and can get no air at all, it's all of four miles, and is longer and harder than any eight miles on a level. Had a good dinner and an hour's nap, then forward one mile to Oak Flat, so named from a mammoth oak, once the pride of the town, now killed by undermining. The town is one of the many "has beens" which dot the mining districts of California. It still affords diggings, but not a tithe of the former ones. The big tree is a fit symbol of the place which it names. The Big Oak will soon be flat, and the town with it.

Thence two miles over an easy road, and through pleasant scenery, to the First Garrote, where there are two good hotels.⁵ We again took to the road, winding through fine forests, over hills not too high nor steep, to another pleasant valley opening around the Second Garrote, two miles from the First. Most readers will remember that this word, *garrote*, is Spanish, and means strangling by an iron-collar tightened around the neck. It is pronounced in three syllables, with the accent on the second—*gar-ró-tay*. These two places received their name in commemoration of the garroting of two or three thieves, robbers, and murderers, done at these two places by self-appointed judges, juries, and executioners of righteously indignant citizens, in the early days of natural justice and spontaneous retribution, before "regular" organization, "settled" government, and artificial justice had made it easy for desperadoes to kill and go free.

Beyond the Second Garrote the road winds up mountains, and through forests, five miles, to Sprague's Ranch. We walked till we knew more than five miles had passed under our feet, but saw and heard no signs of human nearness. Night fell upon our forest road, and all its stillness brought no cheering sound of neighboring habitation. Passed a gate on the left, wound on through trees so tall and thick that the way hardly revealed itself; and still no ranch. Presently, the lowing of kine, and the barking of dogs, away to the left and behind. Fearing we might have missed the way, we turned back, found the gate, climbed it, and trudged toward the lowing and barking, along a winding cart-path, hardly visible through the gathering darkness. Soon the heavy baying of hounds sounded nearer, and suddenly a huge, black dog burst throught the

brush on our right, sprang to the middle of the track, planted himself squarely in front, and demanded our passports. We produced them at once, pointed them straight at his head, and let our feet press close after, still proffering friendship with the disengaged hand, and giving tongue to all the canine compliments and conciliatory blarney we could see to use in the dark, in a somewhat churlish and rather cursory manner. Our muzzles soon overpowered his. Before such a combination, his doggedness speedily yielded: he wheeled himself into advance-guard, and pioneered us to his master's clearing and house, but a few rods away. A pleasant little woman promptly appeared, and her equally obliging husband soon set us in a trail running snug along a fence, so plain that even night and the woods could not keep us from following, till it led us safely out to Sprague's Ranch[6] at last, at nearly nine of the clock and the night. Fortunately, the man of the house was still up. The good woman had very sensibly gone to bed. With wholly undeserved courtesy she promptly appeared, armed with such vigor and skill that thirty minutes thereafter we sat down to a smoking-hot dinner of eggs, omelettes, cakes, and coffee, with strawberry preserves of the freshest, cleanest, and sweetest. After a wide-awake hour of nocturnal nonsense, we camped upon a hard, but most welcome bed, and soon slept with all our might. My first nap suddenly terminated in the sharp consciousness of some imminent peril, which thrilled to my very finger-tips. And there, indeed, I found it; for, rapidly coming out from sleep through an indistinct border-land peopled with dim ideas of mysterious snuffings, growlings, and tumblings into broad wide-awakeness, I found a shaggy, chunky Newfoundland pup affectionately sucking away at my hand, hanging down the front of the bed, and varying his senseless slobbering with semi-occasional canine cavortings over the loose-boarded, rattling floor, with the grace of a rheumatic cow afflicted with St. Vitus' dance. Whereupon, incontinently chucking him through the door, to the rhythmic accompaniment of Leukos' sonorous nasal trombone, I again stretched myself at his side, where he lay supine, with his nobly vocal nose serenely turned up at all things earthly, making darkness audible. The sun rose early, but found us up before him.

A pleasant country lay before us, woody, with occasional "flats," or openings, grass-grown and brook-watered. This morning, we first saw the fresh tracks of "grizzlies," plainly printed in the dust along the trail, and looking quite like the track of a fat human foot. They considerately preceded us so far that we never caught sight of them, and kindly left us the undisputed right of way. As their tracks bore no resemblance to those of any animals we had lost, we never went out of our way to hunt them. Four miles on, passed a big wooden flume, a hundred and thirty feet in the air. Portions had fallen away, and workmen in sheds were building iron ones to replace them. We continued leisurely on, through a more and more beautiful country, enlivened with occasional peeps of distant, snow-capped mountains, or racing with the mail-stage, and three times beating it by short-cuts; crossing a brawling, dashing foaming mountain stream; until at ten o'clock, we made Hardin's Mills,[7] twelve miles from Sprague's Ranch. We took a longer nooning than usual, because the day was uncommonly hot, and one gains little, on mountain roads, by trying to walk through the hottest midday hours. An hour after noon found us threading the first rods of the real mountain-trail,

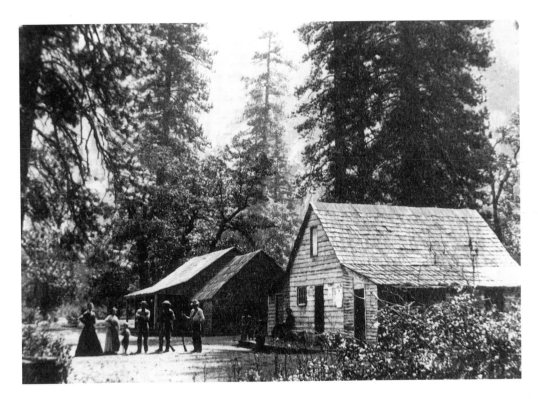

Leidig's Hotel, which he leased from Alexander Black, as it appeared about 1869, the year of Knowlton's visit. The following year, Leidig built his own hotel near the start of the present Four-Mile Trail.

—⌇—

where no wheels had ever rolled. The trail was very plain, so much so that the wayfaring man need not err in it, unless, indeed, a fool, and drunk, too, at that. About six o'clock, it led us by the Tuolumne, or Crane Flat Big Trees. Tramping on, along mountain-sides, and growing painfully thirsty, we began to strike little streams of the coldest, clearest, and most delicious of water. About eight o'clock, Crane Flat opened before us, and Gobin's Ranch[8] received us. Here two or three shepherds kept bachelor's hall, and received us kindly.

The next morning we found grizzly tracks plentiful again, but no trackers visible. Five miles on, Tamarack Flat, with camp-fires yet smoldering, but no campers in sight. Two mules and the welcome boundary-stake terminated the long way, and brought us to the very verge of fruition—the first dawn of Yosemite itself. Through thirty speechless minutes we stood still, then plunged down the steep and dangerous trail, where one would rather walk than ride, and in many spots would rather creep than walk. But the sight was grand—too grand for speech. Such magnificence of rocks, such stupendousness of cliffs, far outstripped conception, and staggered even perception itself. You disbelieve your own eyes. Judgment fails you. You have to reconstruct it.

—⌇—

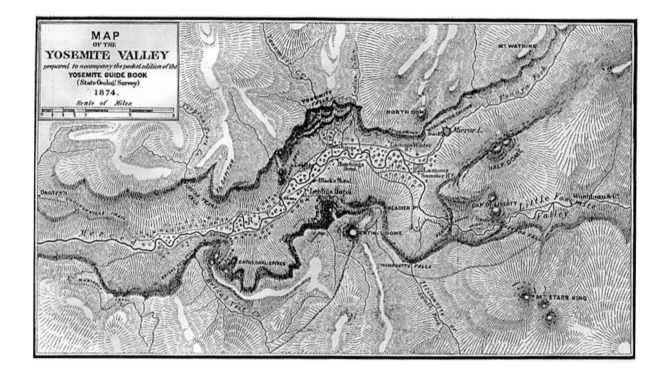

Comparison serves you little for you have no adequate standard with which to compare, or by which to estimate the rock-mountains before you. They are like nothing else but themselves. Look at that tree. Elsewhere you would call it lofty. It must be a hundred and fifty feet high, and yet that wall of rock behind rises straight up to twenty times its height above it. Look again, now turn away; shut eyes and think. Slowly you begin to "even yourself" to the stupendous scale of the gigantic shapes around, though yet trembling and staggering under the overwhelming immensity pouring in upon you from around and above. A score of cataracts in solid rock, Niagaras in stone, pile upon each other and pour over each other in absolutely painful tremendousness. Solidified vastness; infinity petrified; the very buttresses of eternity, overpower the sight and benumb the brain. The works of God crush out the words of man. We can only silently uncover and stand speechless, with abated breath.

Presently the reaction: Nature rallies, and in sheer self-preservation projects herself and her familiar standards upon the surrounding marvels, and denies their grandeur. "I don't believe that Pohono Fall is three hundred feet high," I exclaimed, as the Bridal Veil gracefully waves its fleecy films athwart the tawny gray of the mammoth cliff beneath. "Poh! Oh no!" instantly responded Leukos, presumptuously discharging his vile pun point-blank into the face of the confronting grandeur; and contemptuously adding, "What could a bride be made of, anyway, to want such a veil as that?" "Why, Maid of the Mist, to be sure," I answered, suddenly betrayed to a like degradation, and thus actually goaded to the very verge of atrocity by the utter torpidity of his

unappreciative soul. By sudden, mutual impulse, and in speechless desperation, we silently clasped each other's icy palm, unblenchingly gazed into each other's calm and steadfast eye, to reassure our anxious souls that reason had not wholly fled from our distracted globes, heaved huge sighs of deep relief that seemed to rend our very being, slowly recovered our customary speech, and sadly resumed our walk. It was a narrow escape. Even now, we shudder as we recall it.

We do not propose to describe the valley. He who has seen it, listens quietly to the most enthusiastic accounts of the most widely traveled tourists, simply answering, with a calm, superior smile, "Ah! But you should see Yosemite."

The valley hotels were both good. Both charge the same rate: from $3 to $3.50 a day, according to rooms. When guests stay a week or longer, the charges are less. A third hotel, Black's, probably as good as the others, has been opened since our visit.[9]

Five o'clock on Tuesday morning, July 6th, set us fairly forth upon the homeward stretch. Eight miles from Liedig's [*sic*] brought us to Inspiration Point, whence, looking back with one inclusive sweep, we photographed forever upon our longing memories the multitudinous grandeurs and the unspeakable beauties of that incomparable valley. Then, quickly closing our eyes, that the spiritual operator within might the more surely fix the marvelous psychograph, we slowly betook ourselves to the forest trail toward Clarke's[10] and Mariposa. The trail is plain and easy, and, after a leisurely day's walk of about thirty miles, brought us safely out to Clarke's about sundown. Fortunately Mr. Clarke himself, for whom the ranch is named—one of the State Commissioners in charge of the Mariposa Big Trees and the Yosemite Valley—was at home, and, the next day, kindly accompanied us to and through the famous Big Tree Grove.

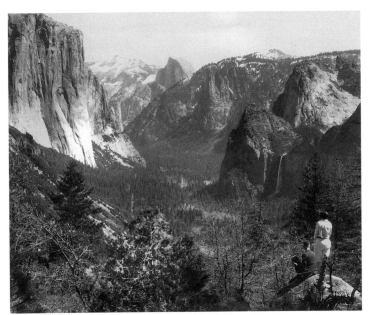

This early photograph from near the original Inspiration Point shows the scene of which Knowlton said: "We photographed forever upon our longing memories the multitudinous grandeurs and the unspeakable beauties of that incomparable valley." (Author's collection)

—⁂—

The Big Trees of California are a kind of redwood. Nine groves have been found. The most noted are the Calaveras Grove, and this, the Mariposa Grove, in the county of the same name, near the South Fork of the Merced River. The most direct way, and the best way for ordinary travelers, lies through Mariposa, whence a good carriage-road runs by the way of White & Hatch's to the house or hotel of Galen Clarke, situated at the head of carriage navigation and at the foot of the mountain-trail, thence

—⁂—

direct to Yosemite itself.¹¹ It is common for parties, going into or coming out from the valley, to lie over one day at Clarke's, and visit the Big Trees, only five miles away, and readily reached in a single hour's ride over an easy trail. Mr. Clarke has surveyed, and now nearly completed, a good carriage-road to the cabin, in the very midst of the trees; so that ladies unable to walk, or to keep a horse between themselves and the ground, can ride to the heart of the grove.

On Wednesday, July 7th, 1869, we walked through this grove, and carefully measured its largest trees, under the guidance and with the assistance of Mr. Clarke himself— the State Commissioner for the care of these groves and of the Yosemite Valley.

On the same day, and with the same unapproachable guide, we climbed to the summit of Mount Raymond,¹² where we quenched our thirst from deep snowbanks, nine thousand feet above the sea, and whence we looked forth upon the very "treasures of the snow," where a thousand square leagues of it lay glistening unmelted beneath the noonday rays of the midsummer sun.

Next day we walked twenty-four miles to Mariposa, dining at White & Hatch's, half-way between. Waking early Friday morning, we betook ourselves to thinking on three simple propositions: 1st. That ninety-two miles yet lay between our beds and Stockton. 2d. That the last boat of the week left Stockton the next day at noon. 3d. That our three thousand pupils began their schools again on Monday, and would hardly excuse their Principals for tardiness on the very first morning of the new school-year. Which considerations compelled us, for simple lack of time, to end our walk at Mariposa, and hasten thence, by stage, through Hornitos to Stockton. After a wearisome ride of twenty-one consecutive hours, we reached that city in good time for the noon boat, which duly landed us in San Francisco a few minutes before midnight. Thus, twelve and one-third days of time, and less than $30 each of coin, completed the summer-vacation walk of the most thoroughly satisfied brace of pedestrians who ever attempted Yosemite on foot.

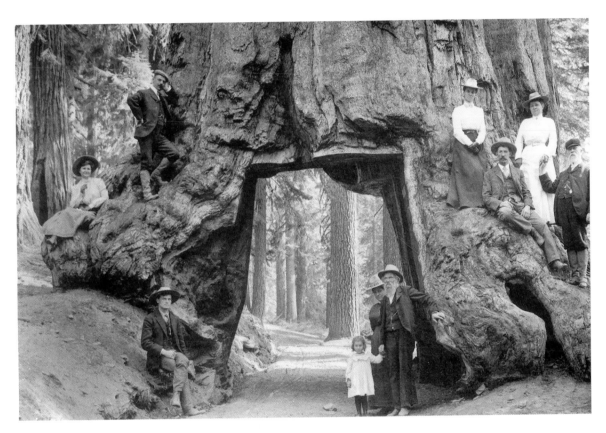

Galen Clark, standing in the foreground by the child, often guided tourists to the Mariposa Grove of Big Trees, which he and Milton Mann discovered in 1857. The tunnel was carved through the tree in 1881 as a tourist attraction. The Wawona Tunnel Tree, as it was known, became the most photographed tree in the world before it fell during the heavy winter of 1968-69.

CHAPTER IV
NOTES AND REFERENCES

—⚬—

1. Josiah Dwight Whitney, State Geologist, *The Yosemite Guide-Book* (Sacramento: Geological Survey of California, 1869). By act of Congress, approved June 30, 1864, Yosemite Valley and the Mariposa Grove of Big Trees were granted by the federal government to the state of California. Upon accepting this grant, the legislature authorized the state geologist to explore the region and furnish a full description of the country. Two books resulted from the geological survey's work: *The Yosemite Book* (1868), which was limited to 250 copies, and *The Yosemite Guide-Book* (cited above), a more generally circulated description of Yosemite Valley and the adjacent Sierra Nevada. Knowlton's reference here is to the second book.

2. "We rode to Stockton" undoubtedly means that Knowlton and his friend took the overnight steamship trip from San Francisco up the San Joaquin River to the Stockton pier—the route used by most Yosemite-bound tourists at the time.

3. The hotel was actually called the Garrett House, not the "Granite House."

4. In the mid-1850s Alexander Kirkwood came to Big Oak Flat from his native Scotland with his bride, Margaret Dick Kirkwood. By 1858 the couple had established a wayside inn called Kirkwood's at the top of a steep 20-percent grade on the road to Big Oak Flat, one mile to the east. After Kirkwood died in the early 1870s, his widow married Kentucky-born William C. Priest in 1875 and changed the name of the hotel to Priest's Station (see note 5, Chapter I).

5. Since the late 1870s, First Garrote has been known as Groveland.

6. George E. Sprague, an engineer and surveyor by trade, lived on an isolated ranch beyond Second Garrote in the 1860s. In the summer he and his wife furnished lodging and meals to travelers on the Big Oak Flat route. Beginning in 1868, Sprague was for many years one of the principals in the construction and operation of the Big Oak Flat Road.

7. Hardin's Ranch was at the end of the Big Oak Flat Road, then under construction, when Knowlton arrived on July 2, 1869. Here a short, eccentric Englishman named James "Little Johnny" Hardin single-handedly operated a small sawmill and provided rustic tourist facilities for a number of years. The name was later corrupted to the present-day Harden Flat, just off Highway 120.

8. In 1869 Louis D. Gobin, owner of a 3,000-acre ranch in the foothills east of Knight's Ferry, began running sheep and cattle in the meadows surrounding Crane Flat

—⚬—

during the summer months. He and his wife Ann soon erected a rough log shanty and began offering meals and beds to travelers. Once the Big Oak Flat Road was completed all the way to Yosemite Valley in 1874, Gobin's business greatly declined, although the hotel remained open on a limited basis into the early 1900s.

9. In the summer of 1869, the two Valley hotels were known as the Hutchings House and Leidig's Hotel. From 1866 through 1869, Fred Leidig leased Alexander Black's former Lower Hotel building, calling it "Leidig's." In late 1869, Black evicted Leidig, who then built his own hotel a short distance away, opening in the season of 1870. Black constructed and personally operated a new hotel the same summer on the location of his old "Lower Hotel," which was largely razed.

10. The name is correctly spelled Clark. As previously mentioned, Galen Clark was an important figure in the Yosemite area for more than a half-century. He served twenty-four years as guardian of the state grant in two separate terms.

11. The new carriage road from Mariposa was completed to Clark's Station at present Wawona in July, 1870.

12. Mount Raymond, elevation 8,546 feet, a few miles east of the Mariposa Grove, was named in honor of Israel Ward Raymond (1811-1887) by the California Geological Survey. Raymond played a leading role in the establishment of the Yosemite Grant by the federal government in 1864.

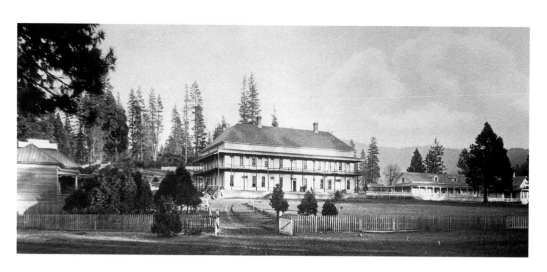

Thomas Hill's Studio, the Main Hotel, Clark's Cottage, and the Manager's Cottage are pictured in this photograph by I.W. Taber made in 1886. The Wawona Hotel was described by many as "the grandest hotel in all of the Sierra." (Author's collection)

V

TO THE YOSEMITE VALLEY
by Susie C. Clark

Entering from the north, the Coulterville and Big Oak Flat Roads reached Yosemite Valley within a month of each other in the early summer of 1874. The Mariposa Road through present Wawona followed a year later from the south. After eighteen years of saddletrain travel, it had finally become possible for tourists to ride all the way from the nearest rail connections to their Valley hotels without mounting a horse or mule.

The scenic Wawona Road attracted the majority of Yosemite travelers from the start. The proximity of the famed Mariposa Grove, the unmatched first view of the Valley from New Inspiration Point, and (after 1878) the comfortable accommodations at the spacious Wawona Hotel could not be equaled by the two northern routes.

Beginning in 1886, the Wawona Road became even more popular with the completion of a branch railroad running twenty-two miles into the Sierra foothills off the Southern Pacific mainline at Berenda, thirty miles north of Fresno. This reduced the stage ride to Yosemite Valley from more than ninety miles to only sixty-one. Pullman cars from San Francisco and Los Angeles were routed over the new spur to a terminus called Raymond during the night. The following morning, tourists boarded the horse stages of the Yosemite Stage & Turnpike Company for the grueling all-day ride over Chowchilla Mountain to the Wawona Hotel, where they spent the night in comparative luxury. The next afternoon, the begrimed travelers were deposited at their Valley hotels.

Susie C. Clark, a New England writer of some note, journeyed across the United States by transcontinental railroad from Boston to California in the early spring of 1890. One of the highlights of her lengthy excursion was a trip to Yosemite Valley and back via the Raymond route. The following detailed, often humorous description of Ms. Clark's experience is reprinted from Chapters VIII and IX of her book, The Round Trip: From the Hub to the Golden Gate *(Boston: Lee and Shepard Publishers, 1890). The account contains some of the best contemporary information available about travel during the lusty, dusty era when horse stages ruled the Yosemite roads.*

To spend a season in California and not visit the valley of the Yo Semite is to witness the play of Hamlet with the omission of its title-role. To go or not to go? That was the question. It was an easy matter to decide, the trip seemed an easy thing to accomplish; the very affable agent of the Berenda route thither, at his office in San Francisco, makes of the journey by his glowing rhetoric an enjoyable pastime, he smooths every difficulty from the tourist's path, allows him to select the seat he prefers in the photographed stagecoach with its three spans of prancing steeds. He paints the scenery with masterly touch, portrays the unprecedented grandeur of the waterfalls after this winter of unusual severity, unblushingly declares the existence of new cataracts, and other remarkable features never known before in the memory of man, with other fictions of his fertile imagination which leaves our previous hesitancy and doubt as to the advisibility of so early a visit to the mountains without a leg to stand upon. If he had asked us to sign away our entire fortune we should not have demurred, and certainly the mere bagatelle of the ticket's compensation was quite a condescension for him to relieve us of. The stage fare is only $50.00 for the round trip (a slight discount being made to Raymond and Whitcomb proteges): $7.00 more pays the railway transit to and from the stage terminus, and as to the slight incidentals—but let us herewith draw a veil.

The start is made from San Francisco at sunset on the Los Angeles train which drops us at midnight on the side track at Berenda. The cessation of motion, with the noise and jerks of disconnecting the car arouses the traveler who after waiting an hour or two for something else to happen, lapses into uneasy slumber only to be again disturbed by the arrival of the engine which, with the customary snorting and explosive puffs, attaches itself to take us to Raymond, by which the recent growth of the railroad, the stage route has been cheated of twenty miles.

From this point the tourist sacrifices all further personal choice of his comfort, or hours of rest and action. He is no longer a free agent. Foreordination and predestination absolute are the rules of his being, the only authority recognized in this locality being the supreme omnipotence of the Yo Semite Stage & Turnpike Company. It arranges his downsitting and uprising and regulates his thoughts afar off, for no bullet is ever sped from the muzzle of a gun with surer aim, more unswerving purpose, or with much greater speed than the tourist is propelled in and out of that Valley. Especially is this true of the rising hour. Accordingly we must be up and dressed after our broken night, with every toilet detail finished by 6 A.M., when the matutinal appetite must also be on deck ready for action, for it is thenceforth necessary that the traveler eat his dollar's worth at irregularly appointed intervals.

Breakfast over, the *four*-horse stage drives up to receive its load and we eye it askance. We have heard from friends who had made prior visits to the Valley, of the comfortable stages used on this route, of their canopied tops that serve as much needed screen from the rays of California's sun. Early specimens of the genus stage may have been comfortable; we occupied one of a newer style. The canopy was there, in fact we made capital acquaintance with it at certain points in our ride quite as often as we tested the springs (?) of the seat. The stage had four seats, the backseat upholstered with enameled-cloth all the way down; the middle seat with its minimum amount of

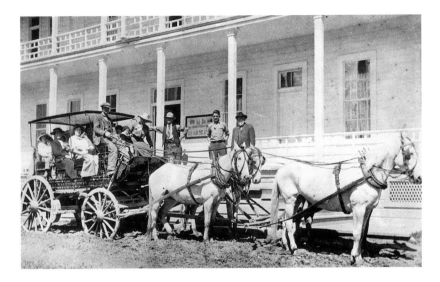

The Raymond-Yosemite Valley stage is shown here in front
of the Wawona Hotel about the time of Ms. Clark's visit.

—※—

motion; the front seat, easier than the rear but with a restricted range of view; and the
much coveted seat with the driver, hot and sunny but having the advantage of a
widespread landscape and the most entertaining conversation of the charioteer who is
always a stuffed encyclopaedia of information, of stories and legends, some of them
perhaps having a shadowy foundation of truth. The drivers are as a rule careful,
obliging and goodnatured, all rules of course being marked by exceptions. The horses
are well fed, well taken care of, are in good flesh despite their daily toil, and are
frequently changed; they are all duly and appropriately christened, Typesetter,
Piledriver and Charley Ross being members of our team. The coaches—perhaps we
mentioned these vehicles before but the subject is a fertile one—are strong and
thoroughly well-made in their running gear, comfort being sacrificed here to
substantiality, but their interior is crude, cheaply finished, with no provision even of
straps suspended from its roof to steady the helpless passenger. A good smart Yankee
would renovate these vehicles with many comfortable and helpful appurtenances. At
present, they are most unbearable even when standing still.

But we load into this commodious lumberwagon and set forth by a narrow circuitous
mountain road, in an atmosphere radiant and redolent with purity, brilliancy and all
sweet odors. The breath of the hills is blown to us, the blossoms of the valley waft
upward their fragrance. Gradually we rise, winding round sloping hillsides, from
whose vantage ground we look down into verdant fields and charming valleys.
Unfamiliar wild flowers line the roadside with many old favorites including several
varieties of lupine, blue and pink and white, large bushes of the wild white lilac, and of
the buckeye bearing aloft their white panicles as do our horse chestnuts at home; and
here also we made our first acquaintance with the mariposa lily, or butterfly tulip, in

—※—

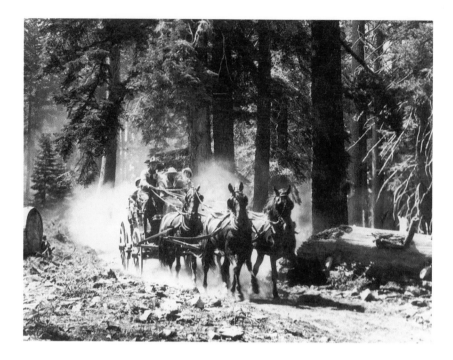

The stage ride down Chowchilla Mountain was so rough that
author Clark said she "will advise everybody to postpone their visit
to the Yo Semite until they get to heaven and can look down."

white and lemon and deep yellow with large brown spots on each of the three leaves
forming its fragile cup.

On and still on we wind, soon gaining glimpses of snow-capped mountains so far
away on the horizon that we cannot conceive our course includes those distant heights,
that any route not threaded by steam could include so long a trip, but we learn that
those misty summits comprise only the first "divide"; the first night of our journey
being spent beyond those snowy peaks. At our second change of horses, we pass a
quartz mill where the mountain has been tunneled for the precious ore and the fair
face of nature has been frequently scarred by the prospector's spade as he for a time
follows a false lead. We pass the lively Fresno River and also an artificial log-flume
built on tall trellises for 55 miles to convey timber from the wooded hills down to
marketable levels.[2] Some of the hills which we pass have a peculiar topography being
ridged lengthwise by a series of undulating swells, divided by parallel hollows about 20
feet apart, as if the hillside had once served as a leviathan graveyard. At our fourth
change of horses—Grant's Sulphur Springs—we stop to enjoy the generous lunch
awaiting us, and a short rest.

Our afternoon's task is to climb by slow and painful degrees to the summit of
Chowchilla Peak, near which as we reach it, a wonderful view is obtained of the San

Joaquin Valley, (the light sedge grass giving it the appearance of a vast desert), of the Coast Range beyond, and of one little dark spot, so far away as to be almost invisible, which is pointed out as the Raymond we left—when? Can it be only this morning that we started, that but a half day has intervened between us and civilization, since the possibility was ours of occasionally looking upon a human habitation? But soon, nearer the height, we have a diverting novelty in the form of snow-drifts as high as the top of our coach, though the road-bed is bare.

The summit is reached joyfully, for now we begin the descent into the valley where our day's journey will end. But such a descent! The stage it seems is behind time, the driver's reputation must be preserved even at the expense of the necks or limbs of his passengers, and so the horses, breathless from their long hard pull, are given free rein, are not checked even at the murderous water-bars, or at the rough places where the wheels wallow in the soft mud to their hubs and the coach oscillates correspondingly. What matters it that the weary, worn, and sore human freight are thrown violently from side to side, or against the roof, until their necks are well-nigh dislocated, what if their breath is beaten from their bodies by severe and incessant jouncing, until the only thought of the hour is the promise of salvation to them who *endure unto the end*, with also the firm resolution if life is spared to reach home (which now seems doubtful) that we will advise everybody to postpone their visit to the Yo Semite until they get to heaven and can look down. We recall the remark of a dear lady who declared that she was never so near her Maker as when in the Valley. We certainly never expect to be so near Purgatory again as when on our journey thither. Other friends had assured us that the surrounding scenery as we rode along would make us forget every discomfort. The scenery is doubtless grand hereabouts, the monarchs of this forest among the noblest specimens we have ever seen. We remember gaining fugitive glimpses, as we came down to the seat occasionally, of several trees reeling and swaying across our spasmodic vision like tipsy revelers, but we neglected to speak of them, knowing our tongues would be severed in the attempt. We shall long remember the descent of Chowchilla as a needless outrage perpetrated upon innocent victims.[3] But our discomforts safely ended at nightfall when we drove up to the Wawona Hotel to receive the courteous attention, the cleanly rooms, and excellent table always provided by those excellent men, the Washburn brothers. The wonder is to find anything to eat so far away from market, or depot.

The sleep of the righteous visits every pillow at Wawona, a baptism of health and strength likewise descends as if from the mountains that surround on every side this cuplike vale, the alchemy of this rare elixir sweetens the sorely-tried disposition of the disgusted traveler and (as a natural consequence) restores to freshness the storm-tossed frame. What luxury it would be to lie in the early dew-fragrant dawn and let the restfulness and calm soak into one's consciousness but—we are bought with a price and our purchasers are *pro-tem.* our masters. We must therefore be awakened at five, breakfast at six, and with dread and trembling mount another coach for the drive thence into the Valley where we are due at 2 P.M. Will it, at last, we wonder compensate us for all this misery? We have ceased to ask regarding distances, for miles mean nothing here. Among the fictions of the trip is the statement that the stage ride

I. W. Taber took this picture along the Wawona Road in 1887. It is titled "General View of Yosemite Valley from Inspiration Point." (Author's collection)

—⚬—

is one of sixty miles. Invert the six to approach nearer the truth. And how do they measure miles in these mountains? We learned this from our truthful (?) driver. A pack of greyhounds are loosed and allowed to run until they drop dead from exhaustion, at which point the first mile stake is placed, a fact which no visitor to the Valley can ever gainsay.

But the ride of today is a great improvement upon that of yesterday. Our driver is careful and compassionate, the road is in better condition and the scenery is much grander and less monotonous. Following for a time the south fork of the Merced, we begin to wind about and ascend the last barrier that lies between us and our goal, reaching a height of over 6,000 feet, gaining along the way, from Lookout and other points, wild grand views of deep gorges far, far below us through which the winding river cuts its way between the mountains. Around us is an almost unbroken forest of sugar pine, and yellow pine with its alligator-leather trunk, while every dead branch and twig is swathed with moss of living green, so kindly does our mother Nature heal every wound, and transform death into beautiful life. Light growths are few, though it is still early for flowers and ferns, but we see an occasional specimen of the wonderful crimson snow-plant. The manzanita hangs full of pinkish waxen blossoms, it branches so twisted and crooked that every bush is searched in vain for a stem straight enough to serve as a cane. This wood works up very beautifully for ornamental veneering.

At our second change of horses about noon, we take the opportunity to run down the road ahead of the coach for a restful change, we inspect the watering trough, the road,

—⚬—

the trees which here allow such restricted range of view, when, speeding on lest the fresh horses overtake us too soon, suddenly, as if the planet had dropped from beneath our feet, the trees disappeared on our right, the sky rolled itself backward like a scroll to give space to a vast army of peaks and domes and mountains of granite, a double row, the verdant gorge between, and we realized with a gasp that was almost pain, that we were looking upon the marvelous Valley. We stood on [New] Inspiration Point.

Majestic, solemn, awesome in the massive sweep of its gigantic contours, in the wonderful stillness, the immovable calm that broods above it, as if here it was that God rested "on the seventh day from all that He had created and made, the heavens and all the host of them." There are some moments, some experiences that come to us which are untranslatable in any human speech, and this was one. Stirred to the innermost depths of our being, where reverence and humility stand side by side, we resolved, realizing our impotence, never to commit the sacrilege of attempting to describe this masterpiece of the Creator, and we never will. Let it be written alone on tables of stone.

How long we might have stood there had not the coach arrived to pick us up, we cannot say. The driver kindly dissected the grand spectacle for us, letting us down easily to ordinary levels of thought and feeling, and explained that the massive buttress on the left was El Capitan; on our right were the Three Graces, in the farthest distance, the North, and South or Half-Dome, as if our stunned and bewildered consciousness could take cognizance of compass-points; over there was Cloud's Rest, so-called because clouds often hover upon it when other spots in the Valley are clear. The white ribbon let down several hundred feet from one of

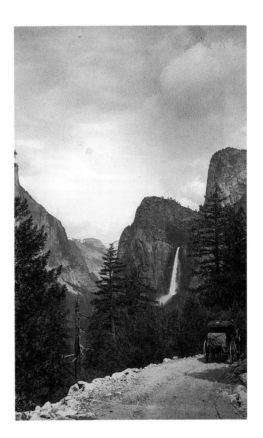

Descending the Wawona Road into Yosemite Valley about 1890. (Author's collection)

—⚏—

these heights is we learn Bridalveil Fall, only to be enjoyed from a nearer view where its misty drapery floats airily and gracefully as the wayward zephyrs frolic with its gossamer meshes, and especially when the afternoon sunbeams, flooding it with their prismatic dyes, make of it a vision of loveliness too fair for earth. A smaller fall high up on the mountain's face is disrespectfully known as "The Widow's Tear" because, being supplied by melting snows, it dries up in six weeks.[4] On the opposite side of the Cañon are Cascade Falls, and the delicate pleasing Ribbon Fall, such airs and graces do

—⚏—

these stern ledges assume, such beauty do they clothe themselves withal. This lightness tempers somewhat, as does this minute particularization of these varied features, the deep emotion, the painful tension which the sublimity and grandeur of the scene inspires. Never again do we expect to read so clearly in terrestrial language the mighty impress of the Almighty Hand, the tracing of the Infinite Sculptor. It was

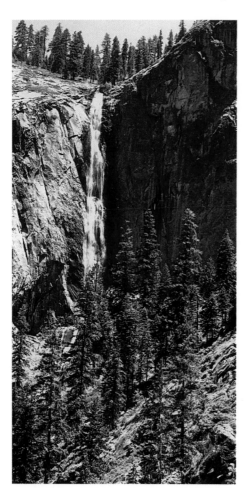

"The Widow's Tears" mentioned by author Clark is now known as Silver Strand Fall. (Conrad Knoll photograph)

—ɷ—

with a positive relief at last that we turned our backs upon the mighty gorge and followed the serpentine trail down the last steep slope to the Valley's floor. A seven-mile drive still lay between us and the hospitable doors of the Stoneman House, but with its genial proprietor, Mr. J. J. Cook, as fellow-passenger, we were naturally in no undue haste to end our journey.

What a drive it was! What a revelation of our own insignificance, of our utter incapacity to take in such immensity with the faintest approach to due appreciation, or the folly of attempting to adapt our little two-foot rule of measurement to this gigantic scale. For instance, the driver pauses to point out a minute green twig just above a heap of talus, on the side of El Capitan. After careful inspection we at last discern something which might serve as a doll's Christmas tree, whereupon we are asked to believe that by actual measurement the tree is 125 feet high. We stop again to admire the grand old Sentinel, the majestic Cathedral Spires, pausing longest at the foot of the Bridalveil whose cool breath suggested to the Indian the baleful influence of an evil spirit, Po-ho-no, which name was given to this vision of indescribable beauty. The cataract feeds three streams which here seek the river, the beautiful river of Mercy (Merced) which, flowing through its entire length, is not the least charm of the Valley. Indeed were it not for this clear, limpid stream, and the beautiful green meadows with which it surrounds itself, the rich growth which it feeds, the austere and massive grandeur of the Valley would be well-nigh unbearable.

As it is, the first mental impression and one not lifted until the second day, is that of overwhelming sadness. The burden of isolation oppresses us. Heaven itself is not so far away as are we from every mundane interest or association. If these stern gray ledges

—ɷ—

The Stoneman House, the state's grand new hotel in Yosemite Valley, is shown here soon after it opened in 1888. (Author's collection)

were not *quite* so high, if their magnificent proportions could be toned down just a little nearer our comprehension, if the cataracts were less tremendous in their daring leaps.

Ah verily, what is man that Thou are mindful of Him, or the son of man that Thou visitest him with such revelation of Thy matchless glory, Thy Creative Majesty?

IN THE VALLEY—The location of the pretty Stoneman House, built by the State, is well chosen.[5] Almost the entire length of the Valley must be threaded to reach it, and when there, the visitor is surrounded by most attractive points of interest. On the left, Glacier Point rises 7,000 feet; on the right are the Royal Arches and Washington Tower, while the grand Yo Semite Fall makes its three gigantic leaps apparently but a stone's throw distant, although if one wishes to make nearer acquaintance with its varied phases of beauty and decides to stroll down the road until he comes opposite to this mighty cataract, he will continue to stroll for some time and approach no nearer to its base than when it proved such an irresistable magnet from his seat on the hotel veranda. A beautiful view can be obtained from the rear of Barnard's hotel,[6] and at this point the majestic roar, with the bomb-like explosions peculiar to this fall are constantly heard. It is a fascination of which one never tires to watch this ceaseless motion, this never-wearied activity, which approaches the Goethean ideal of "unhasting, unresting," for in all these cataracts and cascades there is a suggestion of laziness in their descent, until one remembers the unrealistic height which their waters

span. They seem in no hurry to leave these solemn heights and join the chattering river, they indulge in little side-escapades, shoot out a rocket here and there, take time to clothe their watery sheen with concealing mists and vapors, but the great heart within beats in true rhythm to Nature's mighty laws, and the keynote of their grand symphony is in ascending scale like the "Hallelujah" chorus: "For the Lord God Omnipotent reigneth."

On the hither side of the Yo Semite is the Indian Cañon up whose steep sides and rocky debris the Yo Semite tribe escaped when pursued by the Mariposa recruits in May, 1851,[7] on the occasion of the first entrance to the Valley of any white man. The depth of this defile, its rough and jagged features are wonderfully revealed when the morning sun manages to smuggle a few of his gilded beams into the wild gorge. In winter the Valley's allowance of sunlight is but two hours long. The name Yo Semite, as is well known, signifies a great grizzly bear, not from any resemblance which the gorge bears to this animal, but because of a successful encounter in prehistoric times, of a young chief with one of these monsters, whom the athlete slew, though unarmed, save with the dead limb of a tree. To perpetuate this deed of prowess, the name of the animal was given as a title of honor to the young brave, was transmitted to his children, and thus eventually to the tribe which occupied the Valley when it was discovered.[8]

Speaking of sunrises reminds every Valley visitor at once of the marvelous experience at Mirror lake. It is doubtful if anywhere on the planet there is a lovelier spot than this crystal sheet of liquid purity, at the base of Mt. Watkins especially in the early dawn when it is still, as the Indians called it, a "sleeping water," and not a ripple has as yet disturbed its dreamless rest. It is a visible expression of

"The peace at the heart of Nature,
The light that is not of day."

Clear-cut as a cameo, the mighty peeks penetrate these watery depths, 4,000 to 6,000 feet below us, their scars and clefts repeating themselves with such startling vividness that effects not noticeable through the medium of the air are plainly discerned through the limpid wave. Some discolorations on a crag a mile perhaps above us are a train of cars and engine in that illusive nether world. A clothes-line with the washing all hung out so early in the morning, is the most realistic thing imaginable. Entranced we stand on the margin of this crystal floor watching the marvelous picture, noting its soft contrasts of light and shade play about those gigantic cliffs beneath that wondrous distant sky; we gaze longingly as an exiled Peri might stand outside the gates of Paradise, and yearn in vain to enter. But now a wonderful scene opens. A faint flush glorifies the world at our feet, a golden dart pierces its azure calm, another of roseate hue thrills and warms the scene, gilding each massive outline with a luminous halo, and now quicker and faster the radiant beams shoot over the slopes of yon granite mountain in the nadir realm, until the first curve of the great luminary is seen, higher and higher it mounts till the sun has gloriously risen and dimmed that enchanted world whose denizens we were. Again and again, as we seek a new position on the mirror's edge, is the scene repeated, while we resolutely turn the back of our head toward the zenith where one generally looks for solar displays, and gaze down,

"Pike," a longtime Yosemite guide, stands at right
with a party of tourists about to see the local sights.

—⁓—

thousands of feet, it would seem, into the visionary and unreal. How like it is to our
mortal experience, where the reflection is all that our dull eyes discern, where we turn
constantly away from the real and the true, the life that is spirit, for the glamour of its
shadow, which must ever fade from our perception, as the Sun of Truth dawns upon
our spiritual consciousness.

The trips which can be made in the Valley are legion, and a week, at least, should be
devoted to them, though in this connection it might be well to advise the tourist to
"put money in his purse," for to quote from a witty commentator, "Man brought
nothing into this world, and if he stays long in the Yo Semite Valley, it is certain he
will carry nothing out." All that the hotels and stage co. do not get, the wily livery
man will. The trails to Glacier Point, Eagle Peak and Upper Yo Semite are at the date
of our early visit not yet open (the emphatic ten-days-old statement of the affable
agent in San Francisco to the contrary, notwithstanding), but the most satisfactory and
beautiful of all the excursions (we speak necessarily from limited experience) is that to
Vernal and Nevada Falls.

The trail from Tiss-sa-ack bridge along Grizzly Peak, though hewn out of solid rock,
is almost wide enough for a carriage, and yet our well-trained steed prefers a footing so
close to the edge that we seem to hang far over the steep precipice, but we do not
demur. We remember that he knows far more about his business than we ever shall,
and that if we are born to be hung or drowned we cannot possibly suffer harm on this
winding stair. The Mohammedan fatalism would really be an excellent traveling
companion, or rather that *perfect* trust which casteth our *every* fear and never under
any circumstances knows a shadow of trembling. In entering this grand cañon, we
leave the Yo Semite behind, having Glacier Point one of its boundaries, at our back,
the beautiful little Illilouette Fall high up toward the clouds on our right, towering

—⁓—

ledges on either side, and at their base the main current of the Merced River struggling over its rocky bed. We soon approach a bridge spanning the noisy stream and turning to cross it, that vision of beauty, the Vernal Fall bursts suddenly, dazzlingly upon our view in the near distance, and takes our most ardent expectancy by surprise. Gladly we dismount at Register Rock and clamber over and around moist boulders to approach nearer the foot of this crystal torrent as far as Lady Franklin Rock to which point, in 1863, that lady was carried in a chair. The Fall is not very hospitable in its welcome, it will not allow us to reach the "ladders" by which it is possible to climb to its highest level, for it drenches us and drives us back by a spray so dense as to be blinding and almost suffocating.

Returning, we again mount and thread a zig-zag trail backward, forward, and upward, this equestrian procession forming three or four tiers across the face of the mountain, each row being far above the next lower, when at last reaching the highest point, in a twinkling that takes one's breath away, the marvelous grandeur of the Nevada Fall, and that handsome dome, the Cap of Liberty, bursts at once upon our enraptured gaze. There is something very imposing about this isolated height. It is unique and singular, both in shape and characteristics. It appeals strongly to the appreciation of the beholder, and aroused in us a far deeper emotion than did El Capitan; we could never tire of studying its grand proportions. We turn aside here to visit the top of the Vernal Fall, where leaning over a huge stone buttress, a natural balustrade, we look down its wide expanse of emerald water and diamond spray tangled and broken into rainbows far below, a scene never to be forgotten. The river here is wonderful in its mad haste, its cascades and whorls and wild upward tossings, its Silver Aprons and Emerald Pools. We followed the course upward, our beauty-loving hearts unable to absorb fast enough the wealth of varied grandeur that surrounds us, until we reach the foot of Nevada Fall, an appropriate climax to a day on which we have touched tide-water of rarest enjoyment.

The "Alpine House," pictured soon after construction in 1870, was the original building at Snow's La Casa Nevada resort, erected at the base of beautiful Nevada Fall. (Author's collection)

Beautiful beyond suggestion, grandest, most fascinating object in all the Valley, we could sit for hours and watch its changeful flow. The whole Merced River here falls over a mountain wall 617 feet high,[9] although the water seems less to fall than to resolve itself into froth and foam, and float out upon the air, to wave silvery banners here and there and then pierce them with flying rockets, so rarely repeating the same effects that the observer appreciates the appropriateness of the Indian title, which means "meandering," though this is the last word one would expect to find in a savage vocabulary.

A house has sprung up here (Snow's),[10] we hardly know how, unless it grew through

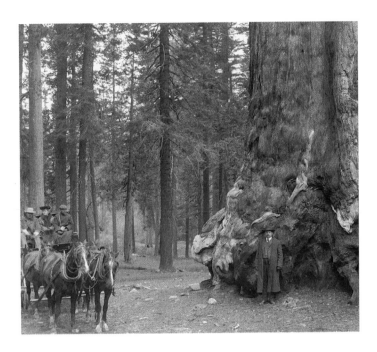

A group of tourists poses at the base of the Grizzly
Giant in the Mariposa Grove of Big Trees about 1890.

a new law of evolution peculiar to this land of wonders. It was not yet open, so we spread our lunch upon an adjacent rock and quaffed nectar from the clouds, feasting our eyes meanwhile (the truest refreshment) on that lovely veil of silver sheen, suspended across the mountain's breast, on whose enchanting grace we hope sometime again to look.

Morning in the Yo Semite Valley! What a rare experience to return from the realm of spirit and take up again our physical instrument amid such sublimity of environment, to renew once more our conscious connection with the material world within the hidden fastnesses of these eternal hills! What a solemn hour it should prove, what new baptism it must impart, to strengthen the soul for all sterner duties which await us! *Is* the hour such? Alas, no; repose is an unknown quantity in this region. Even the border land of dream-life is invaded by the hurrying and scurrying of departing guests, and when at last our time arrives, the porter's prompt reveille upon our door puts a speedy end to contemplation, or devotion. At no stage of the Yo Semite trip is an early departure less imperative than for the drive from the Stoneman House to Wawona, consequently with strange masculine inconsistency, the hour fixed by the "Turnpike Medes and Persians" is the earliest of them all. At quarter of six, with valises packed, and breakfast bolted, our four-horse team (Star and Keno, Girl and Sullivan, who lacks as yet the diamond belt of his godfather) stand pawing the ground at the door. We mount and hurry down the Valley, striving to impress indelibly upon

The size of a big tree is clearly evident in this 1880s photograph.

—※—

our memories its every feature, we pass from its portals, climb again to the summit, jounce down the other side, and reach Wawona at one. The mid-day repast is immediately served and without a moment's opportunity even for customary ablutions, we are loaded into an open vehicle, far easier than the stage, however, and are driven away to the Mariposa Grove of Big Trees, a spot we have longed to visit, but the Frost King having prolonged his reign to this unprecedented date, the snow still lies too deep for the customary drive through the excavated heart of the living tree, Wawona. The Grizzly Giant, claimed to be the largest tree in the world, is 33 feet in diameter and nearly 100 in circumference.[11] Standing against its mammoth proportions the plumpest person in our party looked a child, this being the only way to assist the eye to a true measurement and realization of the tree's enormous size.

These *Sequoia gigantea* are a slightly different species from the redwood of the Santa Cruz region, which are classified as the *Sequoia sempervirens*. Their generic name was chosen to perpetuate the memory of Sequoyah, a Cherokee chieftain of remarkably advanced mind, he having invented an alphabet of eighty-six characters that his tribe might have a written language, the system being still in use. Our national heroes are duly remembered in the christening of the grove, with some of our scientists and poets. One tree known as the Telescope, allows a range of vision 125 feet upwards, its hollow trunk having been burned out, but sap enough still flows through the shell to support foliage. Many of the trees are thus marked by the ravages of fire. The grove is not composed wholly of these giant trees, the growth being chiefly of different

—※—

varieties of pine, whose size elsewhere would seem worthy of note, and the showy white blossoms of the dogwood are also plentiful.

The succeeding night is spent at Wawona, a place with attractions of its own, the beautiful Chil-noo-al-na Falls being nearby, with other pleasant mountain excursions. The studio of Thomas Hill located here is an interesting place to visit, its gallery of art-treasures being freely open to all. The return journey to Raymond held less of the terrors which beset our entrance to this mountain pass, for the road had been put in excellent order by the faithful efforts of the road commissioners aided by the warm dry breath of old Sol. But he was a little too ardent in his glances that afternoon. The heat for many long hours was intolerable, we had a foretaste of the dust which smothers the tourist of a later date, and when at twilight the Raymond inn dawned upon our horizon, with some real Pullman cars awaiting us nearby, the sentiment of the party could only vent itself in the devout doxology "Praise God from whom all blessings flow."

One of the most graceful things ever said of the Yo Semite was inscribed on the hotel register by James Vick, whose name is enshrined in the heart of all flower-lovers the country over. "The road to Yo Semite, like the way of life, is narrow and difficult, but the end, like the end of a well-spent life, is glorious beyond the highest anticipation." But far more practical is the declaration of Hon. Thomas Scott of the Penn. Central R.R. "If my business interests lay upon this coast, I would build a railroad to this truly marvelous valley within one year from this date."

This truly is the need of the hour. The "marvelous valley" is too far away. Candor compels us to confess (for we "cannot tell a lie") that the trip thither is the most inhuman experience in the world. With a railroad built even halfway to its ponderous doors, the Cañon of the Great Grizzly Bear must long remain the Mecca of every traveler, the shrine at which all devotees of Nature will reverently bow.

CHAPTER V
NOTES AND REFERENCES

—w—

1. The San Joaquin Valley & Yosemite Railroad, known as the "Raymond Branch," was incorporated on February 15, 1886, by the Southern Pacific Company to provide an easier route to Yosemite Valley. The twenty-two-mile spur terminated at a new town called Raymond, in honor of Walter Raymond, a principal in the popular Raymond-Whitcomb tours (Ms. Clark was a patron). The first train arrived on May 14, 1886. The Yosemite Stage & Turnpike Company soon built corrals, barns, cottages, and a large hotel at Raymond, which remained the principal point of access to Yosemite until the completion of the Yosemite Valley Railroad in 1907. The Raymond Branch actually reduced the stage ride by more than thirty miles, rather than twenty, as Ms. Clark wrongly states.

2. The fifty-two-mile lumber (not log) flume described by Ms. Clark was owned by the Madera Flume and Trading Company. It was used to convey rough-cut boards from the mountain sawmills near Soquel to the finishing mill at Madera in the San Joaquin Valley. The story of this company and its successor operation is contained in Hank Johnston, *Thunder in the Mountains* (Fish Camp: Stauffer Publishing, 1995).

3. Not long after Ms. Clark's trip in 1890, a new road was finished bypassing Chowchilla Mountain by way of Miami Lodge. The change added six miles to the journey, but made it much less rigorous.

4. The fall has been known since about 1927 as Silver Strand Fall, elevation 1,170 feet. Fed by a small stream called Meadow Brook, it quickly runs dry once the snow has melted. Early stage drivers often told tourists that the fall lasted only a few weeks—hence the irreverent name, "Widow's Tears."

5. The Stoneman House was constructed by the state of California in 1886-88 (opened in 1888) to furnish better hotel accommodations in Yosemite Valley. Although a big improvement over the existing stopping places, the Stoneman House was shoddily built with unsafe chimneys. It burned to the ground on August 24, 1896, in one of the worst structural fires in Yosemite history. For information about early Yosemite hotels, see Hank Johnston, *The Yosemite Grant, 1864-1906: A Pictorial History* (Yosemite: Yosemite Association, 1995).

6. Besides the Stoneman House, Barnard's Yosemite Falls Hotel was the only other stopping place in Yosemite Valley at the time of Ms. Clark's visit in 1890. Barnard's came into existence in 1859 as the Upper Hotel. It was subsequently known as the Hutchings House, Coulter & Murphy's, Barnard's, and after 1893, the Sentinel Hotel.

—w—

7. The Mariposa Battalion first entered Yosemite Valley on March 27, 1851, rather than in May, as Ms. Clark asserts.

8. According to Chief Tenieya, the name "Yosemite," which means grizzly bear in most Mivok dialects, was chosen by his followers because they were experts at killing the grizzlies that inhabited their mountain home, and the name struck fear in their enemies. An account of the Yosemite Indians' history appears in Elizabeth Godfrey, *Yosemite Indians*, rev. ed. (Yosemite: Yosemite Association, 1977).

9. Nevada Fall is 594 feet high. (As the reader must have noticed by now, estimates of the heights of the Yosemite waterfalls vary widely throughout these accounts.)

10. F. Albert Snow (1825-1891) and wife Emily Topple Snow (1823-1889) packed in enough material to erect a barn-like hotel building grandiosely called the "Alpine House" at the base of Nevada Fall in 1870 under lease from the state. During the next six years they enlarged their operation into a small complex known as La Casa Nevada (the Snow house). The Snows ran their rustic inn for twenty seasons, until Mrs. Snow's death in 1889. A successor proprietor continued the business in 1890 and '91, after which the buildings were abandoned.

11. The Grizzly Giant stands 209 feet tall, with a diameter of 20.3 feet at a height 10 feet above the mean base. Although the Grizzly Giant is a most impressive sight, as least two dozen other sequoia trees in California contain a larger volume of wood.

Crossing the hot, dusty San Joaquin Valley was the most toilsome part of the cavalry's annual march from the Presidio to Yosemite. (Author's collection)

VI

UNCLE SAM'S TROOPERS IN
THE NATIONAL PARKS OF CALIFORNIA
by Captain John A. Lockwood, U.S.A.

Although Congress ceded Yosemite Valley to California in 1864 as a state park, it was not until 1890 that the surrounding territory was also set aside from private appropriation as a great national park totaling 1,457 square miles. The act establishing the park required that the federal government preserve the natural scenery and wildlife in the new enclave, but no immediate provisions were made for carrying out this obligation.

Lacking appropriations and personnel, the Secretary of the Interior called on the army for assistance, and a troop of cavalry was assigned to patrol the reserved area, the commanding officer serving as acting superintendent. The precedent for using soldiers to protect the park had been established five years earlier in Yellowstone.

Beginning in May, 1891, and continuing until July, 1914, (except for the war year of 1898 when civilian agents and volunteers assumed the responsibility), federal troops were on duty every summer in Yosemite National Park. After California re-ceded Yosemite Valley and the Mariposa Grove of Big Trees to the federal government in 1906, the army took over protection of those two crucial areas as well.

The most urgent problem confronting the acting superintendent and his forces was trespass. Sheep owners and cattlemen had long been accustomed to grazing their animals on lands now denied them, and they did not propose to abdicate their pastures without a fight. In some instances, park boundaries were uncertain, and in others so remote as to be beyond the reach of patrols—or so the violators thought. But they learned soon enough that the cavalry not only meant business, it was quite competent to handle the situation.

As time went on, fewer and fewer attempts at illegal grazing were made in the reserved area. Other trespasses such as mining, logging, and hunting were similarly curbed. During the last decade of army administration, soldiers spent most of their time fighting fires, searching for lost parties, planting fish, collecting tolls, and guiding tourists. On July 14, 1914, civilian rangers working for the Department of Interior took control of Yosemite National Park, bringing to an end the army's twenty-four-year regime.

The article that follows appeared in the Overland Monthly *of March, 1899. Although author Captain John A. Lockwood gives no specific dates in his story, the events he describes must have taken place in the summer of 1896. That was the*

only year prior to 1903 that two companies of troops were assigned to both Yosemite and Sequoia parks, as Lockwood recounts. All other years only one troop patrolled each park.

Certain material about Sequoia National Park has been deleted from Lockwood's text. A very few additional facts taken from a brief story by James F. J. Archibald, "A Cavalry March to the Yosemite," The Illustrated American (November, 1896) have been added.

The United States Cavalry provided a much-needed service during those formative years when national parks were still a new concept. The dedicated officers and men who resolutely fulfilled their obligations helped to preserve a valuable part of our national heritage for all Americans to enjoy.

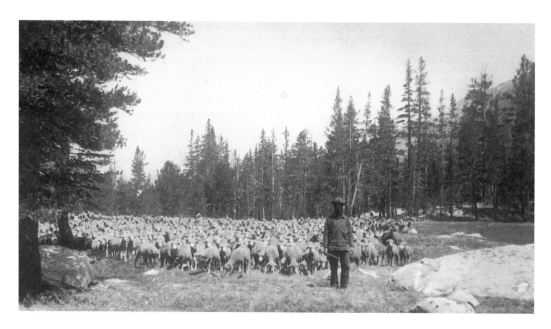

Before the army drove them out, sheep swarmed over the Sierra high country every summer for more than thirty years. Here a shepherd leads his flock into Tuolumne Meadows.

It was an ideal morning in early May at the Presidio of San Francisco. The four troops of cavalry, two hundred odd men strong, had been ordered some weeks before to move out on this particular day toward their summer camps, over three hundred miles away, in Southeastern California. The day arrived and men and horses were ready.

There was no unusual hurry or confusion. All had been carefully planned and arranged for beforehand. "Boots and saddles" and "The Assembly" were sounded, and the men saddled, bridled, led out, and prepared to mount, as if for drill, instead of for an

absence of six or seven months. The pack mules were more refractory. It took a packer no less skilled in handling a mule than the veteran, Dennis, who learned his art under General Crook, to drive the disgusted little animals with their unusual burdens to the rear of the column and keep them there. The last farewells were said, the band, whose sweet strains the cavalrymen would not hear again for many months, played "The Girl I Left Behind Me," the troopers swung into the saddle, and the command was off.

Winding up the hilly road which flanks the reservation on the east, the column moved along at a walk. First the field and staff, then "K" troop, with its coal-black horses, the troop officers riding at ease at the head, then the three other troops, followed by a dozen or more four-mule army wagons with their white canvas covers, and finally the troublesome pack mules, followed and hurried along by the packers, civilians, and soldiers. After the column crossed the reservation line, it passed through and across Golden Gate Park, and when that beautiful pleasure-ground had been left in the distance, the troop dogs began to make their appearance. They had been lying low and avoiding arrest and the pound and the other bugbears of dogdom, until, danger apparently passed, the dogs' best friend, the trooper, turned his charge loose.

At the end of the first hour, the command halted and saddle-blankets were smoothed out and cinches tightened. In the next half-hour the word "Trot" was given, and the column swung into the steady regulation gait of eight miles an hour. Soon another stop for water and so on, with alternating gaits, rested by occasional halts, and cheered by the novelty of changing scenes after a winter in garrison. At one o'clock the command was finally halted until the next morning, and went into camp. The first day's match is always a short one. Thus day followed day.

The troops moved along the magnificent county road which stretches from San Francisco past the handsome villas of Burlingame, San Mateo, Santa Clara, and San Jose, and then on down the picturesque Santa Clara Valley. At Gilroy the column swung off to the southeast, and two days later, the soldiers went through Pacheco Pass, over one of the earliest roads across the Santa Clara Mountains, into the valley of the San Joaquin. The trail winds back and forth as it climbs the mountain, and in some places you can see below over five different parts of the squadron on the trail directly under you as they crawl up the steep inclines like a

Beginning as a young lieutenant in 1895, Colonel Harry Coupland Benson was a terror to all wrong-doers in Yosemite National Park.

—⁂—

A trooper waters his horse at an irrigating canal in the San Joaquin Valley. (Author's collection)

—⁂—

—⁂—

mighty serpent; then down into the San Joaquin Valley, which took five days to cross. It is always dusty, hot, and alkaline, or else it is muddy, cold, and rainy, according to the seasons.

The dogs before mentioned as not visible at all when we left the Presidio, by the time we were three or four days out, had taken unto themselves other dogs, and when the sun-baked plain of the San Joaquin was reached, the original number had certainly doubled—all different in appearance, in bark, and in capacity to hunt; for they chased, with tireless activity, the fleet cottontail or the frightened jack rabbit, disturbed in their haunts by the march of our column. It was rare indeed when a dog actually caught a rabbit; but when that did happen, the men became as excited as the dogs over the great event.

At Madera, on the eastern side of the San Joaquin Valley, the cavalry column divided; two troops headed toward the Yosemite National Park, and two were bound farther south, toward the General Grant and Sequoia Parks.[1]

A trooper stands at picket duty in Yosemite in 1896.

—ᴡ—

Briefly, the objective had in view in sending troops to the national parks of California is to preserve the magnificent timber found in those parks, as well as the vegetation, and to protect the fish and game. The first summer spent by the Fourth Cavalry in the parks was in 1891. That was, perhaps, the hardest summer's work, as the trails were new or nearly obliterated, and the sheepherders and cattlemen had yet to learn that the soldiers were there to drive out the vandals and destroyers. So energetic did one lieutenant become, and such a terror to the wrong-doer, that to this day it is said the angry mother in that region reduces her obstreperous offspring to subjection by shouting, "Be good, or Benson will catch you!"[2]

The permanent camp of the cavalry troops detailed to patrol the Yosemite reservation is about a mile from the well-known Wawona Hotel, on the north side of the Merced River. The famous Yosemite Valley is some twenty-five miles beyond this camp, and the celebrated Wawona grove of big trees[3] is some eight miles distant from the camp.

The old story of bad roads repeats itself in the less traveled districts of the Yosemite reservation. The Tioga road has been neglected until it is no longer passable for wagons; yet if kept in repair, this road would connect with others, over which could be made a tour of the park extending over one hundred miles, and diversified with some of the finest scenery in the world. This road, such as it is, leads to the summit, almost, of the Sierra—Tioga Pass—at an altitude of nine thousand feet. There are easy trails from here to two other elevations— Mount Lyell on the summit of the grand Sierra, and Mount Conness, whence the ascent to the very summit can be reached in ten miles over a good saddle trail. Here the altitude is thirteen thousand feet, and commands one of the grandest views in the world. Both the main road and the side trails lead through a veritable Eden, and

—ᴡ—

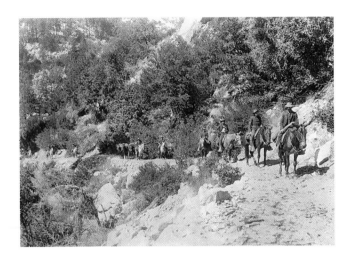

A cavalry troop on patrol in the Yosemite back country.

should, by all means, be kept in good condition. The panorama unfolded along this Tioga wagon road defies description. It skirts Mount Hoffmann and Mount Dana. It touches the shore of Lake Tenaya, with the ten-lake country within easy distance. Countless wild and beautiful mountain torrents cross its path in the wake of glacial meadows. It is skirted by plateaus of luxuriant grasses and multi-hued flowers. The original cost of this road is roughly estimated to have been sixty thousand dollars. A few hundred dollars a year would keep it in good repair.

In the Yosemite, some of the troopers are constantly kept busy in removing the marks of the tourist and the advertiser. All appeals to public favor which can be made on bits of wood and tin and muslin are destroyed almost as soon as created. It is not so easy to obliterate the defacements made on rocks and trees. But while sometimes the tourist is a vandal, more often he appreciates the work of the blue-coats, and is glad to meet the soldierly looking columns of troopers riding over the trails, or to come across them in out-of-the-way nooks and mountain recesses. At times, a prospector, a legacy from '49, will follow the trail of a soldier detail and usually manages to overtake "Uncle Sam's" boys just at mealtime; for the wearer of brass buttons is proverbially generous and ready to share his last crust with the hungry wayfarer.

The troopers, at times, are obliged to arrest all sorts and conditions of men. A well-known society man of San Francisco, in search of novel sensations, made a trip through the Yosemite Park alone, on foot. As his garb and mode of progression was unusual, he found himself much annoyed by inquisitive tourists, whom he met, stopping him and asking him questions; so he pretended to be deaf and dumb, and replied to all questions by using the deaf and dumb alphabet as he strode along. A well-meaning trooper endeavored to arrest him as a lunatic at large, when the member of the four hundred suddenly found his voice.

The principal object of the troops is to protect the National Park from encroachments of the herds of cattle and sheep that graze in the park and thereby destroy its natural

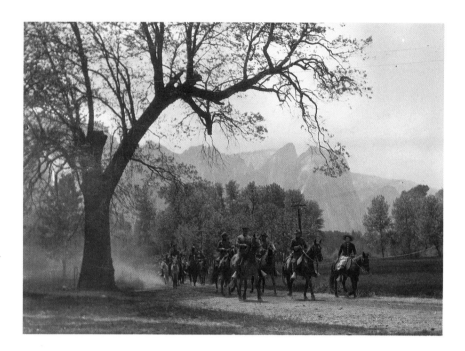

After California re-ceded Yosemite Valley and the Mariposa Grove of Big Trees
to the federal government in 1906, the army took over the administration and
protection of those two areas along with the rest of the national park. A group
of soldiers is shown here patrolling the south-side road in Yosemite Valley.

beauty. For more than thirty years the sheepherders have been grazing their stock
within the precincts of this reservation, until now they deem it their right and resort to
all manner of tricks to elude the federal forces.[4]

Late in September, the sheep, having been driven back down to the plains, and the
tourist no longer finding life in the mountains desirable, the work of the soldier-
guardians of the park becomes much easier, and by November of each year, the guard
is withdrawn for the winter, snow and ice forming a no less impenetrable barrier to
depredators than the bayonets of the soldiers. When the snow finally arrives in
earnest, the soldiers return to the Presidio of San Francisco for a well-earned winter of
garrison duty.

CHAPTER VI
NOTES AND REFERENCES

—⧞—

1. The overland march described by Lockwood from the Presidio to Madera was made annually from 1891 to 1899 (except for 1898). Beginning in 1900, troops and their supplies and equipment were transported by railroad to Madera, at which point they assembled for the march to Yosemite.

2. Colonel Harry Coupland Benson (1857-1924) was the most notable of the sixteen regular army officers who served as acting superintendents of Yosemite during the cavalry's administration. Benson began as a young lieutenant in 1895 and was continuously in the mountains almost every ensuing summer until 1905 when he became acting superintendent, a position he held through 1909.

3. This reference is, of course, to the Mariposa Grove of Big Trees, which remained under state jurisdiction until 1906.

4. Sheepherders started grazing their flocks in the Sierra after the great California drought of 1864 forced them into the high country to obtain feed and water for their animals. The shepherds originally ignored the army's warnings to desist from grazing their flocks in the park once they discovered that the only penalty authorized was expulsion. In 1895 the army instituted an inspired new plan. When sheep were captured anywhere in the reserved area, they were gathered together, mixing the brands, and then driven out of the park over the nearest boundary. Meanwhile, the shepherds themselves were escorted on a fatiguing journey of several days and ejected at a far distant point. By the time the shepherds recovered their scattered flocks, the season's profits were gone. It took only a few such experiences before sheep owners stopped the incursions.

—⧞—

Anton Veith is the only person known to have
photographed an actual horse-stage holdup as it
was happening. (Author's collection)

VII

DEPOSITION OF ANTON G. VEITH

(Taken on the 16th of August, 1905, at 2:30 p.m.)
Mariposa Grove of Big Trees
State of California, County of Mariposa

On August 15, 1905, about three miles above the foothill town of Ahwahnee, the Yosemite-bound stage from Raymond was held up by a lone highwayman carrying a shotgun and pistol. It was not an extraordinary occurrence, considering that there were a number of similar incidents during the years of Yosemite stage travel, with this exception: the bandit permitted Anton G. Veith, one of the passengers, to snap two pictures of the robbery in progress. Only one came out, but that print exists today as perhaps the only authentic photograph ever taken of a real stagecoach holdup as it was actually happening.

The following day, Veith, the Austrian Consul at Milwaukee and editor of an agricultural newspaper, gave a deposition concerning the holdup to the Mariposa County Justice of the Peace at the Mariposa Grove of Big Trees. It was attested to and signed by his fellow passengers, with the exception of two men who were employed by the Yosemite Stage & Turnpike Company, owners of the stage line.

Sixteen hours after the holdup, the Mariposa County sheriff and a five-man posse took up the bandit's trail. Horse tracks were found leading away from the scene, but they soon disappeared in the hard, dry ground. Despite a reward of $700 for his arrest and conviction, the lone highwayman was never apprehended.

Many years later, Will Sell, himself a former stage driver as well as a long-time Yosemite hotel operator, found an unusual block of wood at the edge of his ranch, which was near the robbery site. The block was shaped like a horse's hoof, with a strip of leather attached on top to fit over a man's shoe. The clever imitation (now in the Yosemite Museum) was doubtless one of a pair the bandit used to mislead pursuers into thinking he had employed a horse in his getaway.

For further accounts of Yosemite stage holdups, see Hank Johnston, Yosemite's Yesterdays *(Yosemite: Flying Spur Press, 1989), 20-35.*

Q. What is your name.

A. Anton G. Veith

Q. You were a passenger on the stage that left Raymond on August 15, 1905, at seven o'clock in the morning.

A. Yes, sir.

Q. Make a statement of what took place after you left Ahwahnee.

A. About 2 p.m. I was surprised to see the stage stopping suddenly and the two men in front getting off. I heard someone telling the other man to get off too. Then I saw a man standing on the left side of the stage. He had a kind of a duster over his whole body, only two holes cut out for the eyes, tan old soft hat on his head, a shotgun hanging on a string in his hands, the hand on the trigger, the muzzle of the gun covered with a black cloth about 10-12 inches long. As I looked at him he said: "You come down too." I thought the whole thing a joke and hesitated, but he said come down now quick, and I got off the stage and walked slowly toward him. He said join the other ones, who were already standing about 12-15 feet to the left in front of the stage, one behind the other, and I walked in that direction. Then I turned round and saw him training a revolver (a small one, commonly called a bulldog) and walking toward us. He said to the two laborers/blacksmiths of the Yosemite Stage & Turnpike Company that he would not molest them, then he ordered Mr. G. H. Molzen of Lakefront Park, Altoona, Pa., to give up his money, put his hand in his pocket and took out his pocketbook, then ordered him to open the inner coat and went through his pockets, Mr. Molzen protesting all the time. The highwayman went with his left hand through the pockets, holding in his right hand the revolver ready to fire. He stood to the right and in front of Mr. Molzen and I stood behind. Then he stepped behind me, put his left hand in my left pants pocket and had his right hand with the revolver in my right side. He took out a few papers and my match box, and then he went through my right pocket, took my pocketbook, and then went through my right pocket in my coat and took my other pocketbook. He went through my pockets in my vest, took out what I had and took my watch. Now I said to him: "What use can you make with this old watch?" (Though it was a gold watch.) He returned it after some consideration, but kept the watch of Mr. Molzen. Then he turned toward the stage. I told him that he can take the money, but that the papers I had in my pocketbook are of no use to him, and he threw the pocketbook in the wagon box. Then he stepped on the wagon wheel, revolver always ready, and asked the ladies to put up their money. I looked round and asked Mr. Molzen in German if he wants to help me, I will jump at him, but Mr. Molzen refused, saying he would not risk it. Then I asked the two blacksmiths if they will help me. They flatly refused, saying I should keep quiet because I might get a bullet, but I said if you help I risk it, I take my chance. They refused. I turned round several times, and Mr. Robber, pointing his revolver at me, said: "Don't turn round always or I will help you." But I could not help looking round and seeing him relieving the ladies of what they had. He did not handle them roughly except Miss A. Fullerton, whom he saw hiding some money in her Kodak. He felt through her shirtwaist, but could not find anything. She told him she had only checks and was willing to write one out for "bearer." He said he cannot use checks. He also returned all the tickets.

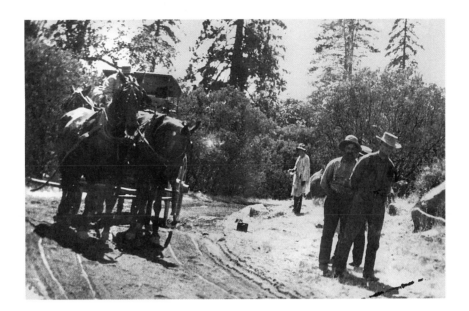

Driver Walter Farnsworth and the six women passengers remain with the stage
(at left), the two laborers of the Yosemite Stage & Turnpike Company stand at
the right with passenger G. H. Molzen just behind in straw hat, while the bandit
stands, gun in hand, in the center for Anton Veith's photograph.

—ᴡ—

Then he asked the driver if he has a weapon. The driver said: "If I had, you can be sure
I had use for it." During all this time, the other men stood like sentinels. I must say I
felt ashamed, four men and one robber holding them in check. Then he ordered us to
go on the stage. Now I said: "You have my money and I want a favor of you." He said:
"What is it?" I said I want to take a snapshot of the whole scene. He said all right,
nobody would recognize him anyhow. I went to the wagon, took my Kodak, and then
took two snapshots. Then he went back a few feet, and I boarded the stage, and he said
go on. I asked the driver to stop, turned round, jumped off, and said to the robber: "You
have in my pocketbook a chain with a little cross, and I want to have it. It is worthless
to you." He took a number of pocketbooks out of his pocket, which he had in front of
his duster, emptied them and threw them toward me. I picked them up. I said: "Will
you not return the watches of the ladies too?" He threw two watches to me. Then I
went back to the stage. He followed, took a satchel out of the wagon, went through it,
and as he did not find anything, came up again to Miss A. Fullerton and said in an
angry voice: "You must have more money." He went again through her satchel, not
finding anything. He jumped down and said to go ahead. He stood for a while, his gun
always ready, and then moved his hand toward us to go. Now I asked everyone what
they have lost:

I had in one pocketbook a $10 bill, and in the other one a $20 bill, and I believe

—ᴡ—

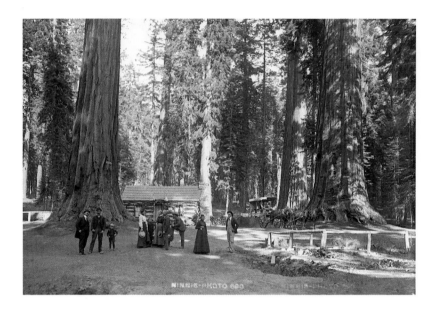

The American flags next to the door of the Mariposa Grove cabin signify that some sort of official business is being conducted. The sign by the door says: "B. M. Leitch, Justice of the Peace." He was the man who took Anton Veith's deposition. (Author's collection)

another $10. I lost $30-$40. I had in my inner vest pocket one other pocketbook with $40, which he did not find.

Mr. G. H. Molzen lost about $30, consisting of one $10 gold piece and one $20 bill and some small change, among it one Prussian silver thaler with the head of King Frederick Williams the Fourth, 1860, some Swedish, Danish, and French money in copper and nickel.

Miss E. Fullerton of Laithbridge, Mass. $1.16 in silver.

Miss A. Fullerton $15 (one $10 bill and one $5 bill) and one silver dollar and some small change.

Miss Helen E. Wilkinson of Philadelphia, Pa., $2 silver and some small change.

Mrs. J. Wilkinson $1 bill and some small change.

Miss A. Wilkinson 60 cents (50 cents and 10).

Mrs. Beithen Taurer of Austria had no money with her.

Anton G. Veith
Subscribed and sworn to
before me this 16th day of
August, 1905.
B. M. Leitch
Justice of the Peace, Twp. 5, Mariposa Co., Cal.

We the undersigned passengers on the stage have heard the foregoing deposition read and made by A. G. Veith and hereby certify that the same is true and correct.

Subscribed and sworn to
before me this 16th day of
August, 1905.

Sgd./B. M. Leitch
Justice of the Peace
Twp. 5, Mariposa Co., Cal.

Sgd./Helen E. Wilkinson
Ethel E. Fullerton
Anna A. Wilkinson
Mrs. James Wilkinson
G. H. Molzen
Mrs. Bert Taurer
Annie O. Fullerton

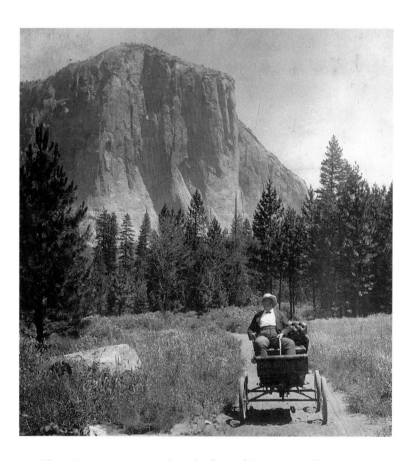

Oliver Lippincott motors along the floor of Yosemite Valley in his
Locomobile in late June, 1900, the first automobile to reach the Valley.

VIII

THE FIRST AUTOMOBILE TO REACH YOSEMITE
by Oliver Lippincott

At 6:45 a.m., Saturday morning, June 23, 1900, the flimsy little automobile that was to become famous as the first motor vehicle to enter Yosemite Valley left the foothill town of Raymond on a historic journey. The car was a brand-new Locomobile, produced by the Locomobile Company of Bridgeport, Connecticut, one of the first major manufacturers of automobiles in the United States. A standard production model, the car weighed 640 pounds empty, and 850 pounds when the gasoline and water tanks were full. A two-cylinder, ten-horsepower steam engine, running at 150 pounds of pressure, powered the vehicle. Top speed was forty miles an hour.

The unlikely owner of the Locomobile, a three-hundred-pound barrel of a man named Oliver Lippincott, operated the Art Photo Co. in Los Angeles. He was accompanied by Edward E. Russell, a thirty-six-year-old machine shop owner, who squeezed into the narrow space beside the corpulent Lippincott as the hired driver-mechanic. According to Russell, Lippincott hoped to generate interest in both Yosemite, where he ran a photographic shop the following two summers (1901-02), and the Locomobile Company, which used a Lippincott picture of the Yosemite car in its advertising for several years.

Lippincott shipped his Locomobile by express freight over the Southern Pacific Railroad, a Lippincott photography customer, from Los Angeles to Fresno. When he wanted to add extra cans containing gasoline, wary train officials at first refused to accept them. Thinking quickly, Lippincott said it was only "developer," and the shipment was permitted. After the Locomobile was unloaded at Fresno, Lippincott and Russell drove on to Raymond where they spent the night of June 22 in a hotel.

Early the next morning, the intrepid motorists set out on their unprecedented journey across the mountains to Yosemite Valley. Lippincott described the circumstances of the trip in a lengthy article that appeared a month later in the San Francisco Chronicle *(Sunday Supplement) of July 22, 1900. Additional information presented in this introduction and the reference notes was taken from an interview by Ralph Anderson, Yosemite Information Specialist, with Edward Russell in 1951 (copy in the Yosemite Research Library).*

Lippincott and Russell remained in Yosemite Valley for at least two weeks (Russell remembered the fourth of July fireworks at the Sentinel Hotel), "keeping the roads of the Valley warm," as Lippincott put it. The only serious mechanical

failure of the trip occurred when a strut rod on the Locomobile gave way. Russell quickly solved the problem by brazing the rod back together using brass from an opium box provided by a local Chinese. Gasoline, which cost $1.25 a gallon—a considerable sum at the time—was brought in by stage from Madera as needed.

Lippincott seems to have had a propensity for being the first to drive automobiles to famous out-of-the-way places. In January, 1902, accompanied by a guide and two other passengers, he reached the rim of the Grand Canyon in a Toledo Eight-horse steam car. Unlike Lippincott's uncomplicated Yosemite experience, the eighty-mile journey from the starting point of Flagstaff took five days in all, during which time the car broke down on three occasions and then ran out of gas. The return trip to Flagstaff was accomplished in just seven hours.

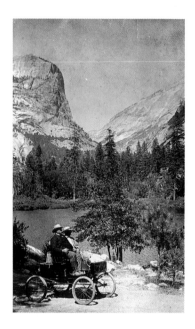

Lippincott and his companion, Edward E. Russell, drove up the road to Mirror Lake without difficulty.

—⁓—

Seated in our locomobile, my friend Russel[1] and myself rode into the little town of Raymond, a recognized starting point for the Yosemite, and announced our intention of making a trip to the valley. The populace was visibly excited over this intelligence, gathering in groups to discuss the audacious proposition, while more than one crept stealthily up to examine the machine, barely visible in the dusk. The thing had a bad reputation for scaring horses, and before evening was over I received a dispatch from Wawona telling me to start out before any of the stages.

We respected this command and were up betimes Saturday morning,[2] but early as we rose the crowd was out before us and collected around the locomobile. Stage drivers who had handled the lines thirty years for Washburn Brothers, making the sharp turns and tight places in the road with a flourish and snap of the whip and shout to their horses, looked on in disapproval. One oldtimer in a linen duster and with a red bandanna tied jauntily around his head turned to me disdainfully.

"Gosh durn it!" he exclaimed. "You don't expect to make them hills between here and Yosemite in that little box, do you? We'll be coming right on after you to haul you up."

I thanked him kindly and proceeded with Russell's assistance to fix my engines for the trip. The hotel-keeper didn't fancy the thing, either, and showed no cordiality in allowing it standing room near his hotel. At 6:45 we left Raymond and proceeded for eight miles without any trouble, although we met all kinds of teams, but were just ascending a steep grade when, on rounding a turn, we came suddenly upon a four-horse freighter. I immediately stopped the locomobile, but the freighter was not under such perfect control, the machine being evidently as new to the wild-eyed driver as to the rearing and plunging horses. As soon as the man realized what the machine was actually meant for his eyes sunk back into their sockets and he yelled:

—⁓—

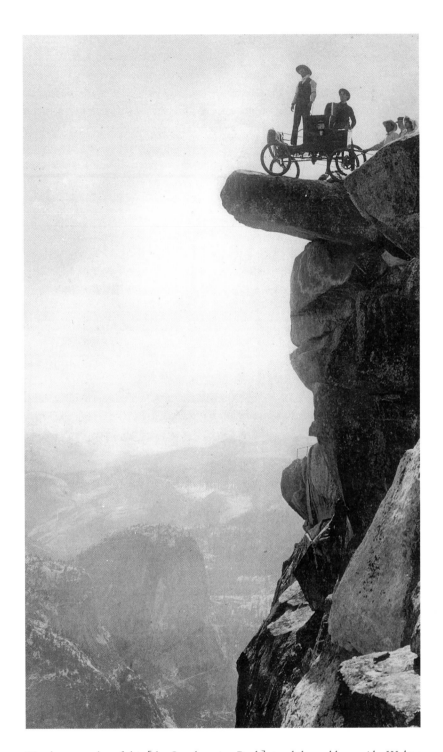

"At the very edge of this [the Overhanging Rock] stood the reckless guide, Walter Henesley, with one of his heels projecting over the valley…" Pushing the Locomobile out on the Overhanging Rock for photographs was a daring accomplishment, according to Lippincott. "It seemed ready to roll over at any moment," he said.

"What in ____ ____ do you want to bring such a nuisance up into this country for? You city people, with your contrivances are always making trouble."

I silently alighted, disentangled his lines, which had become slightly mixed, said a few mollifying words, and my irate friend and the still excited horses watched the locomobile draw up the steep grade at the rate of ten miles an hour. Now a four-horse stage makes the same grade at but three miles an hour, and the freighter, amazed and fascinated by the sight, held his team and watched us until we disappeared from sight.

At Grub Gulch we made our first stop, renewing our water supply for steam. This is

Lippincott drives the very first car through the Wawona Tunnel Tree in early July, 1900.

—⁂—

a typical California mining settlement, and in the early days bore the reputation of being a place where a fellow could always rake up enough dust for grub, hence the name. When the locomobile came puffing up the dusty road the hostler left his barn, and the little woman who sells cool drinks to dusty-throated tourists called to her husband to "Come out quick and see something which looks like two bicycles hitched together with a seat in the middle." People lined up along both sides of the road in front of the postoffice to survey us, and one old woman still in her blue kitchen apron, said:

"Oh, Abe, the world's coming to an end, sure when they begin to make things like that!"

I let them have a good look at the machinery, entertaining them for about three minutes, when we resumed our journey to Ahwahnee, the lunch station, without further incident. There we had to await the outcoming stage from Wawona. It had taken us exactly two hours to cover the road from Raymond to Ahwahnee, and from Ahwahnee to Wawona it took us three hours and eighteen minutes more.

Just beyond Ahwahnee, comes the longest, hardest climb on the whole Yosemite route, excepting, perhaps, Inspiration Point, coming out of the valley. This grade of nine miles, which it takes the stage coach three hours at best to make, with four sturdy horses, was climbed by the locomobile in less then an hour. The grade averages 10 per cent and seems never ending to the weary Yosemite traveler in the stage, as it is along the hottest part of the road. In the locomobile we found it quite cool and enjoyable, although I am, perhaps, not exactly the build of man calculated to go unscathed in the fierce heat of the sun along an almost treeless mountain side. Luckily our machine went fast enough to create a breeze of its own which tempered the air. Our actual running time from Raymond to Wawona was five hours and eighteen minutes. It takes the stage all day to cover this stretch of forty-four miles.

Wawona received us and our little machine with open arms. Everybody had heard that we were coming, and the porch was crowded with people when we rolled smoothly up to the platform without a rumble, and jumped lightly out, cool and

—⁂—

comfortable, with no crooks in our backs from jolting over the ruts in the road. Washburn Brothers were frankly interested in the machine and the trip, and the ladies were all delighted with the possibilities of revolution in mountain travel suggested by our modest conveyance, of which they were given a foretaste by taking seats in turn for a ride around the pretty circular drive in front of the hotel.

The thirty-mile run from Wawona to the Yosemite was made in exactly three hours, the little engine dashing down the curves of Inspiration point. At the entrance to the valley we came upon three Indians who had been fishing, and had only time to notice that one of them held his string of fish suspended in mid-air, wildly gesticulating to his companions. Probably the first stage which Henry Washburn brought into the valley some thirty years ago seemed just as strange a sight.

I have been charged with keeping the roads of the valley warm during the whole of my stay. Lady Woolsley was the locomobile's first guest, and the first woman who had the honor of riding a locomobile in the Yosemite. There were some advantages and some disadvantages connected with the propulsion of the machine amid the wilds of nature. At night in the valley the mere sight of the locomobile's two headlights and the sound of its shrill electric bell, were sufficient to secure it right of way of every other vehicle, for horses were willing to jump over the bank or climb a tree to make way for us. The records of speed made by the little box on wheels were quoted at many a campfire. The remarks of the Yosemite stage drivers, who one and all looked askance at this new fangled method of traveling, were sometimes ludicrous. One of them asked me where I kept my hay, and another declared that he wouldn't go steering that thing without a whip.

Henry Washburn, superintendent of the Yosemite Stage and Turnpike Company, who has made the handling of travel into the valley his life work, took a flying trip around the valley in the machine and was so interested in its movement that he afterward declared he hardly knew where he had been. He wanted to make further trial of it, and proposed to me to take it to Glacier point over a road, which is a steady climb for thirty miles to an altitude of over 7500 feet. This trip Mr. Washburn and Mr. Russell accomplished in five hours, but they did not reach the little hotel on the summit until long after dark, as they started out late in the afternoon. The Automobile Party, as it is now recorded in the register at Glacier point, anxiously awaited the arrival of the little box, as it was growing late and the precipices along the road are not the kind one would like to drop over accidentally. When the anxiety had reached its height, somewhere off in the darkness the sharp ring of the electric bell was heard, and soon the first locomobile in the world to climb such a height was beside the porch. The dining-room doors flew open and the whole population of Glacier point rushed out to receive the travelers. There was good cheer within and toasts were drunk to A. H. Washburn, introducer of the first stage into the Yosemite, and to Oliver Lippincott, the first locomotive driver.[3]

Nothing would do the next morning but that the locomobile must go out on the overhanging rock where only the most fearless and level-headed have ever dared to stand. The little machine was rolled out to the point, and then every one paused, looking at the machine and then at the rock. The general opinion was that it could not be done.

A. H. Washburn said nothing, but mounted the rock himself with a firm step and took observations, then, turning to the crowd, said from his elevated position:

"Now, I'm going to show you that it can be done, too."

He ordered one of the guides to bring him two stout ropes and some logs of wood; then called to his assistance the stout arms and trained muscles of "Babe" Burnett, Stanford's next year football captain, who was one of the Automobile party. Together with the other men of the party they succeeded in dragging the locomobile, only weighing 650 pounds, over the mound of rocks nearer and nearer the edge of the cliff. The women assembled on the rocks and buried their heads in their hands, horrified at the sight. I remember looking up once. There was the overhanging rock, which is

Edward E. Russell, who accompanied Lippincott into Yosemite Valley in June, 1900, was interviewed fifty-one years later by Ralph Anderson. He remembered the trip vividly, even after half a century. (Ralph Anderson photograph)

fairly suspended above the valley, excepting for one little corner, while below yawned an abyss of over 3500 feet. At the very edge of this stood the reckless guide, Walter Henesley, with one of his heels projecting over the valley, tugging away at the locomobile, which was inclined at such an angle that it seemed ready to roll over at any moment. Two inches less space and it would have gone plunging down into the valley. On the other side, Washburn and Burnett, both with ropes tied about their waists, sure to go with it if it should start; while others were lifting or bracing it in equally perilous positions. I firmly believe that if the machine had gone over every man of the party would have gone with it. At last it was out in a firm position, and we grouped ourselves around it, fairly hanging on with tooth and nail while the camera was adjusted. No picture was ever so long in being taken. I was sure I felt the rock shaking under me.

As we sat out on that cliff, on the very top of the world, as it seemed, looking at the people and then at the gigantic mountains, I had a realizing sense of what a very small thing man is, but my respect for my race grew as I reflected upon the wonders it can accomplish, scaling such heights without visible effort and merely by the aid of a little gasoline, some steam and inventive genius. The unassuming little machine on the edge of the cliff would probably inaugurate a new era in the mode of conveyance into the Yosemite. It was simply following out the laws of evolution, and the product of a higher civilization. But would not modern ideas and modern inventions, intruding into the heart of primeval nature, rob it of much of its charm? Yet there is only one Yosemite, I reasoned, now inaccessible to the majority of people, and if modern invention can bring it closer to the people the result must be beneficial. Some of the charm of western life must go. The stage driver, with his six horses and coach, can ill be spared, but cleanliness and comfort will be better subserved by swifter modes of travel. Whatever the new style of conveyance, it cannot detract from the sublimity of the great valley or lessen the majesty of the eternal hills.[4]

CHAPTER VIII
NOTES AND REFERENCES

—⚊—

1. Lippincott's companion's name was Edward E. Russell (not Russel). Russell said that he did almost all the driving except when Lippincott wanted to appear at the tiller of the car in some of the many photographs made during the journey.

2. Although Lippincott states that he departed from Raymond on a Saturday, he gives no further information. The date was actually June 23, 1900. Lippincott signed the Sentinel Hotel register (now in the Yosemite Museum) that night.

3. Russell said that Lippincott was afraid to drive the Locomobile to Glacier Point, so Russell and Henry Washburn made the trip while Lippincott followed by horse stage. Washburn was the superintendent of the Yosemite Stage & Turnpike Company and one of the most important men in Mariposa County at the time. According to Russell, the journey to Glacier Point took five hours because of the lower oxygen content in the air at successively higher elevations. The flame on the Locomobile's burners burned so low that it caused frequent overheating.

4. Lippincott provided no details of his anticlimactic return trip to Fresno, at which point the Locomobile was most likely shipped back to Los Angeles by rail. For a description of early automobile travel to Yosemite Valley, see Hank Johnston, *Yosemite's Yesterdays* (Yosemite: Flying Spur Press, 1989), 6-19.

—⚊—

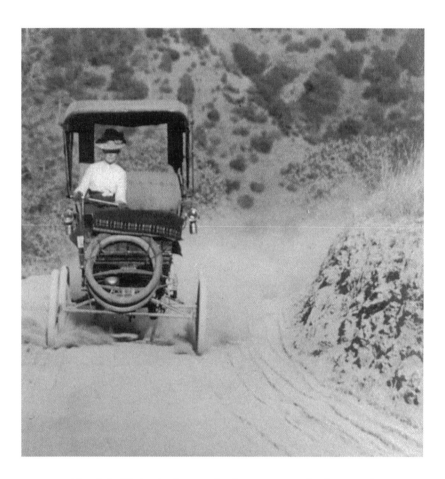

Mrs. Lola Clark wheels around a sharp curve on the dusty road
leading into Yosemite Valley. According to Dr. Clark,
Locomobiles were thirsty, requiring water every twenty miles.

IX

AUTOMOBILING IN THE YOSEMITE VALLEY

by Dr. William A. Clark

In July, 1901, Dr. William A. Clark, a San Leandro physician with a penchant for adventure, made a daring automobile trip from the Bay Area to Yosemite Valley and back in company with his resourceful wife Lola. Their vehicle was a 1900 model Locomobile very similar to Oliver Lippincott's machine (see Chapter VIII). The Clarks made the first leg of their journey from Oakland to Stockton by steamship, their Locomobile transported with them. Disembarking at Stockton the next morning, they fired up the little steam car and set forth on the long automobile journey over the mountains to Yosemite.

Although no precise record of early motor vehicle travel to Yosemite Valley exists, so far as we know two cars reached the Valley via the Wawona Road in 1900, and two more preceded Dr. and Mrs. Clark over the Big Oak Flat Road in 1901, thus making the Clark's Locomobile the fifth automobile to successfully complete the difficult run.

A year later, Dr. Clark wrote the following article for the Overland Monthly *(August, 1902) describing the experiences he and his wife encountered on their Yosemite journey. Many years later, the Clark family donated some of the photographs reproduced on these pages to the Yosemite Museum.*

The new century certainly can chronicle a vast undertaking, successfully accomplished, when it records the automobile journeying to the Yosemite Valley and back.

Up hill and down dale, over ground almost impassable, just to test the sturdy powers of the twentieth century machine, to better study its moves under all circumstances.

An article upon our universities says:

"No phase of social progress is more characteristic of the development of the United States in the nineteenth century than the growth of our universities." And no phase of life in the scientific world has such strong markings, making such rapid strides for first position as the little automobile, combining as it does both social and scientific progress.

On Friday, July 19th, 1901, my wife and I stepped into our automobile to take the four p.m. Creek boat from Oakland. As competition has been great, and the development of the machine has reached a high grade of excellence, we were soon surrounded by an inquisitive crowd, who were especially interested when they were informed that we were en route for the Yosemite Valley.

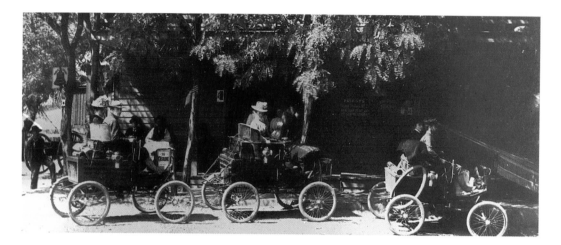

Mrs. Clark sits in the center car at Priest's Station on July 23, 1901, flanked by the Aikens and the Bairds. *Harper's Magazine* for December, 1901, carried an advertisement by the Locomobile Company, which used a photograph of Mrs. Clark in her machine. The caption read: "This is one of a party of three Locomobiles from San Francisco touring Yosemite Park."

To Mrs. Clark belongs the honor of driving the machine safely into the Valley and back, a distance of 246 miles. Our equipage attracted particular attention in San Francisco, as it had on its traveling suit of extra wheels, tools, baggage, etc., everything necessary for so long and severe a trip. It therefore did not present its usual attractive appearance. To better stimulate our ardor and also hold for future reference, we "sat for our pictures," then amid the best wishes of the assembled friends we sped down Market street for the ferry, to take the steamer Peters for Stockton.

On Saturday, July 20, 1901, we arrived at Stockton, leaving at 10:15 a.m. for Knight's Ferry, and were soon flying from our admirers, before they could realize that we had steam up. One does not know how very fast one is traveling until one sees a horse in the distance, comes up to him, knowing him to be a fast one, passes him easily, and leaves him away in the dim background. A mile in a minute and six seconds seems a prodigious speed for a road vehicle, but that is what our machine is capable of doing.

To Farmington, eighteen miles from Stockton, was indeed a pleasant run. Here we filled our water tanks and oiled our engine, while the people greeted us most warmly. The thermometer registered 106 degrees, and as the road was practically treeless, we had the full benefit of the heat.

From Farmington the roads could well be termed park roads. We were greatly surprised to find them in such good condition—this made journeying beyond a doubt perfect. The absolute capabilities of the machine were tested, as we pulled over Knight's Ferry bridge, in dust fully six inches deep, up a hill which we had been warned against, all of which was most successfully accomplished. At the top several

men met us who seemed astounded to learn that we had made the climb without the aid of horses. All the road to Curtin's was full of rocks, and an ugly growth of rocks and niggerheads made us pick our way cautiously for miles. Here we remained over Sunday, enjoying the most generous hospitality and gazing with profound awe at the tone of melting color, the absolute grandeur of the concentrated harmonies in surrounding mountains and hills.[1]

"The prayer of many a day is all fulfilled
Only by full fruition stayed and stilled."

Lost in the daily light, we spent Sunday evening in getting the auto ready for our next trip to Priest's; 9:30 a.m. saw us on our way, and easily we reached the railroad station, called Cloudman, where the people from the porches of their homes, happily greeted us and watched us flying by until we were out of sight.

We finally found ourselves climbing Crimea Hill, where again we encountered ruts, which we were obliged to straddle. The road being full of stones seemed to make the way almost impassible. The carriage bumped faithfully along through Six-bit Gulch, on to Chinese Camp.

The stage company offered to carry any baggage for us, but, declining with thanks, we started down grade, passing the Scharmot-Eagle mine, where the dust was a foot deep, with loose rolling rocks for company. Nothing lingers like memory, and experience is not at all antagonistic to our human nature.

Meeting several mule teams, we invariably took the outside of the road, gaining the good-will of all whom we met, and avoiding trouble with both mule and man. Lunch and Jacksonville came next, the thermometer only registering 112 degrees.

Hurriedly we finished, preferring the picturesque Tuolumne River. A refreshing breeze materially increased the popularity of the place.

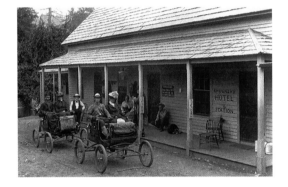

Mr. and Mrs. Baird and Mr. and Mrs. Aiken at Crocker's Station in July, 1901. These two Locomobiles were the third and fourth cars to reach Yosemite Valley. (Celia Crocker Thompson photograph)

—⁓—

Passing homes and mines, we were soon steaming up the foot of Priest's Hill. Here we filled our tank, oiled up the machine, put in a new gasket in the steam pump, preparatory for the difficult climb.

The initial climb to the top, a rise of 1800 feet in two and one-quarter miles, without a level spot in the road, is certainly a commendable undertaking for our carriage.

Within five hundred feet of the summit of the grade was exceedingly steep, averaging twenty per cent. This we made without the slightest trouble, with perfect disregard for dubious imaginings. The situation was intensely interesting and dramatic, illustrative of what an automobile can and will do when put to a difficult test. We were welcomed at Priest's with cheers and hearty congratulations by both our

—⁓—

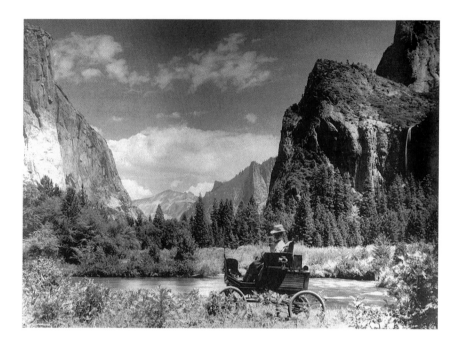

Mrs. Clark at Valley View in July, 1901.

—m—

generous hostess, Mrs. Priest,[2] and the guests, who had assembled on the veranda with their cameras to do us full justice in the way of a frank and impressionable American welcome. The actual running time from the base to the summit was forty-five minutes. The time usually taken with a light horse-drawn buggy is one and one-half hours, while the stage requires from two to two and a-half hours.

After a hearty dinner, exchanging the usual remarks with the guests on the hotel porch, we were startled by a most familiar whistle, and in a second Mr. and Mrs. Baird and Mr. and Mrs. Aiken drew up before the hotel in their respective motor cars;[3] objects for the sun's pity they were; beautifully coated with dust and dirt from their long trip. They had left Crocker's at 3 p.m., arriving at Priest's at 8:30 p.m., covering a distance of twenty-seven and one-quarter miles.

Our personal experiences were exchanged with a naive satisfaction which obliterated all else. Their account of the roads they had encountered was vividly interesting and pleased us immensely. Conceive if you can our thoughts and emotions, as we fully realized what we yet had to traverse in order to reach the Valley. The extreme position almost kept us from attempting the long heavy grades. "Nothing attempted nothing gained," however, so after a good night's rest, with renewed courage we started on our journey about 9:15 a.m., on Tuesday, July 23d. We climbed the miserably rugged grade to Big Oak Flat, where we refilled our water and fuel tanks. Mr. Root, the storekeeper, had an abundant supply of gasoline on hand. The machine, up to this point, had consumed twelve and one-half gallons of gasoline, the mileage being 68.3 miles. We

—m—

reached Groveland at 11 a.m., where we were obliged to have work done upon the frame of our carriage. We sought a first-class blacksmith. Not being able to have the work done until the next day, we spent the time pleasantly, leaving at 6 p.m. Wednesday. Cheer after cheer followed us as we began to climb the heavy grade beyond Groveland.

The splendid road, with its magnificent tall pines on either side, was grand beyond description. Soon we reached the all-famous landmark, the country around the brewery, perched up in the mountains. It serves as a starting point, and all distances for tourists are calculated to and from this tavern.

Our thirst not being exaggerated, and having made a late start, we did not stop, but, ringing our bell to attract attention, passed up and on our way to Swiss Inn. This part of our journey was the most delightful, in all probability, of the entire trip. The heat of the day, intensified by accompanying dust, had been dispelled by the coolness of night. The moon had risen; here and there a sweet clear note of some belated bird, calling its mate, awoke in us the tenderest thoughts.

Surrounded as we were by nature in its careless elegance and superb grandeur, we felt as though an apology was due each giant of the forest, for our intrusion. We passed Smith's ranch, reaching Hamilton's, a distance of three miles, and thirteen miles from our day's starting point, making the run in one hour and fifty minutes, including heavy grades and all stops. Mr. Hamilton, an old pioneer, considered this time exceptionally good.[4]

Thursday morning we left Hamilton's at 9:45 a.m., traveling the distance from this point to the Toll Gate in 12 minutes. Here we met one of the down-coming stages. A pleasant chat ensued between the passengers and ourselves, who discussed our undertakings, made notes of our past experience and time, trials, and pleasures, while we unblushingly told of our interesting experiences. All were impressed with the trip and the excellent work of the carriage. Our delay at this point lost us the right of way,

"At Curry Camp we ran our machine into the midst of a circle of Eastern tourists. . . One and all praised the. . . little carriage, which had done such wonderful climbing with so little trouble to its occupants."

as the up stage passed us here, and we were compelled to endure their dust for several miles. At last the stage horses becoming tired, an opportunity presented itself. The automobile being fresh as a new daisy, we were able to pass the stage, and soon leave it in the dim distance. Entering now upon the grand view of the Tuolumne Gorge, 3,000 feet below, we felt our supreme littleness. It was a magnificent picture of old, old days,

The Locomobile passes through the tunnel in the "Dead Giant" at the Tuolumne Grove of Big Trees.

blissfully sleeping, awaiting the eternal roll-call, with tall pines, firs, and redwoods for sentinels. This run took us through such scenery until Crocker's[5] was reached. We arrived forty-five minutes ahead of the stage. Luncheon over, we fed the machine with its fuel, and duly inspected by tourists, both to and from the Valley, we took our departure, some twenty minutes behind the stage. The same tactics were pursued in following the stage as in the morning. The passengers being doubtful of our ability to climb the heavy grades, caused a flow of comment, original in degree, and spiced with pleasantries—with a cheerful disregard of actual facts soon to be presented, for we again passed the stage, making most excellent time to Crane Flat, then on to Gin Flat. This is the highest point on the Big Oak Flat stage road, 7,500 feet above the level of the sea.

Individually our souls were inspired, mentally we were enchanted; personally we could say nothing, for words fail when the Creator lays before us the sublime in the highest sense.

Again water was taken before starting for the Valley, and noticing a puncture in one of the tires of our front wheel, we stopped for repairs. The tire was easily mended and caused only a slight delay.

The road down into the Valley led past Inspiration and "Oh, My!" points. This run being made without incident, we reached the floor of the valley at 7:20 p.m. Here our worst roads were encountered, the granite dust being inches deep. Nevertheless, the four miles to the Guardian's Office[6] was made in thirty minutes. Here we received our mail, then wended our way to Curry Camp, about one and one-quarter miles from the Guardian's Office. At Curry Camp we ran our machine into the midst of a circle of Eastern tourists, seated around a large camp fire. To say that the apparition of an automobile suddenly appearing among them called forth generous applause and hearty congratulations but feebly expresses it. One and all praised the workmanship and great

endurance of the little carriage, which had done such wonderful climbing with so little trouble to its occupants.

While in the valley trips were taken to Mirror Lake, Indian Cave, Royal Arches, Yosemite Falls, Bridal Veil Meadows, and other places of interest. The machine was used as a preliminary to climbing some of the trails on these excursions. A week spent in the valley was all too short and dream-like, and we were compelled to think of home and the return trip, which departure was begun on Thursday, August 1st.

We left the Guardian's Office at 9:30 a.m., and four miles out our chain parted, the granite sand having evidently cut it in two. A new chain was soon slipped on, and the homeward climb was commenced. For fourteen miles it was a steady pull, made without the slightest difficulty. We met a party of cyclists on their way into the Valley, who were greatly surprised to learn that an automobile had made the trip unaided.

Reaching Tamarac Flat, we soon arrived at Gin Flat at 1:05 p.m., where a stop of one and a half-hours was made for luncheon and rest. Again we sped along the road through the Tuolumne Big Trees to Crocker's, reaching there at 4 p.m. Here we filled our water tanks, took some left over gasoline, leaving at 4:50 p.m., passing the Toll Gate, and running in at Hamilton's at 6: 50 p.m., a distance of thirteen miles, having been made. Mr. Hamilton called it locomotive speed. The following morning a late start was made, and gasoline taken at Big Oak Flat. We reached Priest's for luncheon. The descent from Priest's was made without difficulty, and Chinese Camp was reached. From this point our time was necessarily slow, as we met with many large mule teams and different stages, and not wishing at the end of our journey to summon grief or cause trouble, the machine was always stopped on the outside of the grade, and our fires extinguished, for which consideration on our part we gained the full appreciation of all drivers. The dreaded Crimea road was at last before us, passed with a delightful certainty of success, and Curtin's reached in time for supper. Saturday morning leaving Curtin's at 8 a.m., the run to Knight's Ferry was made without incident; water for the machine and a watermelon for its occupants quenched both thirsts. The thermometer then stood at 106 degrees. This caused loss of time, but we were able to reach Farmington in time for luncheon. The eighteen miles between this place and Stockton was easily made, and we had ample time to reach Stockton.

The whole distance of thirty-eight miles lying between Knight's Ferry and Stockton was made against strong head winds, with the temperature standing at 108. We arrived at Stockton at 3:30 p.m.

A summary of the entire distance traveled, and gallons of gasoline used may be instructive:

Entire distance traveled, 246 miles, on 51½ gallons of gasoline.

14½ gallons gasoline	$2.60
12½ gallons gasoline	4.25
5 gallons gasoline	1.90
14½ gallons gasoline	7.25
5 gallons gasoline	1.50
Total	$17.50

Mrs. Clark and some of the locals were photographed
at Hamilton's Station (now Buck Meadows).

One pint of lubricating oil and considerably less than one gallon of cylinder oil
was consumed.

The suburbs of Stockton was soon reached, where fresh troubles with horses began,
but by careful and judicious management and full consideration of the drivers' rights,
we reached the steamer safely. Again home, where this trip will ever remain a happy
memory, aside from its scientific value and its wonderfully successful termination.[7]

CHAPTER IX
NOTES AND REFERENCES

—⁂—

1. For many years, the Curtin Ranch, originally Cloudman's, was a popular stopping place for teamsters and tourists traveling over the Big Oak Flat Road.

2. William C. Priest, who operated Priest's Station with his wife Margaret for twenty-five years, died in 1900, the year before the Clarks' arrival.

3. A Mr. and Mrs. Baird and a Mr. and Mrs. Aiken, also driving Locomobiles, made their Stockton-to-Yosemite journey over the Big Oak Flat Road only a week or two before the Clarks.

4. Alva and Johannah Hamilton ran Hamilton's Station, a stage stop on the Big Oak Flat Road, from the mid-1870s into the early 1900s. It is now called Buck Meadows.

5. Henry Robinson Crocker, a native of Massachusetts, came to California in 1853. He acquired land, married (his wife was named Ellen), and, at the request of the stage company, erected a substantial inn on his property called Crocker's Station in 1880. During the peak years of stage travel, Crocker's vied with Priest's as the most important stop along the old Big Oak Flat Road. Crocker died in 1904, but his operation continued under different owners until 1920. Today only the decaying foundations remain.

6. In 1899 the state moved photographer George Fiske's former studio from its original Lower Village site to a new location in the Upper Village (then called Yosemite Village). It served as the Guardian's Office, and later the Acting Superintendent's Office, for a number of years.

7. Late in 1905, Dr. Clark made a second motor trip to the Valley, this time driving a 1904 Autocar, TYPE VIII. He reported that—unlike his first Yosemite experience—the roads were in poor condition and the grades almost insurmountable. "Automobiles are not at present made for this kind of work," Clark said in a brief account of his expedition. "I urge all who try it to take extra parts such as a drive shaft, gaskets, and springs."

—⁂—

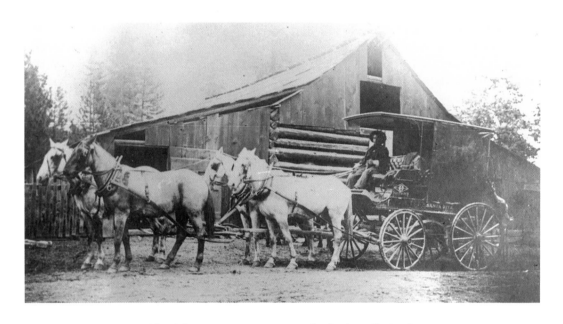

Hazel Green was a stage stop on the Coulterville Road.

—⁓⁓—

X

BY WHEEL TO YOSEMITE
by Ed Pickett

On a cool spring morning in June, 1908, fourteen-year-old Ed Pickett and two teen-age companions departed their Napa, California, homes on an audacious bicycle journey to far-off Yosemite Valley. They began by peddling twenty miles to the port city of Benicia where they boarded the overnight steamer running up the San Joaquin River to Stockton. Here they once again mounted their "wheels" and set out on the long uphill pull through the foothills and over the old Coulterville Road to Yosemite, 150 miles away. By the evening of the third day, the bold young riders finally reached their destination and settled into camp.

Leaving their cycles stored at their campsite as required at the time, Pickett and his friends spent the next two days hiking to Glacier Point, Mirror Lake, and other points of interest in and around the Valley.

The boys departed Yosemite on June 29 via the Big Oak Flat Road, eventually attaining the summit near Crane Flat after a hot, strenuous climb of more than two thousand feet. An hour later, they rode their bicycles through the "Dead Giant" tunnel tree at the Tuolumne Grove, which they considered "a fitting climax" to their journey. The hazardous descent of Priest's Grade was accomplished by dragging bushes or small trees behind their machines to provide extra braking. Then came a train ride, a boat ride, and the final bicycle leg from the Benicia pier back to Napa.

Sixty-three years after the memorable excursion, Pickett wrote an article about his adventure for The Sacramento Bee *of September 5, 1971. The sub-caption to the story seemed to sum up the indomitable spirit of those long-ago youths rather well: "The roads were rough, the grades were steep, but our hearts were young."*

The bicycle trip from Napa to Yosemite Valley was Charlie McDougal's idea. He asked Tibby Hutchinson, my boon companion for several years, to go along, and Tibby said he would go if I would. Tibby and I were 14 at the time; Charlie was older, 17. I hadn't known him before the trip.

That was 63 years ago. Yosemite Valley was a long, long way from Napa and no one we knew had ever been there. But our parents considered us to be self-reliant and we saw nothing daring or unusual about the exploit.

Charlie did the planning and picked a route that even in present-day tour books is least advisable.

Little time was spent in packing as we only carried rolled up blankets and our

puncture repair kits. On June 23, 1908, we met at Inman's bicycle shop, checked over our wheels (as bicycles were called in those days) and set off on our trip.

There were no roads then between Napa and the Central Valley. The only practical way to Stockton was by riverboat. So our first destination was Benicia, about 20 miles away. We made it in good time and then had to wait several hours for the boat.

It was chilly at the dock and more so after we boarded. We covered up with our blankets and huddled against the sheltered part of the cargo deck. We did not get much sleep.

EARLY DOCKING

The boat docked at Stockton at 6 a.m. and we were off and on our way.

The road to Oakdale was fairly good. As we carried no provisions, we bought a can of corned beef for a dime and a small loaf of bread for a nickel. The can had a key attached for opening it and we used our jackknives to slice the bread.

From Waterford the way turned east toward the foothills. We had covered 40 miles from Stockton and had expected to reach La Grange, 20 miles farther, before night. But the foothill roads were rough and many dry washes and gullies had to be crossed. Riding was not possible on many stretches.

We realized we might not reach La Grange before dark, so when we came to a small store we bought another can of corned beef and some cookies. A nice lady living next to the store refused any payment for a loaf of homemade bread. We rode on until we could no longer see, then rolled up in our blankets at the side of the road. Sleeping on the ground was no hardship for us.

The present distance from La Grange to Coulterville is 25 miles but in 1908 the road followed all the contours of the hills in such a roundabout way that our mileage was much greater. The country was dry and uninteresting. It was mid-afternoon when we coasted single file in Coulterville's one dusty street.

ALMOST DESERTED

The old mining town was almost deserted. There were four or five men loafing in front of one of the few occupied buildings. They all wore beards so we took it for granted they were old, a tag we applied to anyone over 30.

The men were greatly interested in our wheels. We had planned to sleep out, but after two uncomfortable nights a bed in the old hotel seemed like a good idea.

From Coulterville to the Merced Big Trees was about 30 miles. This stretch of road had been part of the toll section and was better graded, but it had been completed in 1875 and by 1908 was the least popular way to the valley.[1]

This road was fair and even though we were gaining elevation, another stage station, Hazel Green, was reached by noon.

It was a short distance to the Merced Grove where we had our first look at the giant sequoias. There were about 50 of them. Our first objective had been realized—the great trees, previously known to us only from pictures, could be seen and touched. We did not see another person in the 45 minutes we spent there.

The junction with the Merced River Road was only an hour away. Numerous small

The old Coulterville Road ran directly through the Merced Grove of Big Trees, shown here in the mid-1920s. The boys reported that they did not see another person during the forty-five minutes they spent here. (Author's collection)

—◊—

streams had to be forded, but we made good time. The final few miles was a descent of the Coulterville grade. The roadbed was solid but there were lots of loose, sharp rocks and in places the grade was steep. We stopped once or twice on the downgrade to let our coaster brakes cool. The fast-flowing river was in sight most of the way down.

UNFORGETTABLE SIGHT

One sight I never have forgotten: This section of the river was a series of pools (the Cascades) and each was seething with trout. The crystal-clear water was in full sunlight. In later years, I have fished many streams in the Sierra but never again saw anything comparable.

The, road junction was about 8 miles east of El Portal, the rail terminal.[2] We did not have to register at the park entrance, but we paid a toll of 50 cents for each bicycle and rider.

There were regulations concerning the use of bicycles posted around the park. One of them advised cyclists to avoid scaring horses:

"On meeting a team the rider must stop and stand by the side of the road between the bicycle and the team—the outer side of the road if on a grade or curve. In passing a team from the rear, the rider should learn from the driver if his horses are liable to

—◊—

frighten, in which case the driver should halt and the rider dismount and walk past, keeping between the bicycle and team. . . ."

Another regulation barred automobiles and motorcycles from the park. These regulations remained in effect until 1913. During the summer months a troop of US Cavalry was stationed in the park to enforce rules and maintain order. Civilian rangers did not replace the Army until 1914.

We learned at the toll station that we had to register at the superintendent's office in the village, and we were off.

STUNNING BEAUTY

Suddenly the floor of the valley burst into view. Bridal Veil Falls was to the right as we looked across the rushing Merced River. El Capitan was to the left, and some of the higher peaks were in the distance. As we proceeded up the valley, more of the famed places came into sight. Yosemite Falls on the left, Cathedral Spires on the right, and now, in plain view, North Dome and Half Dome.

The three Napa youths at Mirror Lake in June, 1908. From left: Ed Pickett, author of this story; Thomas "Tibby" Hutchinson; and Charles McDougall. (Author's collection)

—◠◠—

We did not need a guide to name them. Yosemite had been an international tourist attraction for more than 30 years and maps, guidebooks and picture postcards had been widely distributed. Now they were real to us.

At park headquarters, we were assigned a site in Camp 7 and conducted there by a trooper. It was in an open stand of conifers on the north bank of the river, about a half-mile east of the village. We cut some cedar branches, laid our blankets on them and were settled. We had no other equipment. The trooper told us our wheels would be safe so we left them with the blankets until we were ready to leave for home.

Park records disclose not more than a few hundred campers in the entire valley while we were there. A few hundred more persons occupied the hotels and cottages, but there never seemed to be many people around.[3]

The next morning we took the long trail to Glacier Point. We were young and impatient and, except for Charlie's camera, were not hampered by any equipment so we were the first of the day's sightseers to make the summit. We returned to the valley by the Four Mile Trail and explored the floor of the valley. By the time we returned to our camp we had walked 20 miles.

Shortly after sunrise on June 28, we arrived at Mirror Lake. Another early riser

—◠◠—

offered his services to take the only photo in which the three of us are seen together.

HEADED FOR HOME

We headed for home the morning of June 29. It was a hard, hot climb to the summit of the Big Oak Flat Road.

About an hour after making the summit, we reached the Tuolumne Grove. Years before, a tunnel had been cut through one of the giant trees, large enough to allow a team to pass. Riding through this tree on our wheels was a fitting climax. At home, more questions were asked about this than any other part of the trip.

That night we slept in the vicinity of Carl Inn.[4] From there it was downhill over a well-traveled road. Passing the old mining towns of Groveland and Big Oak Flat, we reached the top of Priest's Hill, then one of the steepest grades in California and quite hazardous.

At Groveland, bystanders had suggested we take rope, and tie bushes or small trees to the frames for extra braking. We thought our brakes would hold but picked up some rope just in case. One look from the top of the grade and out came the jackknives to cut braking material.

Priest's Station, at the head of the steep Priest's Grade, was a stopping place on the old Big Oak Flat Road for many years. The buildings shown here burned in 1926. (Ted Wurm collection)

TOOK A HEADER

The first rider started and the dragging bushes raised great clouds of dust.

I was the last to take off and the only one to have an unscheduled stop. I had left my rope too long causing the small tree I was dragging to get snagged on a rock at a turn. My wheel stopped and I took a header into the thick dust. My wheel was undamaged; only my pride was hurt. I shortened the rope and soon joined the others at the bottom. Two hours later we reached Jamestown, called Jimtown by the residents.

Sonora was our goal but one of Charlie's tires was so badly cut it could not be repaired. There was no chance of finding a replacement in that area, and Tibby and I would not proceed without him. The morning train of the Sierra Pacific Railroad had three passengers for Stockton.[5] There a tire was quickly mounted and luckily we located a sternwheeler due in Benicia an hour before dark. There was plenty of July daylight left for the trip to Napa and home.

Bicyclists have ridden to Yosemite for more than a century. Here is a pair
of tandem riders known as "The Boys of Yesterday" in Yosemite in 1932.

LOOKING BACK

I did not see much of Charlie after the trip. He was older and worked regularly.

Tibb and I were closer than ever until I left Napa in 1909, and Tibby's family moved
to Berkeley soon after that. I was in touch with him from time to time, but never saw
him again. He moved to New York after World War I and became one of the pioneers
in radio and, later, television programming.

Both Tibby and Charlie are gone now. But the memories of the magnificent
Yosemite as we saw it—uncrowded, uncluttered, and unspoiled—are as bright and clear
as the prints from the pictures Charlie took 63 years ago.

CHAPTER X
NOTES AND REFERENCES

—ɯ—

1. The Coulterville Road to Yosemite Valley opened on June 18, 1874, the first wagon road to reach the Valley floor. It was the least patronized of the three Yosemite toll roads and had fallen into considerable disrepair by the time Pickett and his friends made their journey in 1908. The story of early roads into Yosemite Valley can be found in Hank Johnston, *Yosemite's Yesterdays, Volume II* (Yosemite: Flying Spur Press, 1991), 31-63.

2. El Portal, twelve miles west of the Valley proper, was the terminus of the Yosemite Valley Railroad, completed in May, 1907. The railroad built a road from El Portal to a junction with the Coulterville Road near the Cascades that same year. Passengers were transported from the railroad station to their Valley destinations by stage.

3. Visitation to Yosemite National Park for the year 1908 totaled about 8,850 persons.

4. Carl Inn did not exist at the time of Pickett's trip. Erected in 1916 by Dan and Donna Carlon, Carl Inn was a popular resort along the Big Oak Flat for a number of years.

5. The Sierra Railway was completed from Oakdale on the Southern Pacific mainline to Sonora in 1897. Some Yosemite visitors rode the Sierra Railway to Chinese Station at milepost 35, then boarded the stage for the sixty-four-mile carriage ride to the Valley.

—ɯ—

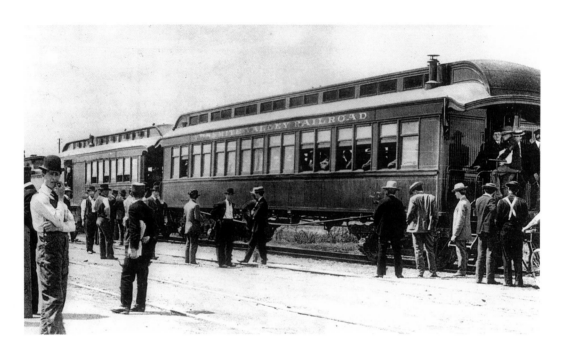

An early train on the Yosemite Valley Railroad makes ready to leave
the Merced station bound for the glorious trip to the mountains.

XI

THE NEW YOSEMITE RAILROAD
By Edward H. Hamilton

When the Yosemite Valley Railroad (YVRR) was completed from Merced in the San Joaquin Valley to the very gates of Yosemite National Park in May, 1907, it was looked upon as the ultimate answer to the need for an easier, faster route to the world-famous Valley. The railroad's backers, a group of prominent Bay Area businessmen, confidently predicted that it would endure for at least two hundred years.

Certainly the YVRR was a vast improvement over the long, jouncing journey by horse-stage that had provided the principal means of access to Yosemite during the preceding thirty-three years. It now became possible for Yosemite-bound tourists to leave San Francisco in the morning and arrive refreshed at their Valley hotel that same night.

The first run over the new seventy-eight-mile railroad took place on May 15, 1907, and for the next twenty years the YVRR showed a steady increase in revenue. Passenger travel reached an all-time high in 1925 when 85,107 fares were recorded. In the summer of 1926, the completion of the All-Year Highway (Route 140) on the opposite side of the Merced River Canyon marked the beginning of the end for the picturesque little railroad. It was far more convenient and considerably less costly for families to drive their own cars all the way to the Valley, carrying their food and camping equipment with them. By 1944, passenger travel over the YVRR had dropped to just 584 paying customers. Freight revenue suffered a similar deep decline. On August 24, 1945, the YVRR made its last run.

The following article by Edward H. Hamilton appeared in the Cosmopolitan Magazine *of September, 1907, only a few months after the railroad was completed. Hamilton vividly describes the virtues of the new route and the sights to be seen along the way. He also presents both sides of an argument then raging in some quarters as to whether or not it was a good idea to make Yosemite Valley so easily accessible.*

The history of the Yosemite Valley Railroad can be found in Hank Johnston, Railroads of the Yosemite Valley *(Yosemite: Yosemite Association, 1995).*

Editor's Note: The main centers of population are not, as a usual thing, situated within easy access of the great wonders and sights of nature, whose beauties consequently are monopolized by those fortunate beings in whom physical prowess is combined with the additional advantages of abundant time and money. This limited class has attempted to spread a belief that any attempt to overcome the difficulties in reaching God's greatest creations is sacrilege. No idea could be more foolish. Such facilities as the Mount Washington and Pike's Peak railways in this country, the Rigi, Jungfrau, and other mountain roads in Switzerland, have proved a genuine source of happiness to thousands of people who, without them, must have been denied some of the most thrilling emotions that the human soul can experience. Hundreds of yearly visitors to California have been compelled to leave without a sight of its greatest marvel because neither time nor means would permit of the long expensive trip into Yosemite Valley. The iron horse now makes its way to the very gates of the National Park. This means quick, cheap transit into one of the most favored spots of earth, and from which increasing numbers of people will bring noble, inspired ideals and memories that will be a pleasure as long as life remains.

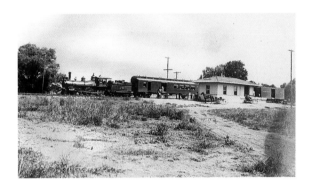

"There are fat lands about Snelling, with orchards and vineyards and a general exhalation of bounty." The Snelling station is pictured here about 1910 with a YVRR train stopped in front.

They have built a railroad into the Yosemite. That sounds very much as if the Black Cavalry of Commerce had been sent out to trample down the fairy rings. In California and the far West already there are people who insist that hereafter the great valley is to be a mere picnic-ground with dancing-platforms, beery choruses, and couples contorting in the two-step.

There has been a sort of worship of the Yosemite, and the worshipers have held to the old idea that nothing is worshipful but that which is difficult and far away. Gods and shrines must be understood only by the priesthood. The religion of nature, like the other religions, must not be cheapened and brought within the compass of the troubled many. Adoration of the Yosemite should be for the stout pilgrims with long purses and no ailments. The surpassing exemplification of nature's greatness must be reserved for the athletic rich.

So argue the "nature cranks," as they have been dubbed by advocates of the other idea. These others want equal rights in scenery as well as in the Constitution. They argue that if Yosemite "proves the existence of God," as one devotee has put it, the consecration and conviction caused by the mingling of grandeur and beauty should be open to all mankind. They declare that the more people that can be brought to see Yosemite the better will the world become. They insist that they hold an equal measure of reverence and appreciation with their opponents, and they are very stout in sneering at selfishness and snobbery in the aristocracy of travel.

Shall you be carried to the skies
On flowery beds of ease
While others toil to win the prize
And sail through bloody seas?

So misquote those who would have everything grand and beautiful in nature as remote and inaccessible as the poles; while their opponents retort that there is no reason why a man in a clean shirt cannot appreciate nature as deeply as the chap with his lungs full of dust, a crimp in his collar, and an ache in his back.

But while the argument goes on and grows fiercer as it goes, there is the railroad into Yosemite, and all the arguments since Adam and Eve will not put it away. A very substantial railroad it is, too, with seventy-pound rails and steel bridges, and a road-bed that was in large part hewn through the solid rock. It is a twentieth-century fact, and even the "nature crank" may not find it entirely incompatible with his idea of worship and veneration to leave San Francisco in the morning and sleep at the hotel in the Yosemite that night. Once there he will be a toughened soul indeed who can "gape joylessly in the home land of the beautiful," even though there are ten people at worship where there was but one before.

In the grand old uncomfortable days very rugged men got glimpses of Yosemite by riding many miles on horseback, and then scrambling afoot. If salvation depended upon a visit to the great shrine by that means, the bright beyond would have been populated entirely by athletes. The first white men straggled in along an Indian trail in March, 1851. When one of the party was advised to move out rapidly else, should he be left behind, he would lose his hair, the reply was, "If my hair is now required I can depart in peace, for I have seen the power and glory of a Supreme Being."[1]

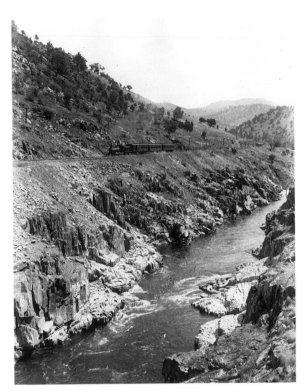

Pushing the seventy-eight-mile Yosemite Valley Railroad through the narrow and rugged Merced River Canyon was an enormous undertaking. This view was taken in 1907, the first year of operation.

—⁓—

It was the throb and inspiration reported by the pioneers of the Mariposa battalion that sent other pilgrims forward on the uncertain trails to brave the grizzly and the Indian. The adventurous men of the "Southern Mines" got into the way of glimpsing the wondrous valley when they had pouched their gold-dust and worked out their bench or bar. The first tourists entered the valley in June, 1855,[2] led by J. M. Hutchings, who had heard of a waterfall a thousand feet high and wished to see for himself. The

—⁓—

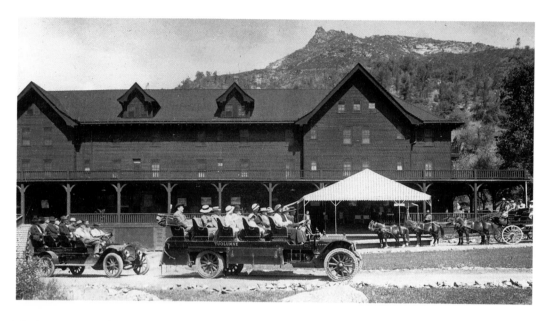

The luxurious Hotel Del Portal had 100 rooms, 30 with bath, and a dining room that seated 115 persons. Completed in 1907 at a cost of $50,000, it burned to the ground on October 27, 1917. This photograph was taken when horse stages were being phased out in favor of motor stages in the fall of 1913 or the spring of 1914.

—⁓—

place so fascinated Hutchings that he became a part of it, and his body now lies in the valley's little cemetery.

From this on the tourists multiplied, and the trails were cut to fit their demands. But it was "a hard road to travel," and it still required a good stomach, stout muscles, and a venturesome soul to secure the uplift and glory of "seeing Yosemite." In time came a road, but at best there were over two hundred miles of hard going in and out, and the tolls were high. Then other roads were built, and at last the railroad crept up so there were only sixty miles of staging each way. But sixty miles of climbing and plunging and the eating of dust does not tend to convince the average man or woman that he or she is on the road to happiness. So many visitors swore through their dirt that they never would undergo that penance again.[3]

The number of pilgrims, however, had grown to about five thousand yearly in 1900 and last year ran up to seventy-five hundred or thereabout. The mighty scenic magnet drew people from all the world—people who stood the fatigue and the discomfort just to be able to say in the face of the world, "I have seen Yosemite." Still the journey was, as one writer aptly said, "The pilgrim who approaches this mighty shrine, like the faithful who seek Mecca, must endure somewhat."

At last this is changed. Man's money and man's ingenuity have made the path easy and the burden light. The non-athletic certainly will rejoice at this, even though those of heroic pose insist that the railroad is poking an impudent nose into nature's holy of holies. Already those who keep to the natural law of following the line of least

—⁓—

resistance are patronizing the railroad, leaving those of the hardier legs and idyllic fancies to follow the old stage-roads or the older trails.

There is nothing scenically banal about this railroading toward the stupendous gorge. If it did not have so unusual a terminus—if it were not a mere curtain-raiser—its own peculiar beauties would soon have a generously heralded fame. For that railroad for the most part winds along the rushing, tumbling, kicking Merced River—fifty-four miles of white water. It is carved out of the rock, and the explosion of its blasts startled many old romances that have slept along the River of Mercy since the miners rocked their cradles there in the brave days of gold.

They tell you that it took 2,800,900 pounds of black powder and dynamite to force that road through the scenery. One tale is that it cost sixty-five dollars in wages to transport a light push-cart less than a mile. A great gang of men worked ten months in hewing two miles of railroad way through "The Broadhead," where the river wallows through a precipitous box canyon. So the intending traveler may know that he is not to pass through a dull state and unprofitable land when he jumps out of the San Joaquin Valley into the mountains.[4]

To those who look for guide-book information it may here be told that both the Southern Pacific and Santa Fe railroads meet the Yosemite Valley Railroad at Merced, county seat of a county that took its name from El Rio de la Merced—the River of the Mercy. Then this new, impudent, and irreverent road pushes right eastward across the flat lands toward the Sierras.

At first there is little to see save the irrigating-ditches, wheat-fields, and pastures of a country destined to become more populous. There are fat lands about Snelling, with orchards and vineyards and a general exhalation of bounty. But not until Merced Falls is reached will there be any great necessity of craning necks from the observation-car. From that point on, however, things are worth the story-teller's attention.

Above Merced Falls the Past and the Present shake hands. Modern methods of storing and utilizing water-power and modern methods of mining are seen beside the broken flumes and the piled cobbles that tell of feverish excitements, swift fortunes, and the "petulant pop of the pistol" in the times when water-power was wasted and only the richest ground was panned.

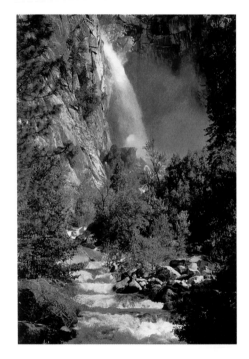

The stage road from El Portal to Yosemite passed through some handsome scenery such as the Cascades. "One of the most impressive of Yosemite's greater waterfalls pours in on the left of the road," Hamilton wrote in describing the Cascades. (Hank Johnston photograph)

—m—

Tumbled in a hollow will be seen the rusted remains of an old arrastre. Four roofless walls of stone with iron shutters still rattling on guard at paneless windows mark what was once a bank, where the gold dust was weighed carelessly, but always for the benefit of the banker. Just over the hills in one direction was Mt. Ophir, where the fifty-dollar

—m—

"O'Brien Arch" referred to by Hamilton was really
Arch Rock, shown here about 1920, on the road from
El Portal to Yosemite Valley. (Author's collection)

—◊—

"slugs" were minted at a private coinage plant—the largest gold pieces ever coined.

On one bench a few seared stone chimneys are all that sorrow over what was a
roaring camp of over five thousand people. Farther up the river was Hell's Hollow—a
name to start the imagination. This was on the Mariposa Grant property of "The
Pathfinder" Frémont. He put a quartz-mill there and called the place Benton's Mills
after his wife, Jessie Benton, daughter of the great senator.

Hell's Hollow has now become "Bagby's," named for a thorough adventurer who set
up a shack-saloon and bunk-house where the Mariposa Road crosses the river and
where modern miners have put in a dam. That dam backs up the water to the place
where, in Solomon's Gulch, the miners of an earlier day panned and cradled over two
millions of "the good red gold." But all the life of that generous day has gone.

Up the South Fork a few miles is a mine found by an Indian named Lucy, who gave
it and its fat fortune to John Hite, who became her husband. His efforts to disclaim the

—◊—

daughter of the forest constituted one of the picturesque litigations of California's early years.[5] There are other rich mines along the road, with now and again a mill or a dam, but should the traveler desire a glimpse of the picturesque past all he has to do is to watch the inflowing streams from the gulches, and whenever he sees a spout of yellow water pouring into the white and green he will know that some man is taking a chance with pick and pan in just the way men took chances when they made California in the wilderness without stopping to ask whether God would say that it was good.

There is even a flare of the old life at Bagby's with the Oakhursts and Jack Hamlin at the gaming-tables, and M'liss and Piney and the rest just as human as they always were even before the master hand scraped away the paint and showed the soul. It is quite in keeping with the romance of the river that power for a rock-crusher is to come from the "nameless dam," and that the rock to be crushed is jasper—there is a mountain of it—and it comes down to paint unusual reds and purples in the river's flood.

There is a great splurge of quartz below El Portal, end of the road and door of the valley. The prospectors passed this quartz by day and by night. It had no lure for them. There was too much of it. Such an outburst could mean nothing in the way of fortune. It was one of nature's jokes. But at last a man named Eigenhoff sat down and hammered away at some of the rock. As a result a company backed by many millions of dollars is putting a big stamp-mill on that long neglected lode. It is just the mining investment that capital seeks—an enormous quantity of low-grade ore.

And then with the stopping of the train at El Portal the Yosemite really begins. To be sure, there are still fourteen miles of staging to the Sentinel Hotel, and there is a good climb to "the floor of the valley." But the Chinquapin Falls are right above the terminus, tumbling fretfully, and the first of the glacial erosions on the tall granite cliffs can be seen just up the river.

Then the road passes cataract after cataract, fall after fall, cliff piled upon cliff. There is no moment when the eye does not command some exclamation of approval or delight. At one point the stage-road has been blasted right through a granite boulder, and this is called the O'Brien Arch, in honor of the contractor whose push and persistence carried the railroad through where it had been said no railroad could go.[6]

The Cascades, one of the most impressive of Yosemite's greater waterfalls, pours in on the left of the road, and the horses drink of its flood. The old roads and trails tumble down from this side or that. And then El Capitan and The Place.

The best pens of half a century have tried to tell the rest, and they have seemed scratchy and mean, for they tried to tell the untellable. But now it is comparatively easy for man to see and feel for himself, and in that presence to wonder why he could not believe; why he cheated and lied and roistered in drunken foolery; how he could have forgotten loves and broken friendships; why he had not always clung to the beliefs and ideals of childhood.

For whether you reach Yosemite afoot or in the saddle, by stage-coach or by train, you will find there an uplift and a benediction. And you will hear the voice of Faunus singing in the mountains; or it may be the voice of God.

CHAPTER XI
NOTES AND REFERENCES

—⚍—

1. The statement about losing one's hair was recorded by Lafayette Bunnell in his book *Discovery of the Yosemite and the Indian War of 1851 Which Led to That Event*, 4th ed. (1911; reprint, Yosemite: Yosemite Association, 1995), 57-58.

2. Hutchings actually made his inaugural tourist visit to Yosemite Valley the last weekend in July, 1855, not June.

3. When the Yosemite Valley Railroad opened in May, 1907, the nearest rail connection was at Chinese Station on the Sierra Railway, a distance of sixty-four miles from Yosemite Valley. From Raymond it was sixty-seven miles.

4. Various totals ranging up to $10 million were quoted as the cost of building the Yosemite Valley Railroad. In 1916, the Interstate Commerce Commission established a figure of $3,356,492 for all property, rights-of-way, and construction on the line.

5. The reference here is to John Hite, who became a millionaire after discovering a gold mine at what became known as Hite's Cove on the lower Merced South Fork in 1862. Many years later, Hite was sued by his common-law wife, a Yosemite Indian named Lucy, in one of the most famous cases of the day.

6. James "Horse & Carts" O'Brien, a San Francisco grading contractor, was construction supervisor on the Yosemite Valley Railroad. The "tunnel" was a natural one, now called Arch Rock.

—⚍—